James Birch

with Michael Hodges

BACON
IN MOSCOW

CHEERIO

CHEERIO

First published in Great Britain in 2022 by
Cheerio Publishing in association with Profile Books
www.profilebooks.com
www.cheeriopublishing.com
info@cheeriopublishing.com

Design : Justine Bannwart
Cover design : Steve Panton

1 3 5 7 9 10 8 6 4 2

Printed and bound in Italy by L.E.G.O. Spa

A CIP catalogue record for this book is available from the British Library.

ISBN 978 1 78816 9745
eISBN 978 1 78283 9484

For John Edwards

'*We want bacon, not Francis Bacon*'
(comment in the visitors' book to the exhibition)

'*In one of Van Gogh's letters he makes this statement:*
"*How to achieve such anomalies, such alterations and re-fashionings of reality
that what comes out of it are lies, if you like, but lies that are more true than
literal truth.*"'
Francis Bacon, London, 04/06/1988 —
Contribution to the Catalogue to the Exhibition in Moscow.

'*I enjoyed Francis Bacon very much. I would like to study art with him.*'
Chuporov Eugeniy, SCL09 No. 791, Form 2B, 8 years old
(comment in the visitors' book to the exhibition)

AUTHOR'S NOTE

This story is written partly from memory but also with the help of detailed diaries that I kept from the date of meeting Sergei Klokov and Elena Khudiakova in Paris in 1985 until 1992.

I also created an archive of all correspondence I received during this time, including letters from Francis Bacon, telegrams from the Union of Artists in Moscow and all relevant newspaper cuttings and invitations.

I have drawn on all of this material while researching this book.

My ambition was to write a true and faithful reckoning of a brief but intensely interesting period in twentieth-century European history from a very personal perspective.

Any mistakes are my own.

James Birch
May 2021

In October of 1988 I took Francis Bacon to Moscow, an unimaginable intrusion of Western culture into the heart of the Soviet system. I was only 32 but I'd known the world's greatest living artist since childhood. He was a friend and from my adolescence onwards I spent a lot of time in his company. I joined him for drinks at the Ritz and accompanied him on his champagne benders around Soho, dining with him in the Greek restaurant The White Tower, which he loved, and conspiring with him as we stood in the sticky corners of The Colony Room (he rarely sat).

But this does not fully explain how I found myself in the USSR just as it was teetering on the edge of its own destruction, under twenty-four-hour surveillance by the KGB and side-lined by the British establishment. More than that, I felt morally responsible for the thirty or so works of Bacon's due to be shown in the exhibition, and I was falling in love with a beautiful Russian fashion designer.

I could say it was Sergei Klokov's doing. He was the fixer, a man who knew how to make the impossible happen in Moscow and was willing to do almost anything to ensure that it did. It was Klokov who introduced me to the ravishing Elena Khudiakova. But the story doesn't begin with Klokov.

It really begins with James Bond, when I started to read the Ian Fleming books as a boy. I loved the stories and I especially admired the book jackets designed by the British artist Dicky Chopping, their colours and imagery: bones, knives, guns, frogs, everything a child loves. They were of their time and without fully understanding, they ignited my life-long interest in surrealism. I had unconsciously started collecting.

Art was the family affliction long before I came along. My parents met in Cambridge where my father was studying architecture, and he followed my mother to London where she was studying at the Chelsea School of Art. One of her tutors was Henry Moore. It turned out that my father couldn't draw well enough to become an architect so he began to paint instead. After they married, they made a living painting murals together, though

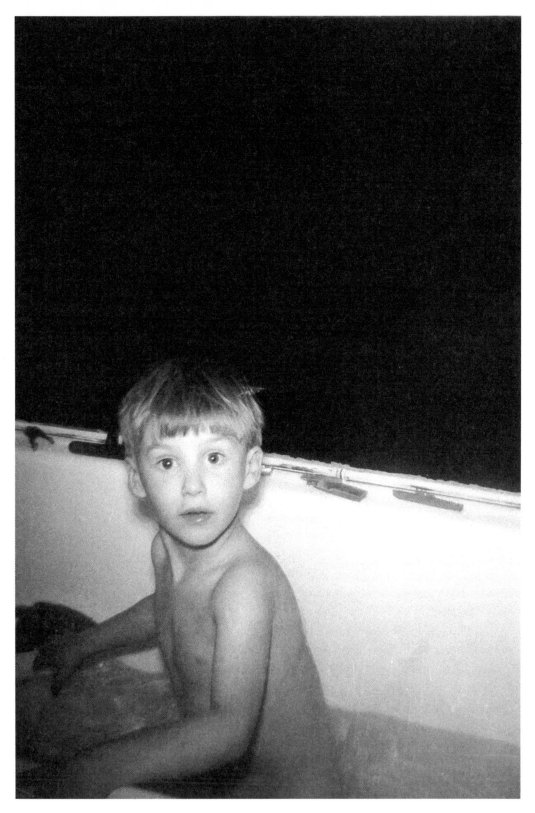

JAMES BIRCH IN BATH. PHOTOGRAPH BY FRANCIS BACON.

mostly for friends. My brother and sister, both born some years before me, went to art school in Florence.

When my parents visited my siblings in Italy I would go to stay with my grandmother in East Anglia. She lived in a Suffolk landscape of marshes, mud flats, tidal reaches and, at night, thousands of stars. All of which attracted flocks of wading birds and, because it was cheaper than London, artists.

Many of these visiting artists would come to lunch at my grandmother's. I would also attend, sitting in wonder as a succession of exotic creatures graced the table. Many were well known at the time ; Cedric Morris, John Nash and, to my great excitement, Dicky Chopping, illustrator of the Bond novels, and his partner Denis Wirth-Miller.

Dicky and Denis lived nearby, and when my parents took a cottage in the area the couple became firm family friends. In turn they would often bring their friend, the painter Francis Bacon, to the house. On one occasion as a boy, I was having a bubble bath when the three of them came into the bathroom. Francis found a camera and took a photo of me. I still have it. No one in our household seemed scandalised by this, though a prevalent view of the time was that all gay men must be paedophiles. I do recall that a friend of my mother later asked, ' What were you doing, letting Francis and Dicky and Denis bath him ? How could you leave him with them ? ' To which my mother replied, ' Well, I trusted them completely. '

According to my sister, Jacqueline, they simply thought of me as an ' angelic child '. Dicky and Denis were family to me and famously kind to the children of their many friends. Later as I grew up I was somehow allowed into the inner sanctum of their friendship with Francis. My dawning awareness of the separation between the man I knew and the great artist he had become began in 1971 at about the age of fourteen, when I bought a copy of *Francis Bacon* by John Russell. I pored over the pictures in the book and failed to see the nightmarish quality that so many people remarked on. Instead I was struck by the grand theatricality, the images, the vibrant colours and the structure of the work.

Denis and Dicky were Francis's oldest friends. Francis was in his late forties when the couple introduced him to my parents. They had liked him from the beginning. Contrary to the popular legend of the unhappy, angry man that was suggested by the brutal and tortured imagery of his paintings, my parents found Francis to have a gentle disposition and charming manners.

Dicky and Denis' Essex idyll at Quay House in the town of Wivenhoe suited Francis's tastes well ; so well that he would later buy a house there, on Queens Road. Francis would come to paint and Dicky and Denis would bring him to our summer cottage. These visits continued throughout my childhood and into my twenties. I'd find the three of them sloshing down wine at lunch or dinner, or sometimes both. My parents were enthusiastic

hosts and the meals often merged into one another. At parties in London, they would often put Francis into a taxi to send him back to 7 Reece Mews only for him to get straight out the other side and return to the throng.

Life in Wivenhoe wasn't entirely domestic. There was an enticing military garrison at Colchester close at hand. Dicky and Denis treated Colchester like it was a sweet shop, frequently picking up squaddies from the town for casual sex. They would then snip off the brass buttons from their army uniforms as a trophy; several boxes of buttons were found in Quay House after their deaths.

I knew nothing of these goings-on as a schoolboy but was very conscious then of the web of connections between us all. Dicky, Denis and Francis were, in effect, my uncles.

But Francis was in my life before it had even properly begun; his story was already caught up in mine. In the 1950s, before I was born, Francis came to our house at Primrose Hill and offered my father two paintings. Francis's career was really beginning to take off, but he still struggled with money. He was represented by Erica Brausen at the Hanover Gallery in Mayfair. Born in Dusseldorf, Germany, Brausen had helped refugee Republicans to flee from Franco's Nationalist forces in Spain before, finally, arriving in England with little to her name. She survived through sheer determination and an ability to meet the right people at the right time and then magic money out of them; key attributes if you are to make it in the art business.

Supported by American tobacco heir Arthur Jeffress, the Hanover opened in 1948 and rapidly became one of the most influential contemporary galleries in London. When later that year Alfred Barr, the founding director of the Museum of Modern Art in New York, walked in, Brausen persuaded him to look at a startling work by a new figurative artist Francis Bacon.

The work, *Painting 1946* is now regarded by many critics as the moment when Francis stumbled upon a style that captured the existential fears of a Europe that was contemplating both the reality of the Holocaust and the coming of the atomic age. Being Francis, the artist underplayed the importance of the work, and claimed he was simply trying to paint a bird.

Barr paid £150 for the painting and perhaps the price stayed in Francis's mind for he suggested the same figure to my father when he came to Primrose Hill, and that was for two paintings, not one. Definitely a bargain, but £150 was a lot of money in those days and my father had to say no.

Barr had no such financial worries and he became an early and enthusiastic supporter of Bacon's work; in 1957 he wrote to Brausen describing Bacon as 'England's most interesting painter'. But to me he was the nice man who Dicky and Denis would bring to the house; a man who was interested and kind to me.

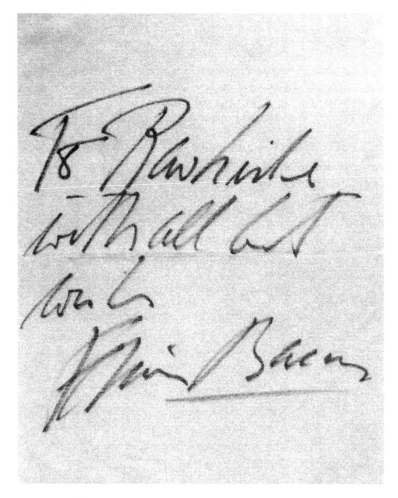

LETTER TO JAMES BIRCH FROM FRANCIS BACON

When I was young, I was obsessed with a TV series called *Rawhide*, so much so that it became my nickname. This tickled Francis's sense of humour and he sent me a letter addressed : ' TO RAWHIDE. WITH ALL BEST WISHES, FRANCIS BACON '. I was thrilled. And like all the things I value, I still have it.

In my teens, on journeys to East Anglia, I would often encounter Francis on the platform at Colchester Junction station, waiting to catch the connection to Wivenhoe, and sometimes we would travel together.

Thanks to the open house policy of both my grandmother and my parents, my sense of what artists are like, how they should be handled, how prickly they can be, how fragile their egos are and above all, how wonderful are the things they create, was formed in my childhood. But I didn't want to be a painter, I wanted to show paintings ; I wanted to have my own gallery.

By 1983, my childhood dream had become my profession and obsession and, much to the surprise of my family, who had put up with various schemes and plans which ran to greater or lesser success, I had my own gallery at Waterford Road, a street at the far, very unfashionable Fulham end of the King's Road, miles away from the centre of the art world in Mayfair's Cork Street and Bond Street in the West End.

Below World's End the King's Road was mostly made up of antique dealers, but it was rare for their customers to enter the gallery. There was also a Coral betting shop next door. We opened Monday to Friday. Saturday was pointless because just a few streets away there were football matches at Stamford Bridge stadium, and boozed-up Chelsea fans would stick their heads in and ask, 'What's all this fucking shit, then?'

It wasn't shit to me. I was enamoured of British surrealists and the more experimental contemporary artists who had a similarly esoteric approach to art, especially the Neo Naturists, a group centred around four mercurial young artists, sisters Jennifer and Christine Binnie, Wilma Johnson and Grayson Perry. They were all good but Perry, an angry young man from Essex, a transvestite who also wore black leather motorcycle gear and made fantastic pots and plates in the tradition of English ceramics but with images of teddy bears, sex scenes and motorbikes, fascinated me. They were like nothing I had ever seen. The Neo Naturists would appear at night clubs, galleries or parties wrapped in long coats and then at some point in the evening suddenly disrobe to reveal naked bodies hand-painted with flora, faces or abstract patterns. In 1985, they had issued a manifesto of sorts proclaiming, 'The Neo Naturists like taking their clothes off for the sake of it.' But their performance art was more than that, they were an anarchic counterpoint to the increasingly money-driven atmosphere of the London art world. I admired their idealistic anti-materialism. The problem was, if I wanted the gallery to survive, I needed some money coming my way.

In short, I needed to sell art. I needed to discover new artists and build my own stable, and I needed to create events to spark interest in their work from a buying public. This was Thatcher's Britain and the prevalent mood was, to quote a Pet Shop Boys' hit of the time, 'Let's make lots of money.' I didn't want to be rich but I needed to survive, and perhaps that put me at odds with the prevailing spirit but Jennifer and Christine, Wilma and Grayson represented the things that excited me most about art. I wanted to spread the word, I wanted people to know about them and their work. But London was bursting with shows and if I wanted the exhibitions I mounted to compete I had to pursue a share of the limited press attention available.

I hosted numerous promotional parties at the gallery but they brought in little money. Jennifer's dream was to ride naked on a white

horse down the King's Road, so for the opening of her second show, she did just that. It made the pages of the *Evening Standard* and the *Hammersmith and Fulham Gazette*, but that was about it.

It was in November of 1985 that my friend Frances Welsh, who was working on the *Standard*'s diary pages, and the artist Pandora Monde, a bohemian aristocrat, came up with an idea: they threw a party specifically to introduce people who didn't know each other.

As much fun as this was supposed to be, I wasn't sure how it would work out in practice, but I understood the power of meeting people and making connections. So, taking a young artist I was showing at the time, a shaven-headed street poet called David Robilliard, we shut up the gallery and made our way to the venue in Campden Hill Road. We arrived at the house to find an uproarious room crammed with people who hadn't met each other before but were becoming better acquainted by the minute. I passed through the throng feeling rather shy, unable to see Frances. David had been immediately swallowed up by the crowd. So it was a relief when I recognised Bob Chenciner struggling towards me. An impish and prematurely balding academic who occasionally came into my gallery, Bob was in the fine carpet business, hunting for 'dragon rugs' and bringing them into the West from the Soviet Central Asian republics and Caucasus, and more generally he had a keen eye for art and architecture.

He described himself as a 'cultural entrepreneur' and regularly visited the USSR where earlier that year Mikhail Gorbachev had become General Secretary of the Communist Party of the Soviet Union. I was aware from the news that Gorbachev had started to talk of two supposedly epoch-making policies, *glasnost* and *perestroika*: openness and reconstruction. But as we drank Pandora's champagne, Bob spoke of a vast, half-starved Soviet empire that had yet to embrace openness or restructuring and remained a terrifying KGB-run country where the ridiculous and the deadly often went hand in hand. Bob had just returned from Ashgabat, capital of the Turkmen Soviet Socialist Republic, 1,597 miles south-east of Moscow.

'I was dancing in the only nightclub in the entire city,' Bob hooted in my ear, 'and my minder, this very eccentric guy called Klokov, said to me, "The KGB have been watching you dance and they've just told me that you are doing it with too much enthusiasm. We have to go now!"' Bob expanded on his theme. 'James, wherever we went, at some point Klokov would stop me and say, "Bob, we have to go now."'

That was the first time I heard Sergei Klokov's name. Though I didn't yet know it, little in my life would be the same again.

'So, what exactly does Klokov do?' I asked.

'Officially, he's a diplomat with a special responsibility for culture,' said Bob. 'But,' he paused dramatically, 'he has other powers.'

These other powers, it seemed, were as much an expression of Klokov's personality as they were of his shadowy status in the security apparatus. They had, according to Bob, most recently manifested themselves at an airport outside Moscow.

As Bob told it, he and his party were nearing the end of the interminable journey from London to Turkmen and had missed the last onward flight to Ashgabat by a matter of minutes. Klokov took immediate action. ' He commandeered a military vehicle, put us in the back and drove it out onto the runway, right in front of the plane as it was taxiing for take-off, ' Bob laughed. ' The pilot stopped, opened the window and shouted down, " What do you want ? " Klokov stood up in the back of the jeep, pointed at us and he shouted back up, " This is a cultural delegation ! " So they dropped down the steps and let us on the plane. '

I was amused by the idea of this unlikely, plane-stopping servant of the Party, but before our conversation became lost in the growing bedlam, I had my own story to tell. For months a potentially money-making idea had been consuming me, a plan to introduce ten exciting new British artists to the happening art scene in New York.

I had no other theme for this trip than that the artists would all be British, youthful and extraordinary. If they got to New York then maybe they would get some attention and it would be fun.

I had travelled between London and New York for several years in the late 1970s and I knew my way around the art world there, but getting this project off the ground was proving harder than I had anticipated. A group exhibition would be fantastically expensive and, even if I pulled it off, the show would be just one event amongst hundreds of others in a city teeming with galleries. It was clear that I would need to call in as many favours as possible from friends over there. It was ambitious but, in those days, I didn't worry about things not working out ; I just tried to make them happen.

Bob looked dubious as I explained my master plan.

' It's obvious, ' he said. ' Don't go to New York, take your artists to Moscow. '

I took a gulp of champagne and contemplated this outlandish idea. The difficulties of the New York plan paled into insignificance.

Bob elaborated. There couldn't be a better moment : ' a new spirit of openness ', ' a rumoured relaxation of cultural censorship '.

' Everything is in a state of flux, ' he said. ' Anything is possible. Why not be the first to take advantage of it ? If you opened in Moscow, you would be the only show in town. You're bound to get a reaction from press and public alike. You wouldn't be able to sell anything, but it would be a sensation James … no Western artist has shown in Moscow for forty years. '

He stared at me, waiting for my reaction. ' Well ? '

' But how could I possibly do it ? '

'Klokov will fix it,' he said airily, taking another glass from a passing tray. 'Klokov can fix anything. He'll be in Paris soon for a Soviet architecture exhibition, just go along to the Soviet section of UNESCO and say Bob sent you.'

'Just walk in? How will I recognise him?'

'Look for a tall Russian, with a beard and glasses.'

Any more detail I might have garnered about Sergei Klokov that evening was lost in the melée of faces and voices around us as somebody else claimed Bob's attention. A few hours and much drink later I caught up with him again, when the crowd briefly opened to offer him up.

'Go to Paris,' he said. 'I'll tell Klokov that you're coming.'

David and I left the party.

David Robilliard made works on paper, with poems underneath. I liked his work, he had a very confident line and lots of people had come to the private view of his show. Unfortunately, none of them had bought anything. Many artists would have been disappointed, but David wasn't. He had a great attitude to life and he was very funny. He was sorry, he said, not disappointed. But I was. I knew you had to seriously engage with David's work for it to really make sense and I was beginning to understand that buyers of unusual experimental material were just not present in London.

I had hoped David would find such collectors in New York (and later he did), but in the days following the party I thought more seriously about Bob's idea. Imagine the effect of showing young artists like David and Grayson in a Communist country where the audience would have never seen anything like their work before. I presumed that most Russians would have no conception that artists like this, and their ideas, existed.

And what if — my imagination slightly running away with me at this point — at the forefront of *perestroika*, they were to become the artists that opened up the Soviet Union? The creative bridge between East and West? At this point my idealism knew no bounds, but if it happened, the novelty of having had a show in Russia would be an enormous boost to the artists' careers, and on their return to London I could curate an incredible show.

Back then I had only a slight interest in the USSR. My knowledge was limited, stretching no further than a few constructivist artists, the odd social realist painting and what my mother had told me of her experience on an Intourist tour in 1971. Being an artist herself, and a communist in her youth, she wanted to see the Hermitage, but like so many other travellers to Russia, on her arrival she was disappointed to find herself herded around the country on a state-controlled tourist trip. When her group visited Samarkand to view the Islamic architecture, a sheep was slaughtered in front of them and then served, three hours later, in a stew so tough it

was inedible. Mum had been a vegetarian ever since. 'I just thought, what an unnecessary waste of a life,' she told me.

Despite Mum's travails, the idea of going to the Soviet Union seemed increasingly attractive, and what harm could there be in taking the trip to Paris?

I had friends I could stay with in St Germain. I knew the UNESCO building very well, a three-winged modernist spacecraft parked on the Place de Fontenoy. So, why shouldn't I look in at the Soviet section?

I called Bob.

'Bob, I think I will go and see this Klokov guy. Does he speak English?'

'Klokov speaks a bit of everything: English, French, German.'

'Will I understand him, is his English good?'

'Of course, he went to the KGB Academy in Tashkent. It's one of the things they learn.'

So I booked a train ticket to Paris.

Two days before I was due to go, I came down with flu and almost called the trip off. But fate took a hand; that week Soviet Secretary General Mikhail Gorbachev and US President Ronald Reagan met for arms talks in Geneva. It was their first meeting and the two leaders established an immediate rapport; a photograph of them laughing together in front of a roaring fire had gone around the world. The image was appropriated by a power company and now a giant Gorbachev and Reagan, 'happiness is a warm fire', appeared on billboards across London. It seemed like a portent of the potential thaw in East—West relations as I shivered and sneezed my way to France and a thaw that might serve my purpose very well.

I felt no better when I got to the Gare du Nord. I took a taxi to the apartment of my friend Eric Mitchell and his girlfriend Françoise Michaud on the Rue des Carmes. They took one look at my pallid face at the door, turned me around and marched me to their local Vietnamese restaurant, where they fed me bowls of fiery chilli soup to burn out the cold — a cure I've used ever since.

When I woke the next morning, the fever had gone. Lightheaded, I set off clutching my portfolio of sketches and slides I had brought. I had no idea if I would even be allowed into the Soviet section of UNESCO. Nevertheless, I presented myself with the confidence of someone who has nothing to lose. That is to say, I was utterly unprepared for an encounter that would change my life. Approaching the first man I saw at the Soviet section I said, 'I'd like to talk to Sergei Klokov.'

'Yes, that way,' the man replied and directed me, without further ado and much to my surprise, towards a dark internal staircase as though it was the easiest request in the world.

What did I expect to find at the foot of the steps: an apparatchik, a sinister party man in a grey suit, representative of what Reagan had once called 'the evil empire', speaking in heavily accented broken English? Certainly not the man who was waiting for me. As Bob had promised, Klokov was tall and brown-haired, with a Tsarist beard. He was wearing mirrored Easy Rider shades and stood at the centre of a long, bright room filled with Russian contemporary art. Behind him a large window overlooked the École Militaire and the Eiffel Tower. His clothes were black: black shirt, black trousers, black leather jacket, and he held a man's handbag. In the coming months I was to learn that most Russian men carried one of these bags, in which they kept their vodka and other vital paraphernalia. To me, he looked like a hairdresser.

He held his hand out and said 'Hello,' then, gesturing at an oil painting of a wooden hut in a birch forest, he asked, 'What do you think?'

I tried to be diplomatic. 'It's rather good.'

'It's a load of shit.'

His English was touched with American. It wasn't unattractive but it wasn't quite natural either. Mid-Atlantic, ersatz, it was as though the KGB had trained him to sound like a bad British DJ.

I introduced myself. 'I'm a friend of Bob Chenciner, he said you were the person to talk to about taking British artists to Moscow.'

'To Moscow?'

Klokov took off his sunglasses. His eyes were almost black, so dark that you could see nothing behind them. I had no idea what he was thinking or feeling. The beard made it difficult to be certain of his age, but later it was revealed that he was 30, only a year older than I was. He seemed much more confident and experienced than me in this environment, and to my surprise the mood in the room seemed very relaxed.

'I know that this would have been impossible before but I thought with *perestroika* and *glasnost* that ...'

I faltered in the face of his unswerving gaze.

'Well,' I continued. 'Bob said you were the right man.'

Klokov put the glasses back on. 'I am the right man. What art do you want to take to Moscow, James?'

'Ten new young artists that I believe in.'

'Revolutionary?' Klokov asked.

'Some of them, perhaps.'

'Good, we need revolutionaries. We don't have any in Moscow.'

Klokov walked me round the exhibition of contemporary drawings and paintings. Some were figurative, some were architectural. They were well executed and attractive in their way but painted by people apparently unaware of any advances in art since the mid-fifties. As we looked at the pictures, Klokov talked about just why modern Russian art was so bad, the backwardness of Soviet cultural policy and the best hotel bars in Moscow

ELENA KHUDIAKOVA IN A DRESS DESIGNED BY HERSELF
PHOTOGRAPH BY GRAYSON PERRY

for Western cocktails. I listened, bemused. Could this really be a representative of the Soviet state?

As Klokov was talking, a minor Soviet official came into the room carrying a stack of papers. Klokov's face immediately turned his way. Unnerved, the man dropped the files.

'Typical!' Klokov burst out, and banged his forehead with the flat of his palm. 'These Russians can't do anything without me telling them what to do. Bureaucratic masturbators!' The man scrambled to gather his papers and left. Up until now I had thought of Klokov as simply slightly unreal but clearly he had status, power over others. I was reminded of Bob's warning: 'Klokov is always hyper — he specialises in making scenes in public, it's like performance art.'

Now calm again, Klokov asked if I cared for coffee from the UNESCO cafeteria. If so, perhaps I had some French currency on me? Unfortunately, he'd just arrived from Russia and only had roubles. I gave him two hundred francs* and he left. When he returned he was carrying three coffees on a tray. The extra cup was for a woman who entered the room behind him.

'Please James, this is Elena Khudiakova,' he announced, as if he were presenting me with a gift.

At that time, no one had a clue that seventy years of Communist Party rule were coming to an end, and most of us in the West still had a decades-old view of the Soviet Union. Brezhnev had died in 1982 but his brooding presence was more real to us than Gorbachev, still relatively new to the scene; to most people *perestroika* and *glasnost* remained just catchphrases. In our collective consciousness, they had yet to fully replace our vision of a dictator state with its KGB and its gulags. The general view of Russian women in 1985, if they came to mind, was equally backdated: either the beautiful Lara from *Doctor Zhivago* wrapped in fur, or rounded babushkas of indeterminate age, in oversized coats, hats and felt boots, sweeping the snow and melting ice from Red Square.

Elena Khudiakova was anything but a rounded babushka of indeterminate age. Tall and athletic, she was in her early twenties. Her skin was almost supernaturally pale, her dark hair cut in a geometric bob above sculpted Slavic cheekbones. She was dressed as if she was going to a high-end roller disco in designer jeans, t-shirt and Christian Dior sunglasses. She seemed to me extraordinary.

Master of the scene, Klokov allowed the silence to last a little bit longer than necessary. I managed a 'hello', before he continued the introduction.

'In Moscow, James, Elena is a high priestess of fashion design.'

I smiled at Elena, but my smile wasn't returned.

'And James, I understand,' Klokov said, 'wants to bring his artists to Moscow.'

* The equivalent of £20.00

I found myself attempting clumsy conversation. How long would Elena be in Paris for? Her English was less fluent than Klokov's. She spoke slowly, her voice was light and warm.

'Not long I'm afraid. I here to work. I design Russian architectural show UNESCO. When exhibition finishes, I must go.'

'What a pity.'

'No, it is a great privilege for Elena to be here,' interrupted Klokov. 'Her present boyfriend is the head of a local Communist party in Moscow.'

I wasn't sure how to react to this revelation.

'Is he still in Moscow?' I enquired.

Elena looked across to Klokov, waiting for his assent before she answered.

'Yes.'

So, if Klokov wasn't Elena's boyfriend, was he her boss? Certainly, when he gave commands Elena acted, but so did everyone else around him.

When Klokov suddenly announced, 'Now we will go for lunch,' I automatically reached for my coat, but Klokov raised a hand. 'First we must have a picture James.' A photographer appeared — where Klokov summoned him from I could not say — and our number increased as previously unseen members of the Soviet cultural mission emerged and stood alongside us. This amused me and I looked to Elena to see if it amused her too, but her face was set on the camera. As I came to understand, having her picture taken, even in these faintly ridiculous circumstances, was always a completely serious matter to Elena.

I presumed it would just be Klokov and I that would be going to the restaurant, which turned out to be one of the many small but expensive bistros in the streets around UNESCO. But Elena also came, carrying large paper shopping bags, as did two men from the Soviet mission introduced by Klokov as Sasha Kamenski, 'a goldsmith and sword-maker', and Emile Mardacany, 'a colleague', later I was to learn that he was Klokov's second in command.

In the bistro Elena sat on Klokov's left, I sat on his right. Sasha and Emile were opposite us. We were in orbit around Klokov. Just as he liked it, I guessed. The Russians all chose exactly the same meal. They ate steak and chips and drank red wine while I showed Klokov slides of work by the artists I wanted to take to Moscow. Between mouthfuls and gulps Klokov nodded at each slide and gave his opinion.

'Yes, this is good.'

'I like this very much.'

'They will like this.'

'Not so good but it has spirit.'

When he wasn't talking, he emitted a series of resonant humming noises that were pleasant and ominous by turn, so that he dominated the

conversation even when he wasn't saying anything. At one point, when Klokov was engaged in a detailed discussion with the waiter about wine, Emile leaned over the table and said, with some pride, 'Isn't his voice mesmerising?'

While I wouldn't go so far as to say Klokov was mesmerising, I was struck by his charisma. He loved making jokes as we talked and he seemed extremely knowledgeable about a wide range of subjects — in particular he talked about his passion for Asian culture and extolled the virtues of acupuncture and herbal medicine — and I was secretly delighted that he seemed to like my artists' work.

Halfway through the main course, Elena left the table with her bags. She returned wearing a remarkable new outfit. It combined a pleated 1920s-style skirt barred in bold blue and yellow with a short-sleeved boxy blouse emblazoned with the large retro red star of communism. The effect was unique, as if she were about to appear in a Wham! video directed by Sergei Eisenstein. I turned back to Klokov to find he hadn't noticed her change of dress or, if he had, it was far too small a thing to concern him. His mood had changed. He was now less hopeful about the possibility of a show and asked me if the artists had shown before.

'Yes, all of them in London, one in New York and another in South Africa.'

'South Africa?' Klokov said tersely. 'Great, why don't you say Israel as well? You must know that these countries are not friends of the USSR.'

In order to brighten the mood, I ordered two more bottles of wine which quickly appeared at the table. Klokov cheered up. Perhaps it could be done after all.

'But you will need to write a letter, James, and it must go to the right people or it will be lost forever. On no account write to the Ministry of Culture.'

'No?'

'No. You must write to Tahir Salahov, the head of the Union of Artists. Only the Union of Artists deals with the work of living painters in the USSR and internationally.'

He explained how to word the letter and even how to address it. I was on 'no account' to post the letter to the USSR; it would not be delivered. The only certain way of it reaching the Union of Artists was to give the letter to somebody who was going to Moscow and ask them to drop it off. I thought he might be pulling my leg but Klokov was deadly earnest, this was the most important thing to understand. Sasha and Emile nodded gravely.

'Do not think of posting the letter,' he repeated. 'It will be impossible.'

Klokov had been drinking steadily and at great volume without once visiting the lavatory. When he did finally seek out the cloakroom, a clear space opened up between us. I looked to my left, and I realised just

how beautiful Elena was. She had changed again, this time into a black silk shift dress that revealed her winter-white shoulders.

In Klokov's absence she continued the conversation with me in her fractured English. 'What is fashionable in London?' 'Do you know Pink Floyd?' She was genuinely interested and eager for any scrap of information I could give her. She also seemed to have learnt a stock of rather old-fashioned English phrases.

'Don't mention it.'

'This is very prestigious.'

'Thank you for asking.'

'Oh, he is quite important, he is a diplomat,' — this last pronounced with a long, rolling 'aaa' which I found, I admit, very engaging.

'Do you have plans for tonight?' I asked. Even as I said it I sounded a little gauche. 'If you're free I was thinking of Les Bains Douche, it's the best night club in Paris right now, Madonna goes when she's in town.'

'They will not let me out,' she said matter-of-factly. 'We locked in apartment after six o'clock.' How naive I'd been. I was startled back into silence.

Klokov returned and, sensing that something had passed between us that had escaped his jurisdiction, brought lunch to an end in the same brusque manner he had begun it.

'Enough! We are finished. James, write that letter!' Chairs were pushed back, coats, hats and scarves were passed to and fro, dropped and picked up again; the elaborate ballet of slightly drunk Russians finishing a good meal. A waiter approached with the bill. 'Yes, yes,' said Klokov and nodded in my direction. The others turned and thanked me warmly. It had been so kind of me to buy them lunch. I had no choice but to reach for my wallet.

'Out of interest,' I asked Klokov when we were out on the pavement, 'What do Russians think of Surrealism?'

'We don't like it,' he declared. 'Life in Russia is surreal enough.' With that he departed, leading his party up the street; Elena turned once to fix me with a questioning look, then followed on after Klokov.

I rattled back to London on the train and I mulled over this strange encounter. I had a strong sense that Elena and Klokov were engaged in a practical joke that I wasn't privy to. The situation felt unreal.

Did Elena really have a Communist Party boyfriend back in Moscow? Was she a designer? Why did she keep changing her clothes? It was only when I went for a drink in the bar on the ferry that I realised Klokov had not even given me the change from my 200-franc note, but I didn't mind. I was excited at the prospect of this new project.

At Victoria station Gorbachev and Reagan were still smiling down from the billboard. I returned home, sat down and wrote a letter to Tahir Salahov suggesting a visiting exhibition of new British art in Moscow.

'Such an exhibition,' I wrote, Klokov's voice resonating in my ear, 'could only build upon the new feeling of understanding and cooperation between East and West.'

The next morning Bob called.

'So, what did you think of Klokov?'

'He was a remarkable guy, but I think he fleeced me out of 200 francs. Is he hard up?'

'Klokov? He's one of the gilded elite, one of the darlings of the Party. Of course he's hard up.' Bob roared with laughter.

'Wait 'til you get to Moscow. You are coming, aren't you?'

'Yes, I am,' I said, suddenly certain. 'But I need to find someone to take a letter to the Union of Artists. Klokov said on no account should I post it.'

'No, don't post it! Give it to Johnny Stuart, he goes to Moscow all the time.'

Johnny was the director of Sotheby's icon department and outside of Russia was considered the world's leading expert on icons. He dressed in black leathers and was an aficionado of British motorbikes and rockers. He had learned church Slavonic and his role at Sotheby's meant he spent a lot of time in Moscow.

I called him at work and he agreed to take the letter as long as I dropped it off at an address he gave me in Notting Hill. Given his occupation I expected to arrive at a grand stucco terrace but Johnny lived in a flat over a garage stuffed with old British motorcycles. I found him working on one of them, barely visible in clouds of exhaust. He was lanky and long haired, and yet still elegant with it, his overalls spotted with engine oil. He turned the motorbike engine off and ambled over, wiping his hands on a dirty rag.

'James? Sorry about the racket, just tuning up the Triumph. Got a letter for me?'

He reached out a hand black with engine grease. I gave him the letter and he read the address and whistled softly. 'Tahir Salahov, eh?'

'Have you met him?'

'Me? No, he's too grand for that. I'm just the icons chap. Anyway, have to crack on. Need to fix this before I fly. Don't worry, I'll get it there.'

I left Johnny Stuart as I found him, engulfed in noise and smoke.

Six months after my letter was taken to Tahir Salahov, General Secretary of the Union of Artists in Moscow, I had heard nothing. That was it then, my lunch with Klokov and Elena had been little more than an incidental Soviet intelligence-gathering operation — though what, I wondered, could Klokov have hoped to gather from me?

Happily, the Neo Naturists were not the kind of artists that pressed you for schedules and long-term plans. They preferred things to be off the cuff.

For now, they were pleased to have my gallery for their shows. But the prospect of the trip to Moscow had temporarily obscured some of the uncomfortable realities of my situation. A show in the USSR would have given us impetus, attracted publicity and, possibly, investment. Without Moscow could I continue to operate the gallery on the King's

Road? I wasn't making a lot of money from the Neo Naturists. That had never been my ambition, but I was also failing to put them on a larger stage, which was galling because I knew they were ready for it. It was clear that an artist like Grayson, young and little known outside London's contemporary art scene, would be successful once he had a bigger audience. His work was unique.

Grayson came from Chelmsford, the sort of small English town that didn't clutch cross-dressing sons to its bosom. Fiercely bright, he had been rejected by a family that couldn't comprehend his difference. He was angry about that and angry too with an art world that didn't appear to value him; he felt he was up against a hierarchy of taste that was conventional in its sensibility.

I was introduced to Grayson by Jennifer Binnie, who he was going out with at the time. After her first show at my gallery she had asked if I would look at her boyfriend's work. When I got to their squat at Crowndale Road in Camden Town, Grayson took me up to his room and showed me a row of plates and pots he had made at evening classes. My heart jumped.

I gave Grayson two shows. Then in the spring of 1986, an Italian curator arrived in London gathering work for a group exhibition. On a recommendation he rang me up: 'What was new? What was good?' I showed him work by Grayson and he chose three pots on the spot. So it was that, in early July 1986, now convinced that Moscow wouldn't be happening, Grayson and I stepped off a plane in Rome.

Neither Grayson nor I had been to Rome before. We hired a motorbike and had fun riding around the city, weaving through the traffic jams beside the Coliseum. But as I hung on at the back of the bike I wondered, a little wistfully, about what it would have been like to have taken Grayson's art to Moscow. I had discussed the proposition with him — there would be no exhibition if Grayson and the other Neo Naturists objected to it on political grounds. But as the months passed and the opportunity seemed to have waned, we stopped talking about it and began thinking about other prospects.

I believed (and still believe) in the power of art. Back then the world was divided into two heavily armed camps bristling with nuclear weapons but I felt art could slip through the battle lines and open people's minds to new ideas. I knew that it would be hard to do, perhaps impossible, but it seemed to me to be worth the effort. Even as we whizzed across the Piazza del Popolo, helmetless and with the Roman sun hot on our faces, I was mourning our lost trip to Moscow. It was such a mad, brilliant opportunity of sorts. And I realised, now that it wasn't happening, how high my expectations had grown for my artists, for the gallery and for myself.

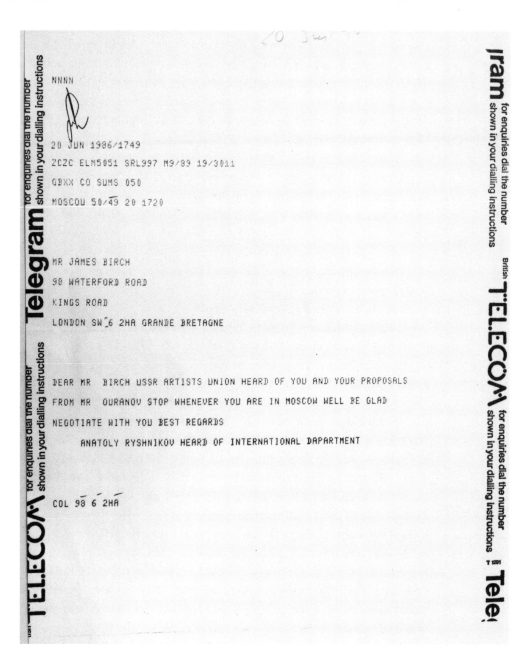

NNNN

20 JUN 1986/1749

ZCZC ELM5051 SRL997 M9/89 19/3011

GBXX CO SUMS 050

MOSCOU 50/49 20 1720

MR JAMES BIRCH

98 WATERFORD ROAD

KINGS ROAD

LONDON SW 6 2HA GRANDE BRETAGNE

DEAR MR BIRCH USSR ARTISTS UNION HEARD OF YOU AND YOUR PROPOSALS

FROM MR OURANOV STOP WHENEVER YOU ARE IN MOSCOW WELL BE GLAD

NEGOTIATE WITH YOU BEST REGARDS

 ANATOLY RYSHNIKOV HEARD OF INTERNATIONAL DAPARTMENT

COL 98 6 2HA

TELEGRAM FROM THE UNION OF ARTISTS

But fate and destiny march to their own drum and I had only been back in London for a few days when a telegram came from Moscow. The spelling was eccentric and I didn't recognise any of the names.

DEAR MR BIRCH USSR ARTISTS UNION HEARD OF YOU AND YOUR PROPOSALS FROM MR OURANOV STOP WHENEVER YOU ARE IN MOSCOW WELL BE GLAD NEGOTIATE WITH YOU BEST REGARDS ANATOLY RYSHNIKOV HEARD OF INTERNATIONAL DAPARTMENT.

I presumed it had been sent under the instruction of Tahir Salahov. Was this it, was I going? I couldn't be sure. Nevertheless it was thrill enough to hold the telegram in my hand. I rang the artists to tell them. It was the next step.

I called Bob, hoping he'd be in London and not hunting carpets in the Caucasus. He picked up, jaunty as ever. 'Great timing James, I'm just back from Baku.'

'I've had a telegram Bob. But I'm not sure if this is an official invite or not.'

I read out the message. '"Whenever you are in Moscow we'll be glad to negotiate with you." Is that an invite?'

'James, it's the red carpet,' Bob laughed. 'It's a passport to the Soviet Union.'

'So, I can just go to Moscow?'

'No, no one can just go to the Soviet Union. You have to be part of an invited group to get in.'

'But I don't have a group. I'm just me.'

'Join my group. I'm flying to Moscow with two *National Geographic* journalists, you can come on that.'

It seemed almost too good to be true. 'Who organised this group for you?' I asked.

'Klokov of course,' said Bob. 'Just go and get your visa.'

In those days there was only one travel agency in London where you could make arrangements for visiting Russia, a Soviet-sanctioned operation located on Kensington Church Street. The process was, in its way, a rehearsal for the intricate difficulties of life in Moscow. First, I had to take the telegram I'd received from Anatoly Ryshnikov to the travel agency to prove that I really had been invited to the USSR. Then the agent had to telex a copy of the invitation back to the appropriate state ministry in Moscow which then, if it was approved, would send back provisional permission for my visa. Finally, I should present myself at the Soviet Consulate, also in Kensington, where, hopefully, the provisional permission would have arrived. Then, in turn, if the consulate was satisfied, the visa would be issued.

I arrived at the Soviet consulate on Kensington Palace Gardens early in the morning. I had to wait for most of the day and, as each hour passed, I felt a little more edgy. Eventually, it was my turn to meet a stone-faced Soviet official. I greeted him warmly and held out my hand for him to shake. There were no reciprocal pleasantries.

I grew more nervous still when he turned his attention to what was, I began to fear, an inappropriate get-up. What should you wear for this occasion, to seem both respectable but not overly capitalist? I had worn a suit but had not been able to find a tie.

He cast an unimpressed eye over my Doc Martens.

'You are to be a guest,' he asked with some suspicion, 'of the Union of Artists?'

'That's right. Yes.'

He considered this for a moment then, for reasons he clearly didn't have to tell me, stuck the visa into my passport and stamped it. The Union of Soviet Socialist Republics had smiled upon my application.

Bob picked me up from my home in Fulham in a taxi on the morning of Tuesday, 15 July 1986. My bags were packed, a picture of my eleven-year-old daughter Zoe was, as always, safely stored in my wallet — Zoe didn't live with me, so I always carried a photograph of her. At Bob's suggestion, I had also included a packet of chocolate digestive biscuits in case we were short of food. Once through passport control at Heathrow, Bob steered me into duty free where he bought several bottles of whisky and suggested I did likewise. I had thought we were going to the land of cheap vodka but I was behind the times. As well as introducing *perestroika* and *glasnost*, Gorbachev was attempting to tame the Soviet Union's catastrophic alcohol problem. At Gorbachev's instigation, the Central Committee of the Communist Party had passed a resolution on 'Measures to Overcome Drunkenness and Alcoholism and to Eradicate Bootlegged Alcohol'. The state, which made all the vodka at the time, had drastically reduced production by 30 per cent and raised the price of what was left. Good quality alcohol at a reasonable cost was increasingly hard to get hold of and, said Bob, we'd need it for presents. 'They like their whisky.'

Ballpoint pens were also at a premium and Bob suggested we pick up cartons of Camel and red Marlboro. The Russians were rationed to 1,200 cigarettes a month per person, or forty cigarettes a day. These Soviet cigarettes, called Papirosy, were made up of half rough tobacco and half a roll of long cardboard that you squeezed into the form of a filter. There were three brands: 'White Canal' named after the series of ship canals north-east of Leningrad, dug by gulag prisoners in the 1930s at the cost of 25,000 lives; 'Laika' honoured the first dog to go into space; and 'Bogatyry' had a Kazak warrior on the packet. They all smelt the same, bad. Understandably, American cigarettes were a much sought-after alternative.

'There are virtually no taxis in Moscow,' Bob explained. 'But if you wave a car down the driver will pick you up for a cigarette or some roubles.' This only worked, I would later find out, if you spoke enough Russian to be able to tell the driver where you wanted to go.

The British Airways plane was empty apart from Jon Thompson and Cary Wolinsky, the journalist and photographer on commission from *National Geographic*, who were sitting in the back. Once in my seat I did a mental check for the twentieth time of all the things I needed to bring with me. Slides, CVs, business cards. Apart from my friend Paul Conran and the artists, I had not discussed the trip with anyone else. It still seemed fantastical.

We landed on a dreary afternoon at Sheremetyevo Airport. From my window seat I observed low grey clouds, military vehicles and a missile launcher armed with two green rockets angled to the sky. Soldiers watched as our plane taxied to the terminal. There was a wire fence at the edge of the concrete apron and, beyond that, an apparently endless birch forest. It was exactly what I had expected to see.

I was glad to recognise Klokov in the terminal building, waiting just inside the door, still wearing his Easy Rider shades. His greeting was muted, as if he too was nervous. Despite his patronage, we were obliged to go through border control, where our passports and visas were checked. It was an unsmiling, uneasy business, though I was more nervous about the large amount of cigarettes and whisky in my bags surviving the customs check than anything else. To my relief when we arrived at the desk Klokov pulled something from his jacket pocket, held it up briefly and we were waved through.

'What did he just show them?' I asked Bob under my breath.

'His KGB badge.'

We were almost out, just one last gateway manned by border guards to go. Klokov went first, Bob followed and I came last. But as I stepped through the gate the alarm went off. Two guards immediately pulled me aside. I looked at Klokov and saw sweat break across his brow.

One guard started patting me down, the other asked questions that I couldn't understand. My arms were thrust out and my legs pushed apart. My stomach churned, I was nauseous and dizzy. This, then, was what fear felt like. As I was being searched, I looked down at my feet and realised that the steel toe caps in my Doc Martens had set the metal detectors off. Keeping my arms outstretched I nodded at my feet and said, 'My shoes!' At the same moment, the guard searching me found a lighter in my pocket with a picture of a nude on it that I had been given in Rome. He was intrigued. The other guard considered my exotic footwear. It had never occurred to me that a pair of shoes could cause so much trouble but the atmosphere eased.

'Keep it,' I said to the guard holding my lighter, almost ecstatic with relief. 'Please!'

When we got outside Klokov swore, 'ёбты', '*Yobti*!' — 'fuck' in Russian, blew out his cheeks and threw up his hands in relief.

'What is it?' I asked.

'James. I thought you had a bomb on you.'

I started laughing but when I saw his face, I realised that he was deadly serious.

An informal welcoming committee was waiting for us. The Union of Artists was represented by its Minister for Art Promotion and Propaganda, Mikhail Mikheyev, known by his diminutive plus shortened surname, Misha Mikhev. He was bald, moustachioed, and looked more Italian than

Slavic. There was also a small polite woman who touched Klokov on the shoulder. he turned to me and introduced her as his girlfriend Marina.

Once the formalities were out of the way, Misha Mikhev waved us goodbye and the four of us got into Klokov's boxy car and set out for the city centre. The birch trees ran alongside the road most of the way into Moscow. The forest, vast and dense. As the highway met the city Klokov pointed out a massive jumble of angled steel. This, he explained, was the 'Ezhi' memorial.

'It represents tank traps. James, this is the spot where the Germans were halted in 1941.'

'They got this close?' I said.

'Yes, only a few kilometres from the Kremlin's walls.'

The memorial was massive. This, it occurred to me, was a country that was very serious about its history. Was it ready for the Neo Naturists?

SERGEI KLOKOV AND JAMES BIRCH IN THE KREMLIN
PHOTOGRAPH BY ROBERT CHENCINER

We had been assigned to the National Hotel, and we were lucky. The National overlooked Red Square and the Kremlin. Grand and ramshackle, it had been opened as a luxury hotel in 1903, just in time for fifty years of revolution and war. The first ever meeting of the Bolshevik government took place in the hotel dining room in 1918, Lenin had lived in room 107 and Trotsky had slept here too. In 1932 the Soviets had mounted

a huge mural on top of the building depicting the full industrial might of the Soviet Union. I gazed up at the mural, contemplating the enormous endeavour it represented. To industrialise and collectivise such a huge country in a few short years was an achievement of sorts. No doubt it turned into a foolhardy and often murderous mission but in the face of such ambition the shadow of doubt lengthened over my own plans.

In 1989 the façade of the hotel, like the system it represented, would start to crumble, images of pitheads and powerlines eroding, and chunks of masonry and socialist realist art would fall to the street below. But for now, the National was intact in at least some of its battered glory. Inside there were marbled halls and grand staircases but my room — inserted, I suspected, along with others into what had once been a suite — was tiny. The bed was small, the bedside table was smaller, the light on the bedside table was smaller still. There was a large fridge but it was empty and didn't work. Unaccountably, there was a pungent smell of rotting apples in the bathroom. I later found that all bathrooms and public conveniences in Moscow had a similar whiff — the effect of vodka on the digestive system. There was no plug for the bath.

I didn't have time to further consider my situation. I went straight downstairs to meet the others in the bar. To my surprise, Elena was already sitting there and she started asking me more questions about London. Answering her the best I could, I realised that I was delighted to see her.

Although we were all engaged on different missions, Klokov liked to keep his party together. Bob, I presumed, was once more in search of carpets, and Cary Wolinsky and Jon Thompson were attempting to complete a feature provisionally entitled 'Inside the Kremlin' though, so far, they had mainly been outside the Kremlin. Wolinksy was unmistakably American, in a plaid shirt, and jeans and Jon Thompson unmistakably English in a well-cut suit. A very accomplished photographer, Wolinsky had crates of gear with him and whenever I encountered the two journalists he was festooned with camera equipment.

Each time they visited, Klokov would progress so far through the delicate negotiations required to get access to the heart of Soviet power and then encounter an official, yet to adopt the new *glasnost*, who would say no. That meant that Cary had to return to the States, taking all his camera equipment back at enormous expense until Klokov found a new, more enlightened official ready to listen. It was their third attempt to storm the Kremlin.

But this time, said Klokov, things were going to happen. All the signs were good, he insisted, as we knocked our glasses together. At the airport he had been operating under the gaze of a more conventional security apparatus. Here, at the bar, he was free to arrange things as he wished and he was in an altogether more cheerful mood.

'Tonight,' he now declared with a grand gesture. 'We're going to the home of my great friend Mikhail Anikst to have dinner.'

This news didn't generate immediate excitement.

'Who is Mikhail Anikst?' I asked.

'Who?' said Klokov, apparently surprised at my lack of knowledge. 'He is head designer at the Alexander Press, Russia's best graphic designer.'

To reach the apartment of Russia's best graphic designer we drove back out on the route towards Sheremetyevo Airport until we reached a suburb dominated by a series of huge tower blocks. Confusingly, the entrances to these blocks did not face onto the road, but were at the back of the building. The doors had been layered with leather to keep out icy draughts and the worst of the winter weather. In summer, this had a profoundly deleterious effect on the atmosphere within the building, which had no air conditioning. Outside the block, Moscow was already hot and smelly, inside you were hit by a wall of body odour, vomit and urine and vaporised fuel, the cheap petrol that powers cars and generators, and the ever-present acrid smell of 1,000 people each smoking forty Soviet cigarettes a day.

We rose several floors in a perilous lift then disembarked into a shabby communal area. Klokov approached a scuffed door and rapped on it with his knuckles. The door opened but instead of the anticipated mass-produced utilitarian furniture and grey interiors we stepped into something entirely unexpected — the rooms were packed with Russian Empire furniture. Entering the apartment was like calling upon an elderly grand émigré duchess in Kensington.

'This is fantastic,' I said out loud. Other guests milled around us, smoking heavily in the Russian way and enjoying a supply of vodka which seemed unaffected by the edicts of the Communist Party's Central Committee. Amongst the guests I spotted Misha Mikhev, who smiled broadly back, raising his glass, apparently very pleased to see us.

'Where,' I asked Klokov quietly as I looked around the room, 'is Tahir Salahov?'

'Oh, you will have to deal with Misha for now. He is a very important man,' Klokov said. 'Anyway, it is not yet time for Tahir Salahov.'

We had a very good dinner with lots of fresh vegetables, heavy on the dill which I came to see the Russians love, and such enormous amounts of drink that I found myself drifting out of the increasingly raucous conversation.

I was brought out of my reverie by Misha Mikhev. 'Come James, let us go to the kitchen for coffee and bring your portfolio with you.'

Misha was about ten years older than me and, after an evening drinking vodka, he seemed even more olive-skinned than before.

'You don't look very Russian.'

'No, people think I am Italian,' he replied. 'But when I was in Cuba, they thought I was Spanish.'

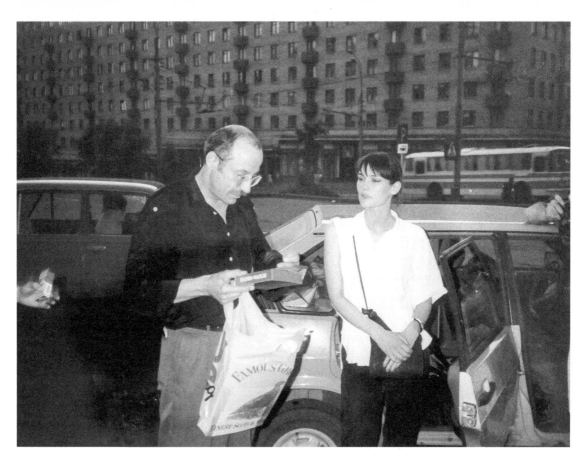

MISHA MIKHEV AND ELENA KHUDIAKOVA

'Why were you in Cuba?'

'To put on an exhibition of Soviet art on behalf of the Union of Artists.'

Now Misha became solicitous, 'What do you want to do in Russia James?'

He leaned forward and patted my knee in a friendly gesture. The vodka mist cleared a little and Klokov's words came back to me — Misha is a very important man, I must impress on him how serious I am.

'I really want to bring English artists to Moscow.'

'Okay James,' he said, as if that was all he needed to hear, but in my excitement I went on. 'They're great artists, Misha, artists who are trying new things, Jennifer Binnie, Grayson Perry, he makes wonderful pots.'

'Pots?' said Misha.

'Yes pots, and plates.'

Misha considered this with some amusement. 'Pots are good, yes. Tomorrow we will show you some spaces for your pots.'

'Thank you, Misha,' I said earnestly.

'No problem. And perhaps you can ask some of the friends here what paintings they would like to see? And James —'

I was lost in a vision of the naked body Neo Naturists' paintings set against a background of ruched curtains and malachite columns in a grand Moscow gallery.

'Yes?'

'Be careful with Russian vodka. It is very strong.'

I awoke with a serious hangover and struggled into my bathroom. The smell of rotten apples was even more overpowering than it had been the day before. I blocked the plughole with my face cloth and shaved in grey water, regretting every glass I'd drunk. When I returned to my bedroom a rat was eating the last of the chocolate digestives.

The breakfast room at the National was huge and there was no sign of Bob. I found a far corner table, and tried to catch the attention of a scowling waiter. He ignored me so studiously that, eventually, I had to stand up and wave. Young and apparently deeply unhappy, he approached the table at a funereal pace. On arrival, he spoke one word.

'Yiss?'

'Could I have some coffee, please. And a boiled egg. Two, if that's possible?'

Silence.

'And soft boiled, please.'

He left without a word. Quite some time later he came back with lukewarm coffee and a single egg that was so hard that I struggled to get a teaspoon into the yolk.

Presently, as I battled on, I became aware of a presence leaning over me.

'Mr Birch?'

I looked up to find a man in his thirties. A Klokov identikit, wearing a dark suit. Like Klokov he had a beard and moustache and, also like Klokov, he carried a man-bag. The overall effect of his appearance was of a young George V (if George V had carried a handbag).

'I am Vladimir.' He sounded light and reedy. 'I have been appointed by the Ministry of Culture to show you galleries and artistic places.'

I was never to discover Vladimir's surname but once he had sat down it was clear he was keen to engage in conversation.

'My favourite film is *Cabaret*,' he began, 'Have you seen it?'

'Yes,' I replied, and a large smile broke through the beard.

He began to talk about how much he loved Liza Minnelli but beyond agreeing with him I had to admit that I couldn't remember every detail of the film.

'I saw it rather a long time ago, Vladimir.'

'Oh,' he said. He looked crestfallen. 'A very long time ago?'

'Well yes, I think it was made in 1972.'

'It is so old?'

'Yes, but it's fantastic.'

His smile returned, only to fade when he observed my plate.

'The egg is not good?'

'No,' I said firmly.

This ended Vladimir's patience with the National Hotel.

'Then we shall visit the first gallery Mr Birch.'

As we left the room the waiter gave me a look of deep dislike, but I was so curious to see potential exhibition spaces that I didn't care.

The road outside the National was heavy with smoke-belching 1950s vintage lorries and square Lada cars. All was grey or brown. People hurrying by had ashen complexions and wore badly cut Terylene flared trousers and skirts, the men sported home-knitted jumpers over wide kipper ties and carried plastic briefcases.

Vladimir guided me through the traffic that crossed the corner of Red Square. As we walked, he shouted out snippets of information at me that I couldn't quite hear above the cacophony of noise:

'Here was executed ...'

'On this spot in 1605 ...'

'Thousands protested here for bread so they could eat ...'

On one side of the square there was a long snaking queue. 'Tomb of Lenin!' Vladimir declared, then dashed on.

Finally we paused in front of a large, single-storey building with a white, unadorned stucco façade.

'This was the stables used by Tsars and is now a gallery being used by the Union of Artists to show their work. Maybe your artists can show here James?'

Inside there was an exhibition of propaganda graphics, the sort of direct art that the Soviets were so good at. I stopped in front of one print that showed a determined-looking couple with their chins in the air. The work, Vladimir said, was an exhortation to the people to stand fast against the imperialists. Which, I supposed, was me.

'You like it Mr Birch?'

'Yes, I think I do.'

'Good!' Vladimir was delighted.

Afterwards, we got into Vladimir's very small car. He pulled a piece of paper out of the glove compartment, covered in rows of Cyrillic text. I don't read Russian, but I could tell it was a long list.

'What is that Vladimir?'

'These are the exhibition spaces of the Union of Artists.'

'There are more places?' I asked, my heart slightly sinking.

'Oh yes, many more.'

Before we pulled away Vladimir threw his man-bag on to the back seat; there was the unmistakable clink of a bottle as it landed.

The morning became an interminable tour. We visited endless venues, all with walls painted the same dirty white. As the rooms became more dismal, my spirits fell. The spaces were too ordered, too dull and outsized. How would one of Grayson's small pots be scaled, or one of Jennifer's paintings? They would be overwhelmed in these large dusty spaces. I felt hugely dispirited. So much for my lofty ambition of changing the world through art. If I couldn't find the right space it was a deal breaker. An exhibition wouldn't go ahead.

Unflagging, Vladimir took me sightseeing, presumably to finish the day with a flourish. We began at the medieval Cathedral of Peter and Paul and then headed back to the Kremlin, where Vladimir stood reverently in front of the huge Tsar Bell that sits in one of the courtyards.

'It is made of bronze, it is over six metres tall,' he informed me. 'It has never been hung in a bell tower or rung.'

On to the Pushkin Museum where, to my delight, I discovered whole walls of fabulous Impressionist and Post-Impressionist paintings. Vladimir told me with some satisfaction that many had been grabbed from private collections on Lenin's orders after the Bolshevik revolution. Manet, Monet, Cezanne, Van Gogh, Degas, Pissarro; it was breathtaking. The Pushkin's rooms of early twentieth-century art were no less remarkable: Léger, Picasso, Miro, Kandinsky, Chagall; it was incredible. But the forward march of modernity stopped suddenly in 1961, with a ballpoint pen on paper sketch by Picasso dashed off, dated and signed in Nice that year. Vladimir stood by the framed sketch, much as he had stood by the Tsar Bell, and explained that Picasso was referencing his famous Dove of Peace, the image he created for the 1949 Soviet International Youth Conference.

'Yes, Vladimir, it's wonderful. But I would also like to see some avant-garde art.'

'I am afraid that there is none.'

'There must be some?'

'No.'

I sensed he felt uncomfortable.

'Avant-garde art is not always ideologically correct. It can be bourgeois and retrograde.'

Despite his taste in decadent musicals it was clear that Vladimir, for one, would not be attending my show any time soon. Grayson's pots or the Binnies' body art would undoubtedly qualify as bourgeois and retrograde. And if Vladimir wouldn't go, who would?

My knowledge of Soviet art had been limited when I first met Klokov in Paris but, in anticipation of the trip, I had done my research since then. I had read, in particular, about the so-called Bulldozer show, when an unofficial exhibition organised by underground artists Oscar Rabin, Evgeny Rukhin, Youri Jarkikh, Alexander Gleser and the conceptual artists Vitaly Komar and Alexander Melamid, had been held in an unused area of the Belyayevo forest in Moscow.

Under KGB orders, on 15 September 1974 scores of off-duty policemen had attacked the show, using bulldozers and water cannons. Artists and onlookers were beaten up, some paintings were set on fire, other works were thrown into tipper lorries where mud was piled on top by diggers. They were subsequently driven off to be buried — location unknown. The exhibition's main organiser, Oscar Rabin, was arrested and then expelled from the Soviet Union along with his family. In 1977, Komar and Melamid emigrated to the US via Israel.

But this was 1986, eighteen months into *glasnost* and *perestroika*, and things were supposed to be loosening up. It was clear that if there was an independent art scene, Vladimir, on behalf of the Ministry of Culture, would not be showing it to me. They might even be plotting its destruction. Seeing his reaction, my heart sank. It seemed unlikely that the Union of Artists would pay to bring an exhibition of ideologically unsuitable art to Moscow.

Klokov came up to my room at the National that evening. I'd mentioned the sub-standard bathroom to him and he went in to look. Rather than checking the plugs he stood in front of the mirror and admired himself. It seemed as good a moment as any to tell him of my doubts.

'Sergei, I don't think the Neo Naturist show is going to work here.'

'Why not?'

'I think it would seem flippant here. In London they poke fun at the pomposity of the artworks but here, I am not sure it is so …'

'Appropriate?'

'Yes, that's the right word, Sergei. Things are so, well, Soviet, here.'

Klokov took this surprisingly well.

'Okay James,' he shrugged into the mirror. 'We will do something else.'

He looked down at my things scattered around the sink, picked up the aftershave, sniffed it speculatively and then pulled a face.

'Is this yours?'

'Yes.'

'I can get you better cologne than this James.'

I ignored his criticism of my toiletries. I'd had an idea.

'If my artists don't come here, what if we did it the other way round?'

'The other way round?'

'Yes, we take Russian artists to London?'

He put my aftershave down. 'James, I like that idea very much.'

As would often happen as our relationship deepened, I had the fleeting but distinct impression that I had just suggested something that Klokov was already planning.

'Tomorrow we will visit some artists. You can decide which you think are right to take to London.'

'You can arrange that straight away?' I asked.

'James!' Klokov said with pained offence.

'Now,' he declared. 'More whisky.'

Once again, I woke with a hangover and, once more, the waiter appeared to be put out by my foreign presence. This time I insisted on two eggs and I got them. They were both rock hard. I called him back.

'Yiss?'

'These eggs are not soft.'

'Is eggs,' he shrugged then turned to leave the table but came to an immediate halt as Klokov, who had approached as quietly as Vladimir the day before, was standing in his way.

'Is everything okay James?' Klokov asked.

'There seems to be a problem with the eggs.' I said.

'We will fix that in due course.' Klokov replied.

There was no mistaking the steeliness of his words.

Klokov seemed unaffected by last night's whisky. I never saw him drunk, no matter how much alcohol was flowing, or hungover. We hailed a car and drove to the Union of Artists where we collected Misha. I was very pleased to see him. Everything in Moscow seemed so entirely strange and unusual but his ease and warmth made it bearable.

We also picked up a translator. I asked Klokov why we needed her.

'Oh, she may be useful later,' Klokov said, waving my question away.

In the car, Misha Mikhev explained to me with some pride that in the USSR, all artists were employed by the state via the Union of Artists. The Union organised exhibitions and was the principal purchaser of artists' work. You couldn't just join the Union of Artists, you had to be invited. This, I discovered over the next few hours, clearly had a deeply conservative influence on the style of the artists and the subjects they painted. People only created work that they thought the Union would like and the Union only liked work that was ideologically correct. Art was bought by high-up Russian officials and those who worked for them, but rarely by private individuals. Paintings were more normally sold through a system of barter.

Once in the Union, an artist was supplied with a studio. These might be converted pre-Revolutionary buildings or purpose-built concrete blocks. In any case, at each artist's studio a similar scene was to unfold. I would be invited to sit on a sofa, courtesies were exchanged, an easel was

put in front of me and the artist would put a painting on the easel. Three or four pictures would be displayed like this, and I would nod and make non-committal grunts. Klokov would then raise one of his thick black eyebrows, which was the sign that I should bring out some of my whisky. It felt like an honour to meet these artists and talk about their work, but inwardly I felt disappointment at how poor some of the art was. So, we would drink and I would consider yet more paintings that were frozen in time, as if their creators were unaware of whole areas of twentieth-century modernism. As I mused on this difference, I was often reminded that Western artists were both practical and radical in the materials they used in their work. I knew that Francis employed sand, dust, corduroy, a dustbin lid to draw a perfect circle, constantly pushing the boundaries of his aesthetic. He set the terms by which he was judged. When these Russian artists did attempt a more contemporary style the results were usually clumsy. One painter unveiled a small work, which I took to be abstract but perhaps wasn't. It was hard to tell. He called it Moscow Nights. He had painted the canvas black and then dotted it randomly with points of colour.

Klokov took his sunglasses off and came to stand by me.

'This title, *Moscow Nights*, has many meanings.'

'Really?'

'Yes, it is a famous song about love. You must have heard the Red Army choir sing it.'

Klokov started to hum a dirge-like tune which I didn't recognise.

'You know it James?'

'Yes, I think I do.'

The artist looked on, unsure if Klokov's singing boded well for him or not.

Klokov stopped as suddenly as he had started and gestured at the painting. 'You like this James?'

The artist now turned to me expectantly. 'It's interesting Sergei,' I said. 'Very interesting.'

At the next studio the resident artist unveiled a picture of a man sitting in a chair. This time vodka rather than tea was served and my mood immediately lifted. I stood with my drink in front of the painting.

'Sergei, can you ask the artist a question for me? Which artist in the West does he like the most?'

Klokov asked and without hesitation the artist went to a bookshelf where he pulled out a much-thumbed German-language art magazine. He found the page he wanted and passed it to me. I was holding in my hands a black-and-white reproduction of Francis Bacon's *Study After Velázquez's Portrait of Pope Innocent X*. It was possibly Francis's most famous work, one of his screaming popes. The pope was taken from Velázquez, the scream from the famous shot of a woman who has been injured in Eisenstein's *Battleship Potemkin*.

'Bacon?' I said.

'Da, da,' nodded the artist.

I was intrigued. This reproduction was only two-thirds of a magazine page. The actual work was over a metre square. The Russian could have no idea of the scale of the real thing nor of its colour. Here it was monochrome, but the screaming pope in the original was wearing purple, he sat on a golden throne hemmed in by golden chords.

Klokov spoke again, the artist responded briefly.

'What did you say to him?'

'I asked him why he liked this picture,' said Klokov.

The artist looked a little unsure of the situation, the vodka bonhomie was slipping away.

'And?' I asked Klokov.

'I don't think he wanted to give me an answer, in case I thought it was a wrong opinion.'

'Can you ask him again?'

Klokov turned to the KGB translator first and barked a few words at her. She blushed and left the room. 'She doesn't have to hear everything. I told her this was a private talk.'

When he turned back to the artist his tone was gentler, reassuring. As the artist replied Klokov nodded.

'He says if you are Soviet then the way that Bacon paints, it feels like he is with you. Bacon sees the darkness. He shows the dark side of life, the dark side of society,' Klokov paused. I was struck by the artist's comment on Francis's work and was intrigued to know more, but Klokov was in a hurry to visit the next studio. 'The darkness in our soul.'

Finally, after an exhausting day, we visited an Armenian artist at his tiny studio. Once we had all shuffled in, the man produced a tray with glasses and a bottle from which he filled them all to the brim.

'Armenian cognac, it's the best,' said the translator.

The Armenian artist then made a toast and everyone turned and held up their glasses towards me to repeat it.

'Давайте выпьем за то, чтобы мы испытали столько горя, сколько капель вина останется в наших бокалах!'

'And the toast was …?' I asked the translator, who had been sullen since Klokov ordered her from the previous studio. 'He said: "May we suffer as much sorrow as drops of the wine we are about to leave in our glasses!" It's traditional.'

Everyone knocked back their drinks in one and I followed. It was like drinking fire and I gasped. The brandy got into my windpipe and for several moments I struggled to draw breath. My difficulties greatly amused everyone, especially Klokov, who clapped me on the back.

'Breathe James. You must breathe!'

When the laughter finally died down, to cover my embarrassment, I asked the Armenian, through the translator, who was his favourite Western artist.

He answered without hesitation. 'Francis Bacon.'

It seemed definitive, as if the Armenian artist, splattered with paint and wild-eyed from the brandy, perhaps not his first of the evening, had the power of prophecy. As if to confirm it, he refilled the glasses and made another toast.

'Francis Bacon!'

I turned to Klokov. This time both his eyebrows were raised and his head was inclined in expectation towards me. A premonition, not something I am prone to, ran through me. How about bringing Francis to Moscow? Could I do it?

It felt like three in the morning, but at about eight-thirty that evening, Klokov took me back to the National.

'You know James,' he said in the car, as if he could read my thoughts. 'If Mister Bacon made a show in Moscow, I'm sure the queues will be bigger than those for Lenin's tomb. People have not seen a Western artist here. Especially a famous one. If Bacon were to come it would be a big sign for the whole world to see: Look, *perestroika* is working, we're not going back to how it used to be. The whole country would come.'

'I'm not sure if Francis would be interested in *perestroika*.'

'You know Bacon well?' Klokov asked.

'I know him extremely well,' I said, truthfully. 'He's a very old family friend and I see him all the time in London.'

I could hardly think of a less Soviet-friendly artist. Francis did not have a communist bone in his body. He dreaded the thought of a collective ideology. He had said that Picasso was 'the reason I paint', and wore his influence heavily in his early works, but Francis shared none of his hero's left-wing politics. He would dread proletarian rule. A workers' state would spell the end of the art world as he knew it and the good things that he enjoyed so much. His most outrageous public act — booing Princess Margaret as she sang at a society ball in 1949 — had been driven by aesthetic distress, not anti-royalist anger. 'Her singing really was too awful,' he had said.

His only close experience of revolution, or of revolutionaries, had come in his childhood at the family's 'big house' outside Dublin where he lifted the corner of a curtain to watch shadows in the grounds. These were the IRA men who might burn the family out at any moment and who occasionally gathered on the edge of the lawn to make their point. Although I felt his art was universal, Francis's life was dedicated to individualism. He had no interest in a collective enterprise.

'No, I don't think Francis is very sympathetic to the cause Sergei. He may call Margaret Thatcher a silly cow but he still votes for her.'

Klokov took his eyes from the road at the mention of Thatcher's name and turned towards me.

'That is perfect James. We all like Mrs Thatcher now. Gorbachev has said so!'

The car headed towards the other side of the road.

'Look out — we'll crash!'

The translator steered it back.

'Don't worry James,' he said. Then he turned to me, 'Francis Bacon, in Moscow. Imagine!'

When we reached the National, and not a moment too soon, Klokov accompanied me to the foyer. The waiter who had been so rude to me at breakfast was there serving drinks. He was walking right past me when Klokov took his arm and led him into a corner. I couldn't hear what Klokov said to him, but I could see the waiter's white face, his fear was unmistakable. Now I felt sorry for him.

Later, I joined Bob in his room for a nightcap and I told him what I had witnessed. Bob said he had seen Klokov threaten people many times.

'But why?' I asked. 'Can't he just flash his KGB card?'

'Don't be fooled, he looks confident but inside Klokov is completely terrified. Because what he is doing, you can't do in Russia. He is playing everything both ways. Chancing it. Every time I see Klokov a bit of me thinks, this might be it, this might be the last time. But then I think, not just yet. By the way, we have to take him out tomorrow.'

Apparently, it was expected that Bob, Cary Wolinsky and I would be hosting Klokov for lunch. Klokov had, in his way, intimated to Bob that he would like to go the Mezhdunarodnaya-1 Hotel. This was a brutalist hulk known as the Mezh, built by Armand Hammer, chairman of Occidental Petroleum. The Mezh was home to the most expensive eating place in Moscow, a Japanese restaurant called Sakura where the raw fish was flown in every day from Tokyo. Or so we were told. When we got there I found out the waitresses weren't Japanese, they were Russians wearing dark bobbed wigs. They were fantastically rude and looked as deeply miserable as many other waiters and waitresses I was to discover seemed to be in Russia. They threw the dishes down for each course with barely a backward glance. Bob was transfixed by them but my attention was elsewhere. Elena Khudiakova had joined us for lunch.

She arrived unannounced at the table, sat by my side and helped herself to some sashimi. She wore the same constructivist outfit of her own design and make that she had worn in Paris. I was impressed by the amount of bags she was carrying and asked, 'Do you sell your line of clothes in Moscow, Elena?'

'No — it's not possible James.'

'Don't you have to queue up for things when you go shopping?'

'No. Why should I? Other people queue up for me.' Even, it appeared, in a communist state, you were allowed to be imperious. Elena was spoilt by Russian standards, of course, part of the elite that Klokov came from, but what her position in that elite was, I could not tell and nobody had explained it to me. Was she one of the golden children by birth, or had her beauty gained her entry? When I asked about her parents, she said her father was dead.

'What did he do?'

'He invented Khudiakova washing machine,' she said.

'He was a washing machine inventor?'

'Yes, he was a very good washing machine inventor.'

This, I would later learn, was itself an invention. There was no such thing as the Khudiakova washing machine. Her father was in fact high up in the army. They had obviously been very close. She was to tell me that some of the happiest moments of her life were spent sailing with him on the Volga.

As I was to discover, compared to most in the USSR Elena lived a charmed life. She was allowed to travel outside of the Soviet Union, albeit under severe restrictions, even to the West, and through Klokov and his circle, had access to the Western press. She was especially enthusiastic about London style and fashion magazines such as *i-D* and *The Face*, which appeared to shape her entire understanding of life in the West.

'*The Face* is very prestigious, a great magazine,' she announced, as if it were comparable to the Communist Party. 'It is very important.'

I told her I admired her style a lot, and she asked me if I could get a story about her designs and clothes published. It so happened I knew some of the people involved at *The Face* and thought that I could. I had my camera with me so I suggested we go outside and I take some pictures of her. Despite all the sake we had drunk, when I got back to London they would turn out well.

As lunch went on long into the afternoon the company became more jovial but not Elena, who remained as intense as ever. She reached into her bag, pulled out a sheet of paper and started making a list.

'James,' she declared, 'these are some of the books you must read.'

I looked at the list. *War and Peace, Anna Karenina, The Idiot, Quiet Flows the Don, The Master and Margarita, A Hero of Our Times, The Brothers Karamazov, Crime and Punishment*; it went on.

'It's not very light reading Elena.'

'Life is not very light James. In England everything is a joke. In Russia we can't laugh all the time. Things are very difficult here; we have learned to live with very little.' I was amused and touched to see a more serious side to Elena. 'I think we are more real than you are,' she continued.

'Sometimes there is not even medicines. If I am ill, I can cure myself with herbs, I know the traditional ways, I can also weigh myself by putting a piece of string around my waist and I know how to boil an egg without timing it.' She said all this with a fierce almost angry pride, and I was charmed and intrigued.

When the bill came it was gargantuan. For a moment I panicked, then Cary put it all on *National Geographic* expenses and I relaxed again. Klokov, I felt, had seen my face blanche, and marked the moment for future reference, as he marked all moments of weakness in other people. But I hoped Elena had not, for I wanted her to think the best of me.

'I'm leaving on Sunday. Will I see you before I go?' I asked.

A look passed between Elena and Klokov. Like so much else in Moscow, I couldn't read it.

'I don't know, perhaps.'

On Saturday Bob, myself and Klokov went to the National History Museum. Elena was not there, where we were met by Marina, who it was explained to me was a curator in the conservation department.

For days now we had been drinking vodka for lunch and supper and in the spaces in between. Coffee was available, and it was good. It came from Cuba. As was the black tea, which came from Georgia. But the drink of choice was vodka. Misha Mikhev drank it for breakfast, and then sucked on a lemon for 'vitamins'.

It was starting to slow me down but the Russians seemed unaffected by it. On and on they drank. Vladimir, Klokov, Misha, Elena; a circle of faces that spun around me. I had not, I realised, been alone since I arrived in Moscow. I was always in company, always being welcomed, being introduced, being picked up, being delivered, being followed around galleries. I was coming to the unnerving conclusion that I was always being watched.

And then, at dinner that evening at the National, where a bored string quartet played 'Those Were the Days, My Friend' repeatedly, the cast had shifted around again. An old face appeared, Sasha Kamenski, the armourer I had met with Klokov in Paris and for whom, I remembered, I had bought lunch. He was sweet and self-deprecating. I asked him how he had been, we gossiped a little and he told me a horrifying story about an encounter he'd had the week before I arrived. Klokov was involved of course. Sasha and his girlfriend and Klokov had been walking past a shop front near the Kremlin when a drunk shouted insults at Sasha's girlfriend. When Sasha objected the drunk pushed him around.

'So I pushed him back, and hard,' said Sasha. 'He fell against the shop window. The glass of the window cracked and then it fell. The blood! People were screaming, shouting. It decapitated him.'

Like Elena, Sasha extended the 'a' so much that I thought he had the wrong word.

'Decapitated? You don't mean the glass chopped his head off?' I asked, in disbelief.

'Yes, like this.' Sasha Kamenski brought his hand down in a sharp cutting motion. 'Decapitated!'

'But what did the police do?'

'I was with Sergei.' Sasha Kamenski shrugged and nodded nonchalantly across the table to Klokov. 'He called a policeman over and explained things. It was okay.'

I was beginning to understand that everyone I encountered was either controlled by the KGB, a member of the KGB or simply lived in a state of fear of the KGB. After all, what was Klokov? Until now I had thought of him as a man who carried a KGB ID card as part of his box of tricks. Along with the aviator sunglasses and the stylish suits which he proudly told me were Pierre Cardin. It was all part of the Klokov effect. I had not thought of Klokov in any serious way as a conventional KGB agent. Had I been fooling myself? If he was the kind of man at whose bidding a headless corpse would be spirited away, what else was he capable of? It was a very unpleasant thought and I put it to the back of my mind. There was work to be done.

On Sunday, Klokov joined me at breakfast. Service in the National had improved considerably since his encounter with the waiter in the foyer. I had just been brought two perfectly soft-boiled eggs and now the waiter returned, unbidden, with coffee for Klokov, who he greeted with deference. When the waiter had retreated Klokov took off his sunglasses and looked around the nearby tables to check we were not being overheard. 'James, I would like to ask you something.'

'Yes?'

'I was thinking about Andy Warhol.' It was an unlikely start to the morning.

'In what way?' I asked.

'If Andy Warhol came here to Moscow then it would be easier to get Francis Bacon to come.'

'Easier?'

'Bacon would follow, would it not break the ice?' He said this with an ironic flourish.

'I am not sure that it would be that easy to get Andy Warhol to come to Russia, Sergei.'

'No?'

'But I can ask.'

'You know Andy Warhol?'

'Yes, I've met him. And I know Fred Hughes, his business manager. But I think it would be easier if we just asked Francis to come to Moscow.'

'But I can't propose this officially.'

'Why not?'

'It is delicate.'

'Delicate?'

'Yes, there is a way of doing things here. I cannot be seen to push provocative ideas too strongly, especially if they are linked with capitalist countries. It could look like I have private business, who knows, I could end up on a train to Siberia. So you must propose it to me. You must do it in front of my uncle.'

'Who is your uncle?'

'He is Vladimir Zamkov, Vice President of the Union of Artists.'

It was the day of my flight back to London. After breakfast, I paid my bill and Bob and I collected our luggage accompanied by Klokov. We were going, he said, to his parents' dacha. Once again, Elena was with us. I was worrying about catching my flight, would we have time? Klokov brushed this concern aside — yes, yes, of course we would.

I had a fairytale idea of a dacha as a simple wood cabin in the forest, nestled, perhaps, by a lake. That wasn't quite what Klokov's parents had, though there were trees enough as we travelled mile after mile through the birch forest that ringed the city. Finally we came to a military checkpoint. As the car slowed down, the soldiers recognised Klokov and they waved us through into what was clearly a military zone, defended by the same kind of rocket launchers that I had seen at the airport.

We turned down a side road lined with yet more birch trees, went through another checkpoint, then came to a high hedge and, set within it, a large gate. We drove through the gateway to find a beautiful wooden Hansel and Gretel gingerbread-style house. It was decorated with a single red star over the front door.

Here we were met by Klokov's parents. They looked totally unlike him. His father was bald and his mother was pleasant looking. They had none of their son's charisma and spoke little English but they were very welcoming and had clearly met Elena before. I was immediately given a glass of hot black tea, and a huge and doleful Newfoundland dog, the size of a small pony, came and settled by my side. There were pieces of good peasant folk-art on the walls and framed photographs.

'Look,' said Klokov, and pointed at a black-and-white photograph of a small boy in shorts standing alongside a military officer festooned with medals. 'Me and Yuri Gagarin,' he said proudly. While we were chatting in the dacha there was the eerie not-so-distant call of a bugle, a reminder that we were in the middle of the main military base of Moscow.

In a Soviet way, Klokov was extremely well connected. Gagarin, the cosmonaut who had become the first human to visit space in 1961, was a family friend, and I was later to learn that Klokov's father, Vladimir, had been part of the elite Foreign Ministry. He was posted as a diplomat to the

YURI GAGARIN, YOUNG SERGEI KLOKOV, VLADIMIR ZAMKOV AND UNKNOWN

US and in 1962 had been a member of the Soviet mission to the UN. He was expelled from the US for spying in the run-up to the Cuban missile crisis.

Klokov pointed to another black-and-white photograph of a crop-haired military officer in late-middle age, his tunic festooned with medals.

'My grandfather, Konstantin Vershinin,' he said. 'He was given this dacha by Stalin.'

'Was your grandfather important Sergei?'

Klokov turned to his parents and translated my question. All three laughed. I appeared to have pleased them.

'Yes, my grandfather was important James.'

So, over black tea, Klokov told me about Konstantin Vershinin, Chief Marshall of Aviation of the USSR, Deputy of the Supreme Soviet and Hero of the Soviet Union. As a teenager Vershinin left his job in a sawmill to join the Red Army and defend the 1917 October Revolution. From there he rose to the very top ranks of the Soviet military and, eventually, was appointed commander in chief of the Soviet Air Force. During the Second World War Vershinin played a vital role in the defeat of the Nazis and, following the war, he was initially in charge of the introduction of jet fighters and bombers into the Soviet armed forces. Just as impressively perhaps, Vershinin survived all of Stalin's regular purges of the USSR's military leadership, though it was a close-run thing. In 1949 Stalin

decided that Vershinin wasn't modernising quickly enough and the Marshall was removed from his position and sent to the provinces. Usually this would be a precursor to the firing squad, but Vershinin kept his nerve, was reinstated and rose again to be the head of the Soviet Air Force for the second time.

As the man who controlled much of the USSR's nuclear strike capability, Vershinin became one of the most powerful people in the world; one of the few men who could, by his own actions, end it. In 1957, he was giving an interview to *Pravda*, the official newspaper of the Soviet Communist Party, and using the opportunity to send a clear message to the US Government, Vershinin warned. 'Belligerent powers must realise that we live in an age of intercontinental missiles, that can deliver the most terrible weapon, the hydrogen bomb, instantly to the remotest regions of any continent on earth.'

This was Klokov's grandfather.

Vershinin had died in 1973. His uncle, Vladimir Zamkov, on the other hand, was very much alive and now made a startling entrance.

'Sergei!' A compact, energetic man in his sixties with grey hair brushed back from his face, he wore an eye patch that consisted of a black band of cloth wrapped around his head at a 45-degree angle like a car seatbelt.

Immediately he called for vodka. Once again a toast was made in my honour. I noticed that Klokov barely sipped his drink rather than knocking it back. Throughout lunch, he drank water.

I had learned that food in Russia wasn't rationed, but it was scarce and only available day by day.

So the lunch we were served in the garden was a relative feast, piles of barbecued shashlik, potato salad, green salad, beetroot, sour cream, the ubiquitous caviar with a scrape of salted butter on black bread, and more vodka. Between courses I agreed to take more photographs of Elena. She had decided that *The Face* would only publish pictures with a certain kind of modish moodiness and Klokov's father teased her for looking so gloomy.

Now Klokov raised his glass and made a speech in Russian before turning to me. 'I was saying that it is your birthday next week James.'

'How did you know that?'

'I am KGB.' The room broke into laughter.

'It also is my birthday next week. Did you know?'

'I didn't Sergei. I'm afraid I haven't got you a present.'

'But I have got one for you, James. Elena, bring it out!'

Elena emerged from the kitchen carrying a package wrapped in brown paper and passed it to me. I opened it to find the familiar dotted blackness of *Moscow Nights*. The company applauded.

'It was the one you liked James, yes?' said Klokov.

'Yes, thank you so much Sergei.'

I was both touched and amused that they had chosen this particular picture to give to me but I did wonder what he might want in return.

When the dishes were being cleared away Vladimir Zamkov came and sat with me.

His English was not as good as Klokov's and there was no tinge of American. It was impossible not to look at his eye patch.

'I lost it in the war James, but I still paint. Look!'

He pointed out a picture on the wall, a bold and strong social realist portrait of Klokov's mother. It had been done when she had been much younger and caught much of the hopefulness of youth and, by implication, belief in socialism.

'It is very good,' I said.

'Now I am the Vice President of the Union of Artists. I paint less. It's all office work.'

Zamkov turned his good eye on me.

'Sergei tells me you would like to bring Andy Warhol to Moscow James.' I looked over Zamkov's shoulder, where Klokov offered a barely perceptible nod.

'Yes, I could ask him.'

'I like Warhol very much. And if that doesn't work, then perhaps Francis Bacon?'

'Yes, perhaps,' I said, once more aware that I was part of an elaborate masquerade which Zamkov was clearly not party to.

'Good! Then it is agreed,' Zamkov announced. 'I will tell the president, Tahir Salahov.'

Back in the car, motoring again through endless birch forest, Klokov was exuberant.

'Thank you James, this went very well.'

'Sergei, if Zamkov is your uncle and he works with Tahir Salahov, why didn't we just ask him in the first place?'

'You don't just ask people James. That is not the Soviet way.'

Elena was to come partway to the airport with me and Klokov.

If she was disappointed that I was leaving, she didn't show it when we dropped her off at the Kosmos building where she lived in the suburbs. Her parting words were: 'Remember James, read the books.'

When we arrived at the airport Klokov took my trolley for me and pushed it through customs with my suitcases and, amongst them, *Moscow Nights* re-wrapped in an old copy of *Pravda*.

I didn't know that Westerners were not allowed to export art works. Anything apart from a small amount of caviar and tourist knick-knacks needed an export licence. Klokov could have shown his KGB card but for his own reasons chose instead to smuggle the picture through for me.

He started talking to the customs officer to distract him and slowly pushed the cart through. On the other side he gave me one swift bear hug before I headed towards the plane.

'Andy Warhol, James!'

'Yes, I'll ask as soon as I get back.'

I was just about to turn the corner into the check-in area when Klokov called after me, 'James, you must bring me Lea & Perrins Worcestershire Sauce the next time you come. Please remember.' And with that final strange request, he was gone.

The plane was virtually empty. My seat was at the front but the flight attendant asked me if I could move to the back to balance the weight. They sat me across the aisle from a man with giant sideburns and hands like shovels. He was a Yorkshire miner who'd been laid off during the National Miners' Strike in Britain and had been given a fraternal holiday on the Black Sea, courtesy of the Soviet Union.

They served us drinks as soon as we had come out of the climb. I think the accumulated alcohol had finally got to me. As the empty plane hit turbulence it started to lurch wildly and drop for what felt like hundreds of feet; my stomach lurched with it. The cabin shook noisily and the doors to the overhead luggage compartments sprung open.

Completely unmoved by all of this, the Yorkshireman turned to me and said, 'Don't worry lad, they can only kill you once.'

But I can't die now, I thought, I still haven't met Tahir Salahov.

IV

My 30th birthday, 24 July 1986, fell shortly after my return from Moscow. If he was telling the truth, so did Klokov's. I had no idea if he was spending time with Marina or perhaps Elena, or whether he was in Moscow or at his parents' high-security dacha. Wherever he was or whoever he was with, I doubted the celebrations were like mine. I had planned a joint party with an old friend Lisa Freedman and we had hired an entire theatre, the Donmar Warehouse in Covent Garden. I invited all my friends, including the Neo Naturists, and Lisa invited all hers, many of whom, it turned out, were lawyers. True to form, later in the evening the Neo Naturists stripped naked and took to the stage to sing 'Friggin' in the Riggin''. At which point most of the lawyers left.

 If that was how London lawyers reacted, I thought, what would Party members in Moscow have made of the nudity and body paint, the gestures and the rowdy singing? I shuddered inwardly at the thought of the artists cavorting naked across the stage, being watched, perhaps, by some of the same KGB men who had wrecked canvasses and beaten up painters at the Bulldozer exhibition in the forest.

My more immediate problem was addressing Klokov's suggestion that the way to persuade the Soviet authorities to allow an exhibition of Francis's work was first to mount a Moscow show with Andy Warhol. Why go about things in such a complicated way? Why not just invite Francis?

 Klokov was thinking of himself, of course, and the reflected glory that a Warhol show would bring him. As I read my way through Elena's recommended books and did my own research on the history of the Soviet Union in an attempt to gain an understanding of the world I had encountered in Moscow, I came to realise that, like any well-tutored Marxist—Leninist, Klokov saw art as implicit value made real. He was a historical materialist in Pierre Cardin suits, drawn to those aspects of capitalism that most conspicuously reflected its processes. By that reasoning, he was bound to regard Warhol, the master chronicler of

Western consumer capitalism, as a more important artist than Bacon. Nonetheless, he would be taking a serious risk. Many more powerful people in the Klokov hierarchy thought that all Western artists were decadent bourgeois monsters. Did Klokov have an answer to that? Could I ask Warhol to put on a show that was based around the screen prints of pansies he had made in the 1960s?

'Pictures of flowers, James,' Klokov had implied, would be sufficiently anodyne to get past the Soviet authorities. 'After all, who declares class war on pansies?'

It would have been a triumph for Klokov to bring Warhol to the heart of Soviet power. I had no doubt that he imagined himself standing with the artist outside the Hermitage or the Kremlin, facing the flashing bulbs of the world's press. If so, Klokov was very wrong. If he ever did come to Moscow, Warhol would be surrounded by his own entourage. It was unlikely that Klokov would get close. The only thing he might have got out of it was a signed poster.

Klokov had made a second mistake. As so many Western pundits were pointing out, history was moving in ways that the Communist Party had not predicted. The opinion of an artist in New York, and the fashion and media crowd he kept company with, was just as important as the considered position of the politburo. As the 1980s progressed, soft diplomacy was facilitating cultural meetings between East and West and with it, the prerequisite visas. It was to become even more so, when Western pop culture along with unchecked nuclear arms spending would prove to be an unstoppable pairing. Though he didn't know it, Klokov's sell-by date was soon to expire. Meanwhile he was hoping to convince the layers of Soviet bureaucracy above him that a Warhol exhibition in Moscow was a good idea, without, as he put it, 'being sent to Siberia' for even suggesting it. But the bureaucracy that really needed to be persuaded was the one that had been erected around Andy Warhol.

Ever since he had been shot at the Factory in 1968 by the radical feminist Valerie Solanos who was suffering a mental disorder, Warhol had been protected by his own courtiers, who controlled nearly all access. There were a few survivors of the old Factory scene who had come to London and naturally gravitated towards the contemporary art world. I was sharing a flat with one of them, Nico the singer from the Velvet Underground, though I wasn't sure how happy she was in London. Grayson and Jennifer occasionally organised super-eight film festival nights at Crowndale Road. I took Nico along to one. It was a good evening. Grayson, who at one point had lived in the same house as the filmmaker Derek Jarman, showed *The Green Witch and Merry Diana*, a magical film he had made about a witch who finds a box of spells in a field. The rooms of the squat, and many of the people who were gathered there, were daubed with Neo Naturist motifs. Knowing of Nico's times at the Factory during its

raw early years, and of her roles in many of Paul Morrissey's experimental films, I thought she might feel at home. Not at all.

As we left, she revealed the terror she'd felt throughout the evening at this sinister English gathering.

'It was like being in Charles Manson's boudoir,' was her opinion.

I also had very good connections in New York, at the court of Warhol. In the late 1970s I had flown over from London courtesy of Freddie Laker and his cut-price airline. For my generation, it was an extraordinary idea to be able to fly across the Atlantic for £100. I went with the stylist Pru Waters and we stayed with the English designer Ray Spencer-Cullen and her then-boyfriend Glenn O'Brien, who was a longstanding friend of Warhol's from the old Factory days. O'Brien had his own cable TV programme, collected Jean Michel Basquiat and would later edit Madonna's *Sex* book. I was barely 20 and could hardly believe I had landed in such glamorous company.

On our first night in New York we went to Studio 54 and I was introduced to Fred Hughes, Warhol's business manager, who had survived the shooting because Solanas's gun had jammed. We got on well. This was the first time I had been allowed into a proper nightclub. It was amazing. It was sheer disco — everybody was dressed up and the first drink was always free. As it happened, while I did not see Bianca Jagger on a horse, or Paloma Picasso, or Debbie Harry, I did spot Tiny Tim, whose 'Tip-Toe Through the Tulips' had been the rage in the late 1960s — I was innocently thrilled.

I stayed in New York for three weeks and went to Studio 54 virtually every night. Every time I went to the club, I bumped into Fred, and I came to suspect he was running all his business operations from there. Eventually, Fred introduced me to Warhol. I would meet him several times that summer but the first night has stayed in my memory. There was a barely audible 'hi', the slightest of smiles registering on his pale face. His ubiquitous black jacket and platinum blond wig made him look more Warhol than Warhol. It was quite a moment; I didn't know if he was just shy or looking past me in search of the beautiful people. But who cared? I was talking to Warhol. Like many very famous people, in the flesh he appeared almost too real. It was as if he was being played by a highly skilled Andy Warhol impersonator — the mop of blonde-white hair, the spectacles, the narrow tie and white shirt were too Warhol to be true. But it was true. I almost expected him to say, 'It's better to always wear the same thing and know that people are liking you for the real you and not the you your clothes make.'

Now, seven years later, I rang up Fred Hughes, went through the usual niceties, and made a request that sounded unlikely even as I said it; I was inviting him and Warhol to join me behind the Iron Curtain for a speculative meeting with, as yet, unnamed Soviet officials.

'I've just come from Moscow and they told me they'd love to have an Andy Warhol show,' I enthused.

'Really?' said Fred.

'Absolutely.' I was determined. 'But the Russians are suspicious, they would need to meet Andy before they'd finally agree to give him a show.'

'Uh huh,' came the reply.

'Do you think it would be possible for both of you to come with me to Moscow and meet with officials from the Union of Artists?'

'The Union of Artists?'

'Yeah, it's how they do things there. The state acts as both the artist's agent and gallerist. Andy wouldn't be able to sell any work' — I faltered for a moment — 'but a show would have a phenomenal impact.'

There was a long pause.

'Well, the thing is James, Andy's just been to London and now he's back and, well, Andy really doesn't like flying.'

'So, the flights would be an issue?'

'James, Andy is not coming to Moscow,' he said, and the conversation was over.

If I was honest with myself, I knew it was never going to happen. But meanwhile, I was still working my way through the list of books that Elena had given me. I had been baffled by *The Master and Margarita*, though the idea of the devil visiting Soviet Moscow appealed to me. *Crime and Punishment* was dispiriting: as far as I could take any moral from the travails of the anti-hero Rodion Raskolnikov, who commits murder and then regrets his actions, it was better, on the whole, not to do anything. Or not to do anything in Russia, anyway. I felt dragged down by the despair of the book and, perhaps, by Russia itself. I rang Klokov to tell him that Andy wasn't coming. He seemed surprised, but hid his disappointment.

'Shall I go direct to Francis?'

'Yes', came the reply, 'but it might be more difficult.'

I felt his uncertainty; would the Russians truly understand his work? I felt uncertain, too, of Francis's response to the invitation.

So, instead of taking the proposition to Francis immediately, I turned to my own problems and found they were pressing. I had only been making a few sales in the King's Road gallery, mainly of British surrealist artists, which was always my great interest, but it was no longer enough to keep the business going. The speculative trip to Russia had been expensive and I had covered all the costs myself. If I wanted the gallery to survive, I knew that I would have to move to the West End and do it quickly.

I had been in Fulham since 1983, when I had gone into business with the then owner Oliver Bradbury. When I moved in the interior was painted a fashionable but terrible 1980s grey, so I repainted it white, removed its

sticky carpet and polished the floorboards. Initially we called it Oliver Bradbury and James Birch Fine Art, as Oliver wanted to keep his hand in. Before any openings took place, we had gathered a mix of works, including two huge paintings by the Californian pop artist Mel Ramos: one of a nude on a walrus and another of Superwoman. In the window we put *Woman in Black*, a striking, stylised representation of Sheila van Damm by the brilliant British portraitist Gerald Leslie Brockhurst.

Van Damm had been a remarkable woman and a fitting totem for a roadside gallery. In the 1950s she was a champion rally car driver several times over; she also helped her mother run the Windmill Theatre in Soho. The Windmill was famous for its tableaux vivants in which a naked and motionless female cast recreated historical scenes, a form of nudity that was legal as long as none of the women moved. Alongside *Woman in Black* we added some pieces of pre-Columbian art, assorted Modern British Artists and the ubiquitous Picasso ceramics. It was eclectic by any standards.

Because the far end of the King's Road was nowhere near the centre of the art world, we had to find a way to get people to come down from the West End. Oliver said the best way to publicise the gallery was to have an exhibition. It was very good advice and it came at what seemed to be a particularly serendipitous time in my life. Two weeks after Oliver said we needed an exhibition Paul Conran, a dealer I knew, came into the gallery and said, 'Are you interested in a Wyndham Lewis drawing?' Yes, of course I was. Wyndham Lewis was a very important British artist and writer, pioneer of the Vorticists, a modernist cubist-inspired British art movement in the early twentieth century. He was very much out of fashion, possibly because he had been so violently anti-Soviet that, at times, he had supported Hitler, Franco and Mussolini, seeing all three dictators as an antidote to Bolshevism. Although he was later to recant his extreme right-wing affiliations he remained a lifelong libertarian. The 1980s art market would soon contrive to overcome failings like that. Paul hung around in the gallery and we talked about art and the London market. I told him I wanted to do an exhibition of the artist John Banting, a Vorticist who had later become interested in Surrealism in Paris in the 1930s.

'Banting?' said Paul. 'I have a portfolio of his work.' It turned out to be a good enough collection to base a show on. I asked Richard Shone, editor of the *Burlington Magazine*, to write an essay for the catalogue. It all seemed to come together of its own accord and in May 1983 we opened our first-ever show at the gallery, John Banting: A Retrospective. I sent Francis an invitation and I did the same to Dicky and Denis. They had all known John Banting and I was thrilled when they turned up.

'Banting was a little shit,' Francis declared.

Now, three years later, I was putting together my final two shows in Fulham. The first was of charcoal drawings by Mary Lemley. She wanted

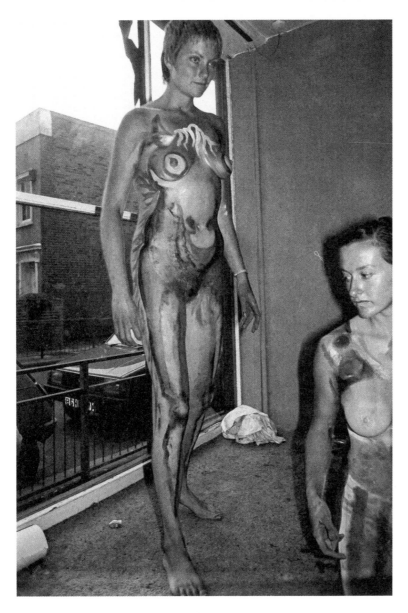

NEO NATURISTS JENNIFER BINNIE AND CHRISTINE BINNIE
PHOTOGRAPH BY JANE ENGLAND

two huge speakers installed outside the door and we obliged. Reggae music and the Beastie Boys thundered along the King's Road. Cars stopped, neighbours complained, the road filled with people and, eventually, the police arrived and closed the party down.

How could I better that ? Since they would not be going to Moscow after all, it seemed right to give the last show to the Neo Naturists. I felt bad on their behalf but, as it turned out, they thought the trip to Russia was as likely as pigs flying. I also wanted to end the way I had begun, with a surrealist. So, the Neo Naturists shared a show with Conroy Maddox, one of the original and most important British surrealists alive. The plan

was for them to disrobe and for Maddox, by then in his mid-seventies, to paint animals and other objects directly on their bodies. Then, by careful positioning of each model onto rolls of white paper I'd bought from an old newspaper print shop, we would transfer the images from their bodies.

The show opened in the afternoon and quickly filled up. Jennifer and Christine, Wilma and Grayson were all there. It took much longer than we had thought to paint everyone and even longer to successfully transfer the images to paper and then hang the body prints on the wall. Towards the end of the process, Maddox painted a bull on Jennifer. Then a very strange thing happened. When she stood up after lying on the paper the transferred image was not like a bull at all but, instead, a sheep. Jennifer, Christine, Wilma, Grayson, Maddox and I looked at each other, slightly disconcerted and the crowd went quiet around us. Then Maddox spoke.

'That,' he declared, 'is surreal.' Which, coming from one of the last surviving surrealists, was praise indeed.

If that was an ending, where would I find a new beginning? Paul Conran had agreed to join me in my new venture. It came, like so many remarkable things do, in Soho. An old friend, Rufus Barnes, had just opened a bookshop in Meard Street, a row of Georgian townhouses that runs between Dean Street and Wardour Street. His shop was on the ground floor and John Pearce, the tailor, was working from the basement. I told Rufus about my problem, that the art world was based in Mayfair on the other side of Regent Street, but I wasn't. I got little sympathy in return; to him it didn't seem like a problem at all.

'It's simple James,' he said. 'Why don't you just get a space in Soho?'

And why shouldn't I? Much of my social life was spent there. The French House pub — where legend had it a punter once asked Francis: 'What do you do?' 'I'm a painter', came the reply. 'Will you paint my house?' — Gerry's, the after-hours drinking den favoured by actors, and the Colony Room, the notorious Bohemian drinking club where Francis spent much of his time. In fact, nearly everywhere I went in Soho I walked, or rather drank, in Francis's footsteps.

Paul pronounced it a brilliant idea. He even knew where the gallery should be: on Dean Street. Before long we came across the empty offices of an old film production company at number 40. It was a good long space, with a basement and a big window. Perfect, but how to get the money to pay the rent up-front and transform the space into a gallery? We had quite an ingenious accountant who played golf with somebody in Wimbledon, who knew somebody at Midland Bank … and in the end they lent us the money. That this process was apparently so easy was largely thanks to Margaret Thatcher, who had recently suggested that the banks start lending to small businesses. I was in good company in accepting her largesse, as Thatcher had also given Gorbachev a helping hand on his way

up the ladder, telling the press, 'I like Mr Gorbachev. I can do business with him,' while he was positioning himself to take over after the ailing Party Secretary Chernenko died.

I had not heard from Klokov for a while but I was an interested party keeping track of Gorbachev's travails as he battled to implement *glasnost* and *perestroika*. I was reading everything I could find. Newspapers, articles, Tolstoy, Chekhov, Dostoyevsky. Russia was constantly in the news. But I was equally preoccupied with my ambitions in London and things were looking up. On Tuesday, 28 April 1987 we opened Birch & Conran Fine Art at 40 Dean Street. I had a West End gallery.

We had to pay key money: literally an extra cash fee to the landlords to get our hands on the key so we could open the door of the property that we had already rented. We went back to the bank to ask for what seemed to us an unimaginable sum of money. This was normal in the 1980s. The contract also had a baffling entry at the bottom of the last page: 'insurance'. 'What's that for?' we asked the estate agent. He replied: 'Don't ask.' I did ask someone else later and was told that, in Soho, 'insurance' was the protection money that went to the local gangsters. It was to insure against having your windows broken or worse.

The rent was much more than it had been in Fulham and our landlord was the pornography publisher Paul Raymond, a well known figure called by some The King of Soho, though he was actually from Liverpool. A former wartime spiv who had made millions publishing *Men Only*, *Mayfair* and *Razzle*, Raymond was happy to have us in there because he was trying to gentrify the area, which had become quite tawdry. This tawdriness was in large part thanks to Raymond himself. He owned large chunks of the neighbourhood, over 400 properties, and was responsible for many of its sex shops. In our time at the gallery we only ever saw Raymond once, when he came to inspect the premises with his son-in-law. The two of them wore fur coats, smoked cigars and offered no opinion on the art. They seemed to be more interested in the state of the walls than anything that was hanging on them. Paul and I offered to take Raymond to the Groucho Club for lunch, hoping to persuade him to keep the rent at a reasonable level. We generously ordered oysters and steak, and kept the wine flowing. Afterwards Raymond put the rent up five-fold. A naive negotiating mistake on our part — if we could afford to treat him to steak and oysters then we could afford to pay more rent.

Soho had its fair share of sex shops and the open-door walk-ups with hand-written signs advertising 'models'. But that wasn't the whole Soho story. These same streets, the 'other square mile' bounded by Shaftesbury Avenue, Charing Cross Road, Oxford Street and Regent Street, had seen epoch-making events. The first-ever successful public television broadcast took place in John Logie Baird's studio at 22 Frith Street on 26 January

1926, watched by forty members of the Royal Institution. In 1847, at a pub nearby on Great Windmill Street, the same street where Sheila van Damm's performers had stood naked and motionless on stage, Karl Marx and Friedrich Engels began the process that would, I had learnt through my now voracious reading of Soviet history, see over half the population of the world living in a communist state by the 1950s.

When the second congress of the Communist League, a precursor of the Communist Party, was held in a room above the bar of the Red Lion in late November 1847 it would shape the twentieth century for millions of people. The first congress happened that summer in London. Marx had not been present, but he travelled from Belgium to Soho for the second congress with Engels, determined to ensure that the Communist League was an effective political force rather than a secret society. In short, to take control. The congress above the Red Lion lasted ten days and at the end Marx and Engels carried all before them. The meeting ended with a motion inviting Marx to put his ideas and aims in a document to be officially adopted by a new Communist Party. Marx went back to Belgium and wrote the Communist Manifesto.

In the ensuing years of Soviet rule, the immortal phrases it contained — 'The history of all hitherto existing societies is the history of class struggles', 'the proletarians have nothing to lose but their chains. They have a world to win. Workers of the world, unite!' — would be drilled into Klokov and every other Soviet schoolchild's head by rote.

Most biographies of Marx I encountered were hagiographic but I picked up some telling details. By 1850 Marx had moved to a top-floor apartment at 28 Dean Street, above a restaurant now called Quo Vadis. He lived there for four years with his young family, surviving on handouts from Engels and occasional journalism. Like Francis Bacon a century later, his bouts of work were interspersed with the fierce drinking binges that Soho seems to demand of its denizens. One evening Marx got so drunk that he smashed the glass in five gas streetlamps before returning home to his eternally forbearing wife Jenny. Three of their children would die in that mildewed, smoke-filled apartment, succumbing to illness exacerbated by poverty.

Now I was installed at the other end of the same street but in much happier circumstances. Paul and I were working really well together and I was still showing Grayson and Dan Harvey but also introducing new artists into the gallery, which was a few doors down from the Groucho Club. In the late 1980s and 1990s the Groucho would become the best-known private members club in the country. It had been running for two years when we opened Birch & Conran. Even in its early days, it felt very glamorous. The line-up at the long downstairs bar might include the captain of the England cricket team, the leader of the Labour Party, a former

armed robber and a Hollywood mogul. It was status free, as long as you could afford the membership, and it was to prove the perfect place for us to meet people and discuss business: the Groucho would provide half our clients. Luckily, I was made an honorary member.

We were almost directly underneath the Colony Room and I found myself there a lot, too. The Colony was started by Muriel Belcher at 41 Dean Street in 1948 with Francis as a founding member. It was just the living room of a Georgian town house, reached by a rickety wooden staircase and consisting of the main room with a bar and a small back area where you could find the lavatory and the cloakroom. Another small room on the stairs, little more than a cupboard, served as an office. There was a piano and usually a pianist, the walls were painted in racing green and covered with an accumulation of pictures, photographs and memorabilia. It was not a late-night place, it closed at 11pm by when, Muriel said, 'You've had the best from 'em'. She saw no reason to continue into the night with a roomful of obstreperous drunks. For decades it was usually known just as Muriel's, but after Muriel died in 1979 it was taken over by Ian Board, who was not so well appreciated by some of the members. Jeffrey Bernard and the Coach & Horses crowd, who were to be immortalised in Keith Waterhouse's *Jeffrey Bernard is Unwell*, found Ian insufferable and wouldn't go to the Colony after Muriel died, but I liked Ian.

I'd first gone there in the late 1970s and it delivered on its reputation immediately when I encountered Vicky de Lambray, the 'notorious' transvestite prostitute as he was known in Fleet Street, who told me that he had given a blow job to every male member of the Royal Family. But I didn't frequent the Colony until much later when I had the gallery in the King's Road. On Friday afternoons, the artist Chris Battye, who dressed like a teddy boy in a beige jacket, bootlace tie and wild west brooch, would pick me up and off we'd go. After a while Ian made me a member so by the time I opened the gallery in Dean Street I had become a regular.

In the months that had passed since my trip to Moscow I had rescued my business, renovated and opened our new gallery and made preparations for our opening show. I continued my reading — not always with unabashed joy I must admit, but I wanted to have greater insight into the new world I had been introduced to and also perhaps understand the life that Elena was leading. It was hard work and I was less social than before. What I had not done was to make a serious attempt to persuade Francis Bacon to come to Moscow.

Birch & Conran's first show, British Pop Art, opened on 27 April 1987 and included works by Richard Hamilton, who had created the famous collage: *JUST WHAT IS IT THAT MAKES TODAY'S HOMES SO DIFFERENT, SO APPEALING?*, and works by Peter Blake and other Pop artists. It also set in motion a chain of events that would lead me back to Moscow. The critic

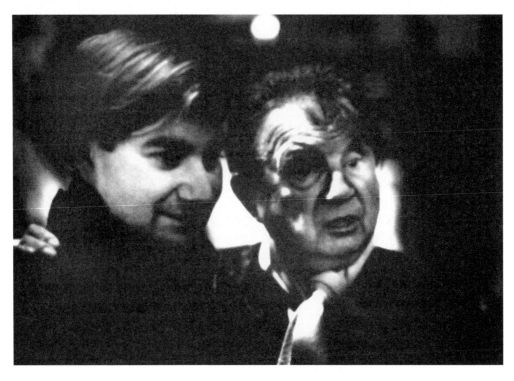

and jazz singer George Melly came to see the show in a fiendishly tight suit and he recommended it to many of his friends. Word got around that it was good. Then towards the end of the run, the model and singer Amanda Lear popped her head round the door and said, 'Oh, be very careful. I've just seen Francis Bacon and his friend. I think they're on their way here.' I don't know why she thought I should be careful. I had sent Francis an invitation as always, so it was no real surprise that he came. But I knew he had just had an exhibition in America where he received terrible reviews. It was the usual stuff, 'Lumps of red meat' — and he was bound to be smarting.

Yet when Francis came into the gallery, he was smiling and pleased to see me. I felt the familiar sense of excitement in his presence. He took in the room with one sweeping glance. I was struck, as always, that despite his strange looks and slightly distorted physique he projected such power and intensity.

Generous as ever he proclaimed, 'James, some of this is rather marvellous.' He spoke in an old-fashioned way with long vowel sounds, he didn't have a lisp but his 'r's were soft. People were aware of him in the art world and it was considered an honour if he came to a show. He was a dazzling attendee at any party, and only in retrospect did I comprehend that his remarkable charm was often employed as a way of holding people at bay.

He was accompanied by John Edwards, the working-class East Ender who had become his best friend and confidante. Many people thought that John was Francis's lover but this was not true. During a drinking session, John told me they had sex once, nothing elaborate, 'only a hand-job,' he said. 'It wasn't really about that.' Sex was not what Francis was looking for from him, John told me. Francis was more interested in hearing what John got up to elsewhere. John was gay and had a long-term boyfriend called Philip Mordue; John had met Philip when he was 15 and they had been together ever since. This didn't stop them indulging in a very promiscuous lifestyle. Mordue was well known in East-End criminal circles and had spent time in Wandsworth Prison for burglary.

Bacon didn't like Mordue, whose hold on John he resented, but he did have a fondness for working-class Cockneys and was, in his own way, as committed to the betterment of the proletariat as Karl Marx. The great love of his life George Dyer, a petty criminal from the East End, had overdosed in Paris in 1971. John Edwards was from a similar mould as Dyer but less troubled. The son of an East-End dock worker who had previously been a champion boxer, he was severely dyslexic and could barely read or write. Dyslexia was not properly understood before the 1980s and as a consequence John was very poorly educated.

Francis was quite capable of drawing attention to this. On one occasion the three of us were having lunch in Wiltons, an upmarket West-End restaurant on Jermyn Street, St James's in the heart of traditional London clubland, and Francis passed the menu to John. As he couldn't read John had barely scanned it.

Watching him carefully Francis asked, 'What do you like the look of John?' It was a cruel tease for Francis to play but John, to his credit, bluffed his way through.

'I think I might have bangers and mash.'

'But that's not on the menu John.'

'Well, it looks like it is.'

And so, Francis had the kitchen make bangers and mash specially.

Despite their forty-year age difference — John was born in 1949, Francis in 1909 — John had been Francis's companion ever since they had met in the Colony in 1974. That first fateful encounter became part of art world and Soho lore. John's brother David had a string of pubs in the East End and John ran one of them. Tipped off by Muriel Belcher that Francis would be visiting, John ordered in extra champagne. When Francis failed to show up John descended on the Colony in a rage, demanding, 'Where the fuck were you Bacon?'

Francis was smitten. At last, here was someone who would stand up to him. Francis bought him a drink and they became immediate friends, a friendship dependent on a balance of power that John was always careful to maintain. Francis's life with his previous companions, George Dyer

and an earlier boyfriend Peter Lacy, had been a torrid psychodrama. John's fixed-ness, his impermeability, offered Francis an unconscious security. John was quoted as saying, 'You couldn't ever give in to Francis — that would have been the end of it.'

John was an amazing man, a prince in his own way, and met Francis's implacable grandeur with a unique and unshakeable sense of self. When with John, Francis was like a clucking hen around her chick. John would say, 'I might lend my Rolls Royce to so-and-so,' and Francis — who had bought it for him — would be, 'Oh, are you sure?' 'Can this person drive?' 'Have they got your keys?' On the other hand, when I bumped into Francis and he was without John, I found he was much more relaxed. So it was an odd accommodation between the two but, ultimately, successful.

Also, and more simply, I think Francis had been so upset by the suicide of George Dyer and the death of his lover Peter Lacy, who had effectively drunk himself into the grave, that he didn't want anything to happen to John.

I first met John with Francis around 1981, at one of Dicky Chopping's pantomimes at the Royal College of Art. John had a chain around his neck with a padlock on it. It was post-punk by this time and I remember thinking, 'This guy's really not on the case.' But, as it turned out, John was very much on the case. Francis painted Edwards' portrait over twenty times, more than any other sitter. More importantly, for me, I began to realise that despite my long friendship with Francis, John had become the gatekeeper, albeit a benign one, to the great artist and he would feature heavily in my life over the coming months as I tried to encourage Francis to take the trip to Moscow.

Francis had always thought the art of Richard Hamilton was good and he loved *Swingeing London*, a series of paintings and then screenprints Hamilton had created, based on a photograph of Mick Jagger and Robert Fraser in the back of a police van following their 1967 drugs bust. Francis wanted to stay in the gallery and talk about Hamilton and art and I wanted to listen to him. But conversations like these naturally strayed into areas where John's lack of education left him unable to follow, and he pressed Francis to leave and go for a drink. On this occasion John got his way and we went up to the Colony Room. Ian Board was there to greet me and toast the show's success. Everyone in the club was talking about it and now Francis had sealed our triumph by giving it his benediction. We were joined by Daniel Farson, the journalist and chronicler of Soho. He and Francis were old friends and got involved with some quite dodgy people. One year I gave Francis a book on the Kray Twins for his birthday and he said, 'I don't need to read this, I know it all already.'

At the Colony, champagne was ordered and large amounts of drink followed. A vision of Moscow swam into my mind as I thought this is the

moment I must ask Francis. In the mid-eighties, before laptops, before the internet, before smartphones and social media, it was in clubs such as the Groucho, the Colony Room and the Chelsea Arts Club where the art world exchanged its ideas and information. It was a world of drinks and socialising, that's how projects came about, and it could be exhilarating, or draining, or both. Not just in the art world, but in all types of business. Even American businessmen drank and parts of the City were awash with cocaine. The people in the circle surrounding Francis Bacon were all champion champagne drinkers — and usually at his expense. Francis was enormously generous but despite the heavy drinking, even he had to eat. John peeled off. So Francis, Dan and I went a few doors down the road to the Italian restaurant on the corner of Dean Street and Romilly Street that everyone in Soho called the Trat. Its full name was Mario and Franco's La Trattoria Terrazza and it had been the trendy place to go in the 1960s, when you might have seen The Beatles, Michael Caine, David Bailey or even Princess Margaret tucking into some pasta. Brigitte Bardot was one of their first customers. It was authentic Italian food but you could get a side order of chips with any of the dishes. By now it was a little run down and we were put in a gloomy alcove surrounded by gurgling pipes down to the sewer and heating flues that ran by the seats. At the restaurant, more champagne was ordered.

It was here that I told Francis for the first time about my trip to Moscow. I tried to describe what I had seen and the people I had met. How exciting it was to be engaging with a world which was vast, insular and totalitarian but seemed eager to open up. What a huge impact the trip had on me in unexpected ways. I told Francis how every artist I had talked to had mentioned his name, which I could tell delighted him.

'They would like you to come Francis,' I said. 'The Russians want you to have an exhibition in Moscow. They're serious.'

It was a significant moment, the point where the whole endeavour could have come to a halt, but looking back now I was almost casual about it. I didn't want to show too much excitement or exert too much pressure at this stage. As the pipes around us gurgled and swooshed, I prepared for rejection.

Francis looked at me over his linguine. 'Oh yes, I should like to go have a show in Moscow. What a marvellous idea. I love Russia.'

I was so surprised at the response of the auto-didact artist, all I could manage to say was, 'You love Russia?'

'When I was younger I met two Russian sailors in Berlin, they were very good to me.' He looked up and away with a characteristic private smile.

This amused Dan greatly but Francis now addressed the subject seriously. He talked about his interest in the great Soviet filmmaker Sergei Eisenstein. We discussed *Strike*, *Battleship Potemkin*, and how he

had used images from those films in his work, particularly the famous screaming woman with broken spectacles. Afterwards we shared a cab and I dropped him off in South Kensington. I said I'd call him the next day to confirm that he was still keen. I woke up the following morning excited and energised, and rang him straight away. In fact, it turned out, he was a little annoyed to think that I thought he hadn't meant it.

'James, I really want to have an exhibition in Moscow.'

All I had to do now was get hold of Klokov. In those days you couldn't just ring up Moscow, you had to book a call through the operator. It would usually take about five hours — it could have been a long day but, finally, I got through. Yet despite what I thought was astonishing news, Klokov seemed nonchalant. It was the first time we had spoken since I had told him that Andy Warhol would not be coming to Moscow and he was in a wary mood.

'Look Sergei, Francis Bacon is interested in doing this exhibition. What shall I do next?'

'Get Francis Bacon to write a letter addressed to you, saying he wants to have a show. You will also need a covering letter to Tahir Salahov, the General Secretary of the Union of Artists. With a proposal.'

So I sat down once more and wrote to Tahir Salahov, informing him that Francis Bacon, perhaps the most highly regarded living artist in the West and an artist, furthermore, who was open about his creative debt to the work of Soviet filmmakers, would like his work to come to Moscow. I then composed what would be the accompanying letter from Francis.

John collected this for Francis to sign and said he would have it back to me later that day.

I heard nothing until a week later when John came into the gallery and told me 'Eggs' — as in 'Eggs and Bacon', which was how John liked to refer to Francis behind his back — was upstairs in the Colony Room and keen to talk more about Moscow. Francis proved to be delighted and, in his words, 'chuffed' with the whole idea. He gave me the signed letter and we started drinking champagne to celebrate. I felt a sense of absolute elation.

At 4.30 p.m., to make the most of the afternoon, Francis, John and I went gambling at Charlie Chester's on Archer Street. That was the other thing about Francis, his life-long commitment to gambling. If you were out with him then, at some point in the evening, you would find yourself in a casino. Over the years Francis did win quite a lot of money and I often ran into him and Dicky, who didn't gamble, and Denis at Langan's Brasserie, celebrating because they'd just won ten grand or, to me, some other great sum. I didn't win ten grand that evening though. With only a chequebook, banker's card and fifty quid cash, I was hardly a big player. I managed to get out of the casino without losing. Anyway, I had won the big prize — Francis had agreed to go to Moscow.

FRANCIS BACON, JOHN EDWARDS AND JAMES BIRCH
PHOTOGRAPHY BY JEREMY BLANK

7 Reece Mews
South Kensington
London SW7

James Birch
Birch & Conran Fine Art
Soho
London W1

2 June 1987

Dear James,

 Further to our conversation, this is to
confirm that it would be a great honour to exhibit
my current work in the Soviet Union. I would very
much like to come to the U.S.S.R. to discuss with
the appropriate officials the details of where and
when such an exhibition would take place and how
many paintings would be suitable.

 Yours sincerely,

 Francis Bacon

LETTER FROM FRANCIS BACON AGREEING
TO THE EXHIBITION IN MOSCOW

We then went on to eat. I was still on a high, I had never expected to have a letter signed by Francis in my pocket to send to Tahir Salahov. Over the course of the dinner, I talked about Russia and what he could expect to see: the Pushkin, the galleries, but also a little about what the people were like. Francis and John were eager to learn more. I tried to explain how Russians were polite, curious, generous but with a background of everything not being quite what it seemed. That sense of the half hidden, of constraint, of mystery. I thought of Elena.

The next day I took my covering letter and the letter that Francis had signed to Johnny Stuart's garage and asked him to deliver it in person next time he was in Russia. Within two weeks I had a reply from Salahov, saying in principle it would be a great honour to give Francis Bacon an exhibition. The date was quite easy to settle; it had to be in the autumn of 1988 since Francis had told me that there was to be a large exhibition of his work coming up in Washington the following year. On June 18 1987, I dropped off ten copies of the catalogue for the 1985 Tate gallery retrospective, all signed by Francis, for Johnny to give to various officials and bureaucrats at the Union of Artists in Moscow so that they could familiarise themselves with his work in colour and make their final decision about the exhibition.

Meanwhile, in London, I found myself back in Francis's regular company and he and John came to our next exhibition, Eileen Agar: A Retrospective. She and Francis had known each other for years and spent time catching up. It felt like a historic moment. As Desmond Morris said, 'Francis Bacon was a creative genius who also at times was a thief, a homosexual prostitute, a compulsive gambler, a drunkard and a liar. He was also mischievous, sarcastic, vain, abusive, arrogant, disloyal and unreliable ... In other words, and as I can attest, a delightful dinner companion.' Morris continued, 'None of his painted figures share the twinkle in the eye, the ready smile, or the joyous laughter for which he was renowned in his social circle.'

I found I was getting to know Francis again, but this time as an adult and a friend, and through Francis, John, a man of great grace and charm, though utterly dedicated to protecting Francis. I kept a diary at this time, and looking at it now I find it is filled with entries that begin, 'Met Francis for drinks ...' Francis was the most disciplined of artists and now internationally famous but meeting, socialising, conversation, and food and drink were the warp and weft of his life, and Soho was part of his DNA. Throughout the previous two years I had been living with the artist Catherine Blow. We were a couple, but the truth was that I was now completely involved in two things: making sure the gallery was functioning with a high turnover of exhibitions and events, and, the new imperative, getting Francis Bacon to Moscow. Perhaps I wasn't as attentive as I should have been. She was an artist and worked by day and

I should have gone home to her in the evening. But at five to six someone would almost always come into the gallery and say, 'Oh, let's go for a drink.' How else could it be in Soho? This was when one could pick up vital news and gossip. I seldom arrived home until two or three in the morning. So in the end, sadly, and by mutual agreement we split up, although we remained friends.

The summer of '87 ended in a haze. I was alone again and a bit adrift, and I suppose vulnerable, and I spent many nights dining with Francis and John. As the art world started to come back to London from their holidays, I thought we should get down to the practicalities of organising the exhibition. On 21 September 1987 I got through to Klokov in Moscow. He had, at last, obtained approval from the Union of Artists.

'James, the exhibition is on.' He was still very matter-of-fact.

'That is fantastic Sergei!'

'Yes, yes. But you must call Francis Bacon as soon as possible to get this confirmed.' I began to detect some nervousness; I knew that to get this close to success and then fail would have been unbearable for him.

'Don't worry Sergei,' I said reassuringly. 'He wants to do it. Francis is going to come to Moscow.'

I hung up, then rang Francis with the good news. He declared, 'This is marvellous. I'm thrilled,' and we agreed that we would meet at the gallery with John the next day to talk further.

Francis didn't come.

FRANCIS BACON AND CATHERINE BLOW IN DAVID EDWARDS' CARAVAN

'You were worried James, why?' said Francis.

We were in the Colony. He had ordered champagne which John was collecting from the bar.

'You didn't come to the gallery, Francis.'

My hopes were high, so after the no-show I had spent a long and dispirited afternoon presuming that he had changed his mind. I knew Francis was a very honourable man but he could be changeable. Then John had strolled into the gallery at 5 p.m. Francis was upstairs watching the horse racing; I should join them. I found Francis in exuberant mood. One of his horses had come in and he was inclined to celebrate.

'Oh no James,' he assured me. 'You mustn't think that, it's very exciting about Russia.' As he talked, a man I didn't know, and slightly the worse for wear, approached the table as if to address Francis. John reappeared and in one smooth action deposited the champagne on the table and shepherded the unwanted intruder away.

People were always jockeying for position around Francis — critics, curators, Soho friends and strangers who had drunk too much. I felt it was one of the reasons he enjoyed John's company so much. While John could be protective and controlling, he wasn't much interested in the hierarchy. It must have been hard, I thought, for Francis to know who he could depend on. I knew he trusted me enough to agree to take the huge risk to do this exhibition but this was more than business.

Although I didn't fully realise it yet, our exhibition was also a matter of international politics. There was a Cold War going on and we had — all of us, Francis, Klokov and me — been operating in the shadow of larger events. Klokov was all too aware of their importance but I only had a vague understanding of what was at stake. I would soon learn that Francis and I were part of a much bigger game being played out between the West and Moscow. That game had become increasingly visible in the West. Even someone like me, more interested in art than politics, had noticed

in September 1985 when the British government had accused twenty-five Soviet diplomats and trade officials of espionage and expelled them. The Soviet agents had been exposed when Oleg Gordievsky, until recently the senior KGB officer in London, defected to the West. The press revelation of Gordievsky's long betrayal of his Soviet masters had been astonishing. He'd been feeding information to his MI6 handlers since 1974 and was only exposed when the CIA double agent Aldrich Ames told the Soviets. Gordievsky, who had recently been recalled to the Soviet Union, would have faced a firing squad if he'd been arrested but escaped to freedom thanks to a British rescue operation on 20 July 1985.

Given my lifelong liking for James Bond the story was bound to catch my attention, but the Gordievsky affair had a very un-007 denouement. Rather than racing to freedom in an Aston Martin through Soviet checkpoints in a hail of bullets, Gordievsky crossed the border into Finland in the boot of a car driven by an MI6 agent.

Gordievsky was resettled in a house in the stockbroker belt in the home counties, where he wrote his memoirs. He lived in some luxury with freedom to travel. Things were less salubrious for Kim Philby, the best-known of the British defectors who had gone the other way in 1963. He lived out the rest of his life in Moscow drinking heavily, and as I was later to learn longing for Lea & Perrins sauce. Hence Klokov's interest in the English condiment. The USSR put Philby's head, much like W.H. Auden's but without the wrinkles, on a postage stamp in 1990. I wondered if he would come to the show, but as it turned out, he died in May 1988. I visited his grave in a vast Moscow cemetery in 1991, an obelisk of polished deep drab grey granite with a doleful carved representation of Philby in which he appears to be wearing a hairpiece.

Gordievsky's enforced defection quite possibly helped Gorbachev in his mission to re-create the Soviet Union. The circumstances of his escape, under the noses of state security, had weakened the KGB and conservative elements in the party.

The Soviets ordered twenty-five British diplomats to leave the country in response to the expulsion of their own agents. Over drinks in Soho, Bob Chenciner explained to me we were now in a period of 'repositioning'. Even as the expelled British diplomats were packing their cases, other British institutions were looking to find ways back into positions of influence in Moscow. One of those institutions was the British Council, founded in 1934, an organisation for the dissemination of British culture and the English language for diplomatic and political ends.

The British Council was funded by the Foreign and Commonwealth office, and so appeared to the Soviets to be an arm of the British state. No doubt some of its members were, if not fully-fledged agents, willing to share any information they might have picked up in far-flung

LENIN'S LIBRARY

METRO MOSCOW

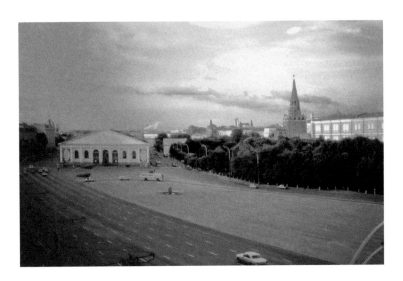

MOSCOW DUSKY SKY

DENIS WIRTH-MILLER, FRANCIS BACON AND DICKY CHOPPING
UZES SOUTH OF FRANCE 1985
PHOTOGRAPH CLAUDIA LENNON

JOHN EDWARDS AND JAMES BIRCH
PHOTOGRAPH PHILIP MORDUE

ZIL CAR, MOSCOW

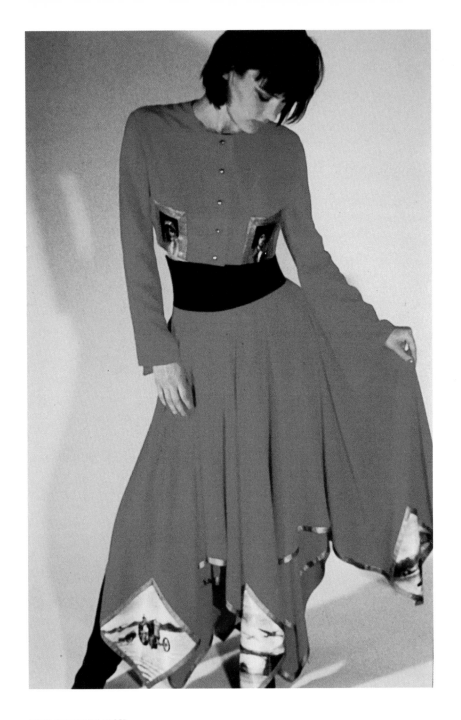

ELENA KHUDIAKOVA IN RED
PHOTOGRAPH GRAYSON PERRY

JAMES BIRCH IN THE KREMLIN
PHOTOGRAPH BOB CHENCINER

RED SQUARE, MOSCOW

JAMES BIRCH & SERGEI KLOKOV
IN THE NATIONAL HOTEL
PHOTOGRAPH BOB CHENCINER

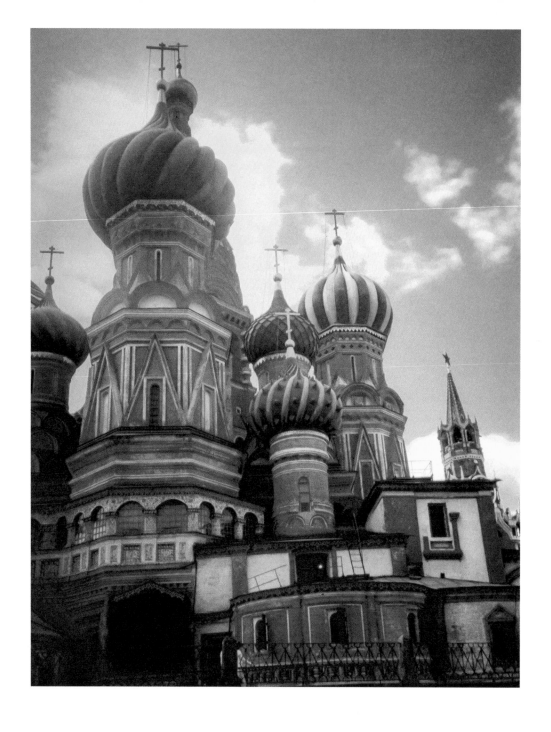

BOB CHENCINER AND SERGEI KLOKOV IN THE NATIONAL HOTEL

BRIDGE MOTIF, MOSCOW

ELENA KHUDIAKOVA AT THE NATIONAL HOTEL

ST BASIL'S, RED SQUARE, MOSCOW

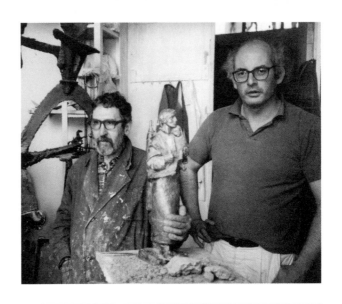

BOB CHENCINER WITH ARTIST

BRIDGE IN MOSCOW

KLOKOV'S PARENTS' DACHA

places over a few drinks at the club when they returned to the UK. Now they were looking for a suitable vehicle to get them to Moscow.

I had been heedless at the start of this adventure about the practicalities involved and I didn't expect to make money personally, although if I could pull off the show it would be an enormous boost to the gallery. I didn't need the permission of the British government to take Bacon to Moscow, but Paul and I had run some estimates and I was beginning to understand the huge costs involved. Transportation and insurance would run to hundreds of thousands of pounds alone, and our gallery had no money. Meanwhile, we were waiting for the all-important letter of intention, which was stuck somewhere in the Russian bureaucratic system. I realised that the next step was to approach Francis's gallery, the Marlborough, but I needed him to formally introduce me.

I was getting reassurances from Francis that all would be well, but privately felt as though little was happening. We'd meet for dinner or he'd pop into the gallery or take me to the Colony Room, but he would not want to discuss timelines or details and I warned myself not to press too much in case he withdrew.

One afternoon I went with Francis, John and other friends to gamble at Charlie Chester's Casino. The casino was split over several floors. I stayed downstairs to play blackjack; the rest of the party went upstairs to play the rather more glamorous roulette. Left on my own I started to make a little money. When Francis and the others came back down I was up £250. They had won nothing; worse, they were out of pocket. The group's mood was irritable, and I sensed it could fast turn to jealousy and resentment. So I put all my chips on one card. Inevitably I lost and everyone immediately cheered up. In the evening we went to Aspinall's, the gambling club on Curzon Street, Mayfair, for dinner. The wine at Aspinall's was Chateau Laffite at £400 a bottle, which I thought was a shocking amount. But it was undoubtedly delicious.

I was, however, very conscious that Francis was paying and that once more I was benefitting from his apparently boundless generosity, supported by the fast-rising price of his paintings, and the truth is I felt embarrassed.

How could I contribute? What could I do in return?

The answer came in conversation. I mentioned that my father, who had been Sheriff of London in 1982, was entitled to visit the invitation-only Black Museum at New Scotland Yard. This is where some of the more gruesome souvenirs of London's long history of murder are housed and Francis, who had a keen sense of the macabre, yelped with excitement.

'Do you think Simon would take me?' Francis demanded.

'Sure,' I replied, pleased that I was able to offer something unusual to Francis in return for his hospitality.

My father was able to fix things with Scotland Yard and, two days later, Francis, John and I joined him for a guided tour of the grim display. The curator showed us murder weapons, walking-stick swords, hangman's nooses. Francis was particularly intrigued by the curator's comment that as people were being hanged, the hangman would pull their legs down to ensure that the job was 'completed'. The bath used by John George Haigh, the 'acid bath murderer', who was found guilty on six charges of murder and hung at Wandsworth Prison in 1949, was also shown to us. Francis revealed that he had lived around the corner from him in Kensington in the 1940s and they were on nodding terms. I was interested that two dark intelligences had been plotting within the same small grid of London streets. I was reminded of Francis's intimate knowledge of, and interest in, the underworld and its absolute manifestation for him of a pitiless universe.

Everything in the museum apart from the noose had been used in a crime. The curator said, 'Look at this,' and he pulled out a pen, opened it up and it had a little Stanley knife blade in it. Francis was fascinated by this slyly concealed weapon. Afterwards the trip developed into one of those magical long afternoons that Francis was so adept at creating. He took us all for lunch at Wiltons followed by drinks at White's and then to the Colony.

I spent as much time with John as I did with Francis and I knew he was an ally in the Moscow trip — he really wanted to go — but he didn't want to get involved in the toing and froing with the Marlborough, and Francis airily brushed aside any suggestions of a meeting: 'Don't worry James, I'll talk to them.'

I also found myself wondering about the intricacies and mysteries of their relationship, about who was beholden to whom. At the end of one evening John and I briefly shared a taxi cab. When we got in the back seat John leaned forward to the driver and asked, 'Do you know who I am?'

'Sorry mate, no idea,' said the driver.

'I'm John Edwards.'

'Whatever you say mate.'

'The John Edwards that Francis Bacon paints.'

'That who paints?'

'He's a famous artist,' I said. 'And we are going to Moscow.'

'Moscow,' said the driver. 'That'll be something.'

'Yes,' said John, now looking at me. 'It fucking will.'

It was imperative that Francis make a list of the works he would like to see in the show, and he was yet to put me directly in touch with the Marlborough. The art world was formal then, and it still is. There was a carefully calibrated protocol that reflected gradations of rank and prestige. I couldn't just stroll into the gallery and say, 'Hi I'm James,

I'm taking Bacon to Moscow.' Francis had to set up that meeting. They would represent Francis in all negotiations with owners of his works that we wanted to borrow for the show, and any other interested parties. I could have no formal role in these conversations; only his gallery could do this.

Possibly my most urgent concern of all was that Francis had not addressed the issue of who would pay for the paintings to get to Moscow. The Union of Artists had no reserves of cash, and Birch & Conran had virtually nothing in the bank, so the costs involved in this exhibition would be down to the gallery or Francis himself, or both. I thought that, in the end, it would be the Marlborough Gallery — they would have to do it to please him — but again it was difficult to broach the subject (Francis had a general dislike of discussing finance) and I was anxious that if they didn't cooperate the plan would come to nothing. But why would they listen to me? Nowadays an exhibition of this importance would be supported by commercial sponsors or financial institutions, but in those days nobody thought like that.

In October, the letter of intent finally arrived. This was the framework for the official agreement between the artist and the exhibitors, in this case the Union of Artists. It was not a financial commitment, but an important next step in the process. Francis arrived at Birch & Conran in order to sign it. This apparently innocent appointment became, as I was finding things often did with Francis, the precursor to a day of intense drinking. While Russia and the UK might still technically be in a Cold War, Moscow and London at least had this much in common.

We went for lunch at the Groucho and Francis began to tell me how upset he was with the Marlborough. I wondered whether this was the real reason for his disinclination to connect me with his gallery. Apparently he had works in France that he wanted to sell independently but Gilbert Lloyd, the head of Marlborough Fine Art, wouldn't let him. This concerned me because the Marlborough would be key to getting a good selection of Francis's pictures to Moscow. I didn't want Francis at odds with his gallery and arguing with them about what he could or could not do.

At this point Jeffrey Bernard came in with his niece Kate Bernard and joined us. Lunch became an all-afternoon affair which was eventually brought to a violent halt when the Irish sculptor Barry Flanagan came crashing down the stairs, absolutely smashed. I invited him to join us and introduced him to Francis and Jeffrey. Flanagan looked around the company then snarled at me:

'You're privileged to know all these people!'

And with that he swept all the drinks onto the floor and threw the table over. Glasses were smashed, bottles broken and everything was

upturned. Dick Bradshaw, the barman at the Groucho Club, jumped over the bar and marched Barry out. More champagne was ordered.

I was unnerved. Usually I was unaffected by the bad feeling and jealousies that were legion in Soho, I just got on with my life. I didn't think of myself as part of a set that others might envy. However, once you were in Francis's orbit you became exposed to strange gravitational forces. He attracted extremes — good and bad — and by this stage in his life he was famous and many people, whether they recognised him or not, were attracted to him by his star quality.

A little to my dismay, Barry Flanagan's departure didn't mark the end of the day, merely a gear shift. We moved on to the Colony. By now we had been drinking for over five hours and I was exhausted. It wasn't just the alcohol; when we got outside the air was thick and heavy. Little did we know it was a sign of the coming tempest; as we slept, the Great Storm of 1987 descended, flattening 15 million trees across the south-east of England and taking the lives of eighteen people.

Soho was a ghost-town the next morning, the trains and tubes were badly affected by trees on the line and most people had stayed at home to watch the cataclysmic events relayed on television. The gallery was empty, so I put in a call to Klokov, to update him on what remained, so far, a very basic plan. It took so long to be connected when calling the USSR because, after making the call, as Bob had explained to me, a security check would commence at the other end. Somewhere in Moscow officials were asking a series of questions:

Who is James Birch?

Why is he calling Sergei Klokov?

Why is Sergei Klokov taking the call?

It was only once these questions had been answered to the satisfaction of an unseen security officer and he or she was convinced that I was not an M16 agent and Klokov was not the next Oleg Gordievsky that the phone rang back and the call was put through.

I found I was speaking to an uncharacteristically terse Klokov.

'James, I need Francis Bacon's passport number.'

'Why?'

'Then I can arrange a flight for him. He must come to Moscow soon, before the show. So we can have preliminary talks.'

'With who?' I asked.

'I need Francis to meet all the officials. They must see that he is not a decadent Western monster.'

'I don't think Francis would like to do that.'

I was right, Francis said he did not want to do that. 'Why do I have to go?' he demanded in the querulous voice I knew well. 'John can go instead of me.' I was almost tempted to tell him the truth, 'It's so they can

double check that you are not a decadent Western monster. 'However,
I didn't think Francis's reaction was out of place. The Union of Artists
should be able to recognise a fellow creative spirit in Francis without actually
meeting him in person. They would have seen his work in the catalogues
I had sent out previously and understood his importance. I also knew that
Francis loathed bureaucracy. I could see why he hated the thought
of this unnecessary trip. In the end, Francis grudgingly agreed to go
to Moscow but explained to Salahov that due to ill health, he could not

T. Salakhov
First Secretary of Administration
Union of Artists U.S.S.R.
121019, Moscow
Gogol Boulevard 10

7, Reece Mews
South Kensington
London SW7

18 November 1987

Dear Mr. Salakhov,

 I am so sorry I will not be able to come to the Soviet Union
till the spring of next year as I suffer very badly from asthma.
My doctor advised me not to come till then due to the cold weather.
I look forward to meeting you and discussing the necessary plans
of my exhibition next year.

With best wishes,

Francis Bacon

make the trip until the spring. It was another lengthy hold up we could have done without.

Although often concerned with apparently trivial matters, with gossip or perceived slights, Francis could be very serious when it suited him. He would talk about existentialism and philosophy and, especially in the company of Lucian Freud, have far-ranging conversations. The two artists had known each other since the late 1940s (Freud had been there on the night Bacon booed Princess Margaret), but they had become estranged by the 1980s and perhaps Francis was all the sadder for the estrangement. Freud, thirteen years younger than Bacon, had studied at the East Anglian School of Painting and Drawing run by Cedric Morris and Arthur Lett-Haines at Benton End in Suffolk. The relationship with Francis had been so intense that Freud's wife Caroline Blackwood was later to claim, 'I had dinner with [Francis] nearly every night for more or less the whole of my marriage.'

Francis had revealed to me how much this parting of ways with Lucian Freud had hurt him earlier in the year on one of those remarkable evenings when apropos of nothing he would let me into his innermost thoughts. On other occasions he could be about as forthcoming as a brick wall. So I was well aware of how important these moments of self-revelation were. I wrote it down in my journal the next day.

In January, Francis Bacon arrived unexpectedly at the gallery, and asked me for a drink 'upstairs'. Ian Board has just got back from Kenya, and there were too many people. Francis suggested we go somewhere more private for a chat. Paul arrived, and the three of us decide to go to L'Escargot for dinner. I could tell that Francis was very upset about something and once we sat down it came out.

'Well, you know James, Lucian and I haven't spoken in fifteen years. And then, out of the blue, he rings me to ask me to go to the opening of his exhibition at the Hayward.'

'What did you say?'

'I said why should I? You haven't spoken to me for years. You just want your retrospective bolstered by me, and I don't want to go.'

Francis was genuinely upset, because I suspect he probably did quite want to go, but he didn't feel like being used to support Lucian.

And I said to him, 'Why? What was the problem? Why did you fall out with Lucian?'

Francis opened his heart up about Freud, said that 'it wasn't one thing', and how sad he felt that they had drifted apart, but remained waspish enough to say, 'Lucian Freud has no vision and reminds me of Stanley Spencer.'

If Bacon was ruthless about Freud's work, despite the fact that Freud was, unarguably, one of the great British painters of the second half of the twentieth century, what was he likely to say when confronted with the often dismal efforts of members of the Union of Artists? Luckily,

that uncomfortable prospect was averted when Klokov got back to me and
reported that Francis Bacon had been deemed well-known enough not
to have to go through the traditional vetting process in person in Moscow.
I breathed a huge sigh of relief.

Nonetheless I continued to worry about Francis travelling to
Moscow. His genius came with particular drawbacks. He didn't like being
propelled in a certain direction, and I realised that I would be forced
to take on this task, for his own well-being if nothing else. Francis could
be a creature of whim and was able to change his mind at any moment.
He could be totally unbiddable if he chose to be and would see offence
where none was intended. He was also assailed by ailments. He had
very severe asthma and slept with an oxygen cylinder by his bed. I knew
that this would be one of the added complications of getting Francis
to Moscow. I would need to ensure that there was an adequate supply
of oxygen. Francis, above all else, genuinely lived in fear of a severe asthma
attack that might be his last. He hated smoking, though he continued to
drink to excess in ill-ventilated bars and breathed in paint and white spirit
fumes every day.

In Moscow, Francis would need to be shepherded to the very doors
of the exhibition at the Central House of Artists. John would be there,
but John's role was not that of nurse or nursery-maid. I would have to
be by his side.

On 12 November, John and his boyfriend Philip Mordue came into
the Groucho Club and reassured me, 'The USSR Exhibition is still on.'
This surprised me, as I didn't know that it had been in doubt. But while
I had gone to and fro with Moscow over the letters of intention and
more recently with Francis's travelling requirements, he had still not told
me what work he had selected for the show.

One evening, soon afterwards, I put it to him head on.

'Listen, this is getting quite serious now. We need to decide on
the pictures.'

'Well you haven't spoken to Valerie Beston at the Marlborough.
You need to do that before anything else.'

He said this as if it were an oversight that was, to a significant degree,
my fault and I felt slightly resentful at this implicit accusation. A disturbing
idea occurred to me, and my blood ran cold.

'You have spoken to them, haven't you Francis?'

It was now that Francis admitted to me that he had in fact only
raised the idea with the Marlborough in the most roundabout way, and
I realised that my worries about his slightly fractious relationship with
them had been well founded. In theory it was Francis's right to choose
for the exhibition. He was far too great and eminent by this stage to allow
anybody else to do it, but in practice he was concerned that there might
be a problem in obtaining works from private hands. They might object to

7 Reece Mews
SW7.

16/5/88 Tel. 584-2925.

Dear James

Sergei Klohov
telephoned and asked to
send him by fax in my
own handwriting my
appreciation of having ~~this~~
an exhetition in Moscow.
I enclose what I have written.
All very best wishes
 John Francis
P.S.

When John comes up
from the country I do
hope you will come to
the Curzon place in
Brunton place

'Tis a great honour to
be invited to have an
exhibition of paintings in
Moscow

When I was young I
feel I was very much
helped towards painting
after I saw Eisenstein's
films "Strike" and The
Battleship Potemkin by
their remarkable visual
imagery

none of Van Gogh's letters

he makes this statement
"How to achieve such
anomalies such alterations
and refashionings of reality
that what comes out of it
are lies if you like
but lies that are more
true than literal truth

———————

an exhibition in the USSR. He suspected that his wealthy collectors were terrified of lending work, that was becoming increasingly valuable, to what was basically still a rogue state with which we were in a Cold War.

Francis had another concern. 'The gallery probably thinks that the Russians are terrible anti-semites. I'm not sure that they will want me to go.' The original Marlborough Gallery had been founded by Frank Lloyd and Harry Fischer, Jews who had fled the Nazis in Austria. Francis thought this meant that the gallery would be extra-sensitive to the charges of anti-semitism that were presently being made against the Soviet Union. It seemed a genuine if unlikely concern to me, but there was an international campaign calling on the USSR to allow Soviet Jews to emigrate at will. As recently as December, 250,000 Jewish demonstrators and their supporters marched in Washington DC demanding freedom for Soviet Jews. This unlikely obstacle was one more problem for me to worry about but not, it turned out, for long.

At last, on 24 November, by pre-arrangement after an introduction by Francis, in some trepidation I went into the Marlborough Gallery on Albemarle Street to talk to Valerie Beston and Gilbert Lloyd. To my relief, no one brought up the question of the Soviet Jews at the meeting. There was a fourth person present, Muriel Wilson, who I had met before at Birch & Conran. She was a collector in her own right, an early supporter of Peter Blake, David Hockney and Eduardo Paolozzi. She was also, Wilson mentioned in passing, here as a representative of the British Council where she had, she hoped, a reputation for supporting British artists in foreign markets.

I explained where the show would take place and about the various specifications and requirements of the USSR, and in particular about Klokov and Tahir Salahov, who I had yet to meet, and their part in this plan. I told them of the hunger for his paintings I had encountered in Moscow; about the artists I had met who called him 'the great Francis Bacon', even though they had only seen his work reproduced in battered Western art magazines so rare and precious they were passed around from hand to hand until they fell to bits.

When I finished, there was a brief silence before Valerie Beston said calmly:

'Okay, we'll do this exhibition.'

There were just two more questions. Who would guarantee the insurance for the show and who would pay to get the pictures to Moscow?

'I think,' said Muriel Wilson, 'that is where the British Council might just be able to help out.'

A month later, on 21 December, I was invited back to the Marlborough to meet Henry Meyric Hughes, Director of the Fine Arts Department at the British Council. His was an important position and I didn't know what to expect. Would he be the classic British civil servant

mandarin, the type renowned throughout the world for their diplomatic skills? Or would he be a passionate art lover like me, intent on helping us get the exhibition to Moscow?

Meyric Hughes was bespectacled, his hair in a side parting. He wore a formal suit, shirt and tie, and he was clearly well informed. The formalities were observed and after an initial discussion of the general state of the art world and the scale of the British Council's many commitments, our conversation settled on the Moscow show. Meyric Hughes was keen to know just who I had been involved with in Moscow. Had I met the Minister of Culture? Who were the people that mattered at the Union of Artists? Delighted by his evident interest, I was happy to divulge all.

'And when did Francis have the idea?' he asked.

'It was my idea actually. It came when I was in Moscow and so many of the artists I met talked about Francis. They all seemed to know his work.'

I wasn't entirely sure Meyric Hughes believed me but I was inclined to view anyone who represented the British Council as a form of saviour. And a saviour is what we needed.

'I shall appeal,' he said, 'for special British Council Funds for this project.'

VI

Generally everything felt a little more relaxed but the required rhythm
of meeting and socialising with Francis and John almost every other
day continued. Francis's flat at Reece Mews in South Kensington was
tiny and not suited for hosting dinner parties. It was cluttered with the
detritus of painting and books, and few guests were welcomed in. John
would come for Sunday lunch, Valerie Beston too, and lately, to my
wonder and joy, me, although we usually had drinks and then Francis
would take me to lunch at Claridge's.

Being allowed to visit this inner sanctum was a final sign that you
had been admitted into the very heart of Francis's life, yet on first arrival
it was unprepossessing. The ground floor was a garage given over to storage
and a washing machine. To reach the flat above you had to clamber
up an almost perpendicular staircase. There was a rope on one side that
Francis used to pull himself up, and an iron handrail on the other. I wondered
how many times he must have attempted this operation whilst under
the influence of drink.

It was common knowledge that the doorway at the right of the staircase
was big enough to be able, at an angle, to get one of his large paintings
through and down the stairs. Consequently, the size of the paintings was
governed by the dimensions of the doorway; anything that was even
an inch bigger would not be able to leave the studio. Canvases were made
to measure accordingly. At the top of the stairs to the right was a little
lavatory and then the mad clutter of his studio. The studio door was paint-
splattered on both sides and was rarely open. Francis didn't use a palette,
he used doors and the walls to mix his colour. Occasionally I caught a glimpse
of the studio itself, which was absolute chaos: it looked as if a skip full
of rags and paint had been dumped willy nilly into a small room. He never
showed me work in progress.

Along a tiny corridor was his bedroom and living room combined: it
contained a table with piles of books — Francis read voraciously, anything
from Aeschylus to Robert Carrier cookbooks — and a round mirror,

possibly from his early London days as a furniture designer, cracked as a result of a lover's tiff with George Dyer. In his bedroom there was a small bed, at the end of which were the oxygen tanks. There was also a galley kitchen on one side and a bathtub opposite. Small wonder that Francis liked to eat out.

Francis was sometimes characterised by others as difficult, but I never found him so. I suspected that his occasional petulant behaviour was a defence mechanism, employed to deflect attention from the interior Francis that was responsible for such astonishing art. It was a way to protect the workings of his mind; the bit that really mattered. He remained fascinated by other people and their stories, particularly when they touched upon his own experience of life, and he had the most beautiful manners.

We often talked of the connection between us in his earlier life, when I was a child, and the friendship we shared with Dicky and Denis.

During this time of plans and intense expectations, Francis was also introducing me to some extraordinary artists and writers, such as William Burroughs: the fact that Burroughs spoke like a querulous little old grandpa rather undermined his austere demeanour.

With Francis, there was not always a great distinction made between who was alive or dead. I remember him exclaiming in the Groucho, 'Cyril Connolly and Evelyn Waugh are a bunch of big snobs and shits.' They were both long gone.

One evening, with Francis, John and Philip, it was announced we were going to the White Tower to meet Stephen Spender.

In 1936 Spender had joined the Communist Party and gone to fight with the International Brigades in the Spanish Civil War. Recanting his earlier radicalism after the Second World War, Spender had been one of the contributors to *The God That Failed*, a 1949 collection of essays written by ex-Communists. He had been knighted in 1983. It was a political journey of sorts, though, as a poet, he did not retain the acclaim that had come his way in the 1930s.

The main topic of the evening, as we sat under a picture of a fabulously moustachioed nineteenth-century military commander, was the success or otherwise of Lucian Freud's new show, *The Unblinking Eye*. When the show eventually crossed the Atlantic, the *New York Times* critic said of the work, 'Only a self-portrait by Rembrandt or Van Gogh comes close to the profundity and honesty of Freud's reflection,' but Spender's take was amusing and interesting nonetheless. Spender knew a lot about art. He had been friendly with Picasso, Henry Moore, David Hockney, Wassily Kandinsky and others and had written *China Diary* with David Hockney. He was intrigued by the upcoming exhibition in Moscow. He also pleased Francis by assuring him that *The Unblinking Eye* was not the absolute triumph he had feared it might be.

I had been surprised, even taken aback, by Francis's introduction: 'Stephen, this is James, the cleverest man I've ever met.' I had never thought about myself in these terms, or even considered in a million years that Francis would think this well of me. 'But it's true James!'

As we continued drinking, Spender, who was bisexual, increasingly and incessantly talked about a young man he was attracted to but, as yet, had not propositioned, and I felt the warmth of Francis's affirmation melt away. Spender was only eight months older than Francis but was white-haired and, by comparison, seemed elderly. It was obvious to the rest of us that the young man in question, to be charitable, might have been more drawn to Spender's intellect than his ageing body, if he was drawn to him at all. But this was the legendary Stephen Spender and no one, not even Francis, wanted to say anything that might offend him. As Spender droned on, over the Cypriot duckling, talking about the impossible boy, I could take it no longer.

I demanded, 'Well why don't you just get on with it and do it?' Silence fell. All eyes turned to me, aghast. I was, I think, starting to feel the pressure of these near-constant nights out in Soho. They were sapping, and with each outing to the Colony or the White Tower we seemed to be getting further away from Moscow.

So I took a holiday to India, flying out on the proceeds of a sale, to see February out. I called Klokov to tell him I would be away. He said he was about to leave for Paris and would hope to get over to London, but it didn't seem that likely a promise. 'Well try and see Francis if you can. I'll give you his number.'

On my return, I received an invitation to have lunch with Henry Meyric Hughes, so we met at the Groucho on 1 March 1988. The bad news came during the main course.

'All good with the special funds?' I asked.

Meyric Hughes's fork stopped halfway to his mouth. The light glinted off his spectacles.

'I'm afraid that might be tricky,' he said. 'I don't think the British Council is inclined to pay for this at the moment.'

The meal ended shortly afterwards. I remember little of the later stages; my mind was whirring with the implications of Meyric Hughes's revelation. The Marlborough wouldn't pay for the show. Moscow couldn't pay for the show. And now the British Council wouldn't pay for it either. Unless we could find more money that was the end of Bacon in Moscow and all I had hoped for.

It was an urgent problem and Francis needed to know about it, but getting Francis to confront urgent problems was not a straightforward task. The big challenge was deciding just when was the right moment during the many days of drinking champagne to broach the subject.

Inevitably, the longer one waited, the more one's ability to decide which was the right moment dissipated. When he was drinking Francis had the perseverance of a much younger man. Even so, the alcohol would inevitably affect his mood as the night went on — as he grew talkative and more expansive, it was increasingly difficult to deliver bad news. Would Francis brush the problem away? Something for the Marlborough to deal with? Would he be outraged and abandon the project? Would he not react at all?

Another evening at the White Tower for supper beckoned and, as ever, we were meeting for drinks first. I was reminded of the cornucopia of plenty that the West was graced with but I was determined that before we had consumed too much, I would tell Francis that the entire exhibition was now in doubt. I finally plucked up the courage in the Groucho, a moment I had been fearing all day since my lunch with Meyric Hughes, and broke the news.

Francis seemed hardly bothered.

'Oh, don't worry James,' Francis declared, as if my tidings were of little consequence. 'I'll talk to the Marlborough if need be.'

In fact, Francis had news for me.

'I had lunch with your friend Klokov while you were away. What an extraordinary man he is,' he said with a long roll on the 'o'.

'He came to London after all?'

'Yes, he said he had business at the Embassy and thought we could briefly talk through the plans. I thought he was rather remarkable.'

John scoffed.

'Very much so,' said Francis, waspishly.

I should have questioned his response more closely. I felt immediately slightly vexed that they had lunch without me, but also relieved. If I was honest with myself, in efforts to stay close to Francis and keep his mind on the exhibition, and because spending time with him was such a pleasure, I was perhaps not focused enough on the practicalities.

At that moment we were joined by Peter Davies, a painter who used to hang out at Birch & Conran. Peter wanted to talk about AIDS, which was cutting a swathe through London and was inevitably terminal. The art dealer Robert Fraser had died the year before and though I didn't know him well it had sent shock waves through the art world. Francis, for his own reasons, probably fear, wasn't inclined to dwell on the subject, which I understood. However, Peter, not picking up on any cues, insisted on discussing it.

Francis finally shrilled at the top of his voice, 'You can't get AIDS unless it's up your bum!' We departed soon afterwards and put him in a taxi home.

'Eggs doesn't like talking about AIDS,' said John. 'It freaks him out. Come on let's go to Fred's.'

Fred's was a small club on Carlisle Street where people would congregate after the pubs had closed. There happened to be an exhibition of photographs on the walls, and one of them was of Francis. It was a terrible picture, a poor portrait, so I was surprised when John bought it for £180. I was even more surprised when he smashed it up right there and then in the club. 'It's a load of shit,' John declared dramatically, rather showing off. A few drinks later he announced 'I will turn Reece Mews into a museum.' This was prophetic as it turned out, as the studio was installed in its entirety at the Hugh Lane Gallery in Dublin at John's request in 2001.

Later that week Francis called and told me not to worry, everything had been agreed. The Marlborough and the British Council had come to an understanding. I was relieved that the meetings that had been taking place between the two had finally proved productive, but had a sneaking suspicion that I was being excluded from ongoing discussions.

My growing uncertainty was added to by the arrival of a two-page letter from Klokov. Written in his idiosyncratic English and dated 1 March 1988, it was both a warning and a revelation.

When he had come to London Klokov had met with the British Council and persuaded them to pay for 'the ensurance [sic], transportation and boxes'. No wonder Francis was relaxed, this guaranteed the shipping of the pictures to Moscow and meant any nervous private owners would have a British-government-backed indemnity against loss or damage.

'I took there Mr Vladim Slavin from the Soviet Embassy,' Klokov wrote. 'Speaking with the British Council I stressed that your name must be duly mentioned in the catalogue (for the exhibition was your idea).'

He also described a terse meeting with the Marlborough.

'I spoke to the Marlborough Gallery (Miss Beston) — ready to contribute — difficult, sharks. My intuition tells me that during the preparation and showing the exhibition they would be possessive, jealous and competitive — one of the weakest points of our plan.'

This, I sensed, was Klokov the KGB agent talking rather than the cultural diplomat. 'Do think it over,' he continued, 'and try to find the formula to neutralise them without losing anything.'

The prospect of neutralising Miss Beston was a startling one but Klokov had clearly taken against her. During their encounter he claimed that she had suggested the Pushkin would be the only suitable venue for the Bacon in Moscow show. According to Klokov, this was 'bullshit fantasy'. He had recently taken the British attaché in Moscow and Sir Alan Bowness, chairman of the British Council Advisory Committee and former director of the Tate, to see the Union of Artists Gallery and it had been approved as a suitable venue for the exhibition. Furthermore, over lunch in London Francis had told Klokov that he was happy for the show to be at any 'appropriate and well-attended place'.

[handwritten at top: Локов· 1987]

<u>Confidential</u>

Dear James,

[handwritten: 22 4 87]

I hope the letter will find you back from India - the trip must be exciting.

Things seem to go on as we planned.

1. The British Council was going to pay for the ensurance (very important), transportation and boxes. I took there Mr.Vladim Slavin from the Soviet Embassy to make my visit more official, you should contact him. He is OK. Speaking with the British Council I stressed that your name must be duly mentioned in the catalogue (for the exhibition was your idea.)

2. I spoke to the "Marlborough Gallery" (Miss Beston) - "ready to contribute",-difficult, sharks. My intuition tells me that during the preparation and showing the exhibition they would be possesive, jealous and competitive - one of the weakest points of our plan. Do think it over and try to find the formula to neutrali them without losing anything.

3. I met Mr.Bacon for lunch very durable and substantial. We had very important discussion.I found out besides many other thing: that the bullshit about the Pushkin Museum as the only place Mr.Bacon could accept for his exhibition was Miss Beston's ambition fantasy. He is ready to show his things at any appropriate and well attented place. And he could rely on our choice. We spoke about you,and I tried to stress what a wonderful idea of yours was to arrange all that. He felt the same. Discussing the introduction for the catalogue from the English side he did not spoke in favour of David Sylvester saying that he started to rewrite and republish one and the same thing about Bacon to earn easy money. As a possible author Lord Gowrie was proposed(may be for the reason that he happened to be at the same restaurant - "Wiltons" at the neigbourin table celebrating his son's birthday and he had a small chat with Bacon). In that case Sotheby's may contribute to the catalogue production fee to be printed with Larry King ("John Coleman anc King Ltd.")

4. The Director of the Tate Gallery came to Moscow for a coupl of days and we visited the Union of Artists Gallery and the Pushkin Museum to compare. He was accompanied by the British Cultural Atta- ché, they approved my choice for the Bacon show. The Union of Artis

will have to send them the plan of the third flour, separate circuit gallery without windows, if you remember.

5. I need black and white photoes with detailed description to start making the layout of the catalogue, appropriate information for the tytle page and acknowlegments, black and white photoes of Mr.Bacon, and black and white documentary photoes (if needed), introduction from the English side or the extent of the introduction in words - that is all we need to start making the layout. (Bacon's biodata, list of the exhibitions and bibliography I have in the catalogues, given to me by the British Council.)

We should not waste time because the exhibition must be opened not later than midSeptember.

The official request for all those materials listed above would be sent from the USSR Union of Artists to the British Counci (to Henry Meyric Hughes). Your should bear in mind that black and white photoes for the catalogue would be used for censorship, as I was told that outspokenly gay subjects with two male figures and cock-exalting canvases "would never be understood by Soviet public (I am afraid vice versa). Approving the choice by photoes is the most favourable way of censorship.

As far as you can see things are getting serious, so you shoul hold on - if the exhibition is a failure we would held responsible for that - if a success-be sure a lot of people will appear to tak all advantages. I trust your feeling of the situation and diploma- tic talent.

Please telephone me. Hoping to see you and your charming artist friend in Moscow as soon as you can.

Friendly, *Sergei*
1.07.88
Sergey

P.S. Please, give this letter enclosed to Mr. Bacon and send me his adress and telephone.

I knew from John that the lunch had not been at the familiar White Tower but Wiltons on Jermyn Street, St James's, in the heart of traditional London clubland. I wondered what Klokov had made of it and I also wondered about Francis's choice. Wiltons was very old world, with stiff white tablecloths and half lemons wrapped in gauze. The waitresses were dressed in white housecoats and were famously nannyish, and the food was very traditionally English. It amused me to think of Klokov ordering potted shrimps, bread and butter pudding and perhaps a savoury Stilton souffle, all beautifully cooked, all incredibly expensive. From experience I could only presume that Francis, not Klokov, had paid the bill. As far as I knew, there was no such thing as a KGB credit card.

I would have liked to have been there. I imagined watching Klokov chain-smoking over his half-eaten steak and kidney pudding, Francis sipping champagne and running an eye over him, perhaps intuiting some of the darkness that lay within. I had missed a key encounter. It served me right for going to India. It was simply unfortunate timing; Klokov wouldn't deliberately arrange a meeting with Francis because I was away. Or would he? I remembered something Bob had told me. 'Klokov uses classic KGB methods, he destroys trust between people. He turns the other players in the game against each other if he can.' Could I trust Klokov? There was no other choice.

The letter also reported that Francis had been in brief conversation with Lord Gowrie who was sitting at the next table. Grey Gowrie was the chairman of Sotheby's and formerly the Minister of Culture in Margaret Thatcher's government. I knew from Bob that Klokov had an admirable knack of mingling with the people that mattered most.

Klokov had also included a request for black-and-white photographs of the paintings that Francis wanted to be in the show. These were necessary for the catalogue but would also, Klokov advised, be used by the Union of Artists as a visual guide for any potential censorship. Klokov thought any representation of gay sex would fall foul of the censors, though he had his own unique way of explaining this: 'I was told that outspokenly gay subjects with two male figures and cock-exalting canvases would never be understood by Soviet public.'

Klokov finished his letter with a rallying cry and an astute prediction. 'As far as you can see things are getting serious so you should hold on — if the exhibition is a failure we would [be] held responsible for that — if a success be sure a lot of people will appear to take all advantages [sic]. I trust your feelings of the situation and diplomatic talent.'

He had given me much to think about. Klokov and I were in it together, whatever his flaws. While I was delighted to see progress made, there were potential pitfalls ahead.

Best of British Bacon in Russian art show

By Geraldine Norman
Art Market Correspondent

FRANCIS BACON, the 79-year-old master of all the nightmares to which human flesh is heir, is to be accorded a full-scale exhibition in Russia. He is bubbling with pleasure, having beaten his French and American contemporaries to the post, with the exception of Chagall who slipped in last year — but then he was born Russian.

Like most deals in the artist's life, the arrangement was cooked up over oysters at Wilton's fish restaurant in Jermyn Street, London and champagne in the Colony Room, the favourite Soho watering hole of a generation of artists, and writers.

The exhibition will be the first major show in Russia organised by the British Council since it took Turner there in 1975. It will be held in the exhibition hall of the Union of Artists of the U.S.S.R. on the Krymskaja embankment in Moscow, from late September to early November this year. Forty paintings will be displayed, dating from the 1940s to the present day, with emphasis on the last five years.

James Birch, who runs the Birch and Conran Gallery a few doors down Dean Street from the Colony, set the ball rolling over a drink.

While making the rounds of Soviet artists' studios during a visit to Moscow, he had been surprised to find how many of them were interested in Mr Bacon's work. He also got to know a Soviet diplomat called Sergei Klokov, a member of his country's UNESCO delegation who has exceptional contacts in artistic circles.

One night in the Colony Club, Mr Birch asked Mr Bacon whether he would like an exhibition in Russia. After double checking by the telephone the next morning to make sure Mr Bacon was serious, he rang Mr Klokov in Moscow. The Soviet diplomat then wrote to the artist suggesting the idea.

The scene moves to Wilton's where Mr Bacon took Mr Klokov to lunch on a visit to London. "When I went downstairs to the gents, I met Lord Gowrie," Bacon said. "He told me that Klokov was a very important man."

Mr Birch approached the Marlborough Gallery, which handles Mr Bacon's work, and the British Council. The official invitation from the Union of Soviet Artists came through the cultural attaché at the British Embassy in Moscow. The agreement was finalised last Friday.

The Independent 18.3.88.

CLIPPING FROM GERALDINE NORMAN
THE INDEPENDENT 18.3.88

Meanwhile another Soviet was visiting London. On Monday 7 March 1988 Mikhail Anikst, the graphic designer from the Alexander Press who had entertained me in his fabulous apartment filled with Russian neo-classical furniture, dropped into the gallery. Coincidentally, Francis happened to be there too. Anikst offered, on the spot, to design the catalogue for the exhibition. But the conversation was a portent of trouble ahead: I knew that the catalogue and who would write it were crucial questions and needed careful consideration. In the Colony later that week, Francis was full of ideas about how the catalogue should look and what would be in it. As we talked, he watched the racing on television. I had to admire his nonchalant calm; what might be one of the most significant exhibitions of his career was under serious discussion and he was apparently more concerned about the 4.15 from Sandown.

I was worried that premature publicity about the show might derail us if Francis was unhappy about what was said. Paradoxically, in the end it was Francis himself who leaked it to the press. He told the story to Geraldine Norman at the *Independent*, an old friend of his. It was published on the front page on 18 March, the first ever public mention of the show.

The piece read as follows:

Francis Bacon, the 79-year-old master of all the nightmares to which human flesh is heir, is to be accorded a full-scale exhibition in Russia. He is bubbling with pleasure, having beaten his French and American contemporaries to the post, with the exception of Chagall who slipped in last year — but then he was born Russian. [...] James Birch, who runs the Birch and Conran Gallery a few doors down Dean Street from the Colony, set the ball rolling over a drink.

While making the rounds of Soviet artists' studios during a visit to Moscow, he had been surprised to find how many of them were interested in Mr Bacon's work. He also got to know a Soviet diplomat called Sergei Klokov, a member of his country's UNESCO delegation who had exceptional contacts in artistic circles.

One night in the Colony Club, Mr Birch asked Mr Bacon whether he would like an exhibition in Russia. After double checking by the telephone the next morning to make sure Mr Bacon was serious, he rang Mr Klokov in Moscow. The Soviet diplomat then wrote to the artist suggesting the idea.

The scene moves to Wiltons where Mr Bacon took Mr Klokov to lunch on a visit to London. 'When I went downstairs to the gents, I met Lord Gowrie,' Bacon said. 'He told me that Klokov was a very important man.'

Mr Birch approached the Marlborough Gallery, which handles Mr Bacon's work, and the British Council. The official invitation from the Union of Soviet Artists came through the cultural attaché at the British Embassy in Moscow. The agreement was finalised last Friday.

Somehow Klokov, 'a very important man', had become the star of the show. But within days I was myself cast as the hero of the hour. In the *Daily Mail* on 22 March 1988, inspired by Norman's piece, Dan Farson wrote:

James Birch, lock of hair constantly falling over his forehead, looks more like a schoolboy than an art dealer. His soft voice and modest manner seem totally out of place in what in recent times, with prices for pictures going through the roof, has become a viciously competitive profession. Yet, single-handed, the 30-year-old Birch has just pulled off the coup that has shaken the art world rigid. Thanks solely to Birch's efforts, Francis Bacon's exhibition will open in Moscow in September — the first time since 1917 that any living artist in the West has received such an honour.

The exhibition had been formally announced. I had to turn my attention to another task, which was to fulfil my promise to Elena Khudiakova to see if I could try and get an article about her in *The Face*. I wanted to repay her kindness and thoughtfulness for giving me a reading list and wanted to offer her some help. I rang my old friend Louisa Buck who was writing for the magazine. I showed her the photographs I had taken of Elena and the slides of her work. Louisa said she would talk to the editor and do her very best. I was delighted when *The Face* came back to say 'yes'. It was something positive to offer Elena on my return to Moscow.

I never sought personal publicity, but I was pleased to know everything was progressing. If a figure as significant as Grey Gowrie liked the idea of the show then that could only be a good thing.

I was not, this close to the date of the exhibition, going to risk upsetting Francis. As well as the ability to tolerate great amounts of alcohol, life in Francis's inner circle also required a certain ease of attitude. Given our long friendship it was best to be thoughtful and relaxed in his company. I had spent many months worrying about the possibility of him changing his mind about Moscow. Something I knew he was capable of doing if he felt the project was becoming too much trouble for him.

If anyone doubted that this could happen there was ample evidence to hand. Since 1987 Bruce Bernard, picture editor at the *Independent*'s Saturday magazine, had been working on a book on Francis called *About Francis Bacon*. Francis really admired Bernard's attention to detail and had been committed to the project. The book was to be a visual documentary of his life, with press reports from 1931 onwards, photographs of him and his friends, posters of shows, a running biographical narrative and, of course, reproductions of his paintings — all done with the full backing of Marlborough Fine Art. Bruce said that his intention had been 'to make the best possible picture book of Bacon's work, with a text consisting mostly of extracts from press criticism'. It was designed by Derek Birdsall. Bacon thought Birdsall's design dummy was 'marvellous'. He also read Bruce's text and told him he 'rather liked it'.

But the book was never published. Francis had a change of heart, and I knew from experience that once he had changed his mind it was almost impossible to persuade him to change it back. Just before the book was due to go to press Francis took Birdsall, some of his family and Bernard to a lunch where, Bernard reported, 'He charmed us all with his generosity and enjoyment.' But then, according to Dan Farson:

With less than two weeks before the book was due at the printers, Francis phoned Bruce and asked him to come round to 7 Reece Mews, he asked that all the photographs and Bruce's text, apart from a brief introduction, should be removed, and no work before the 'Three Studies' should be reproduced. Understandably, Bruce Bernard found this unacceptable.

And so, the book that was almost certain to happen did not happen. It was a terrifying lesson, that while I delighted in my time with Francis, I was simultaneously aware that all our plans could fall apart at any moment.

A few days later, on 29 March, I went for dinner with John and Francis at the Caspia, a caviar restaurant in Bruton Place. Unexpectedly, and to my great embarrassment, Francis attempted to bestow on me the greatest gift in his possession.

'James, I would love to give you a painting to thank you for all your work on the Moscow show.'

I felt overwhelmed and very shy. I didn't react immediately. Which was a mistake as John's cockney bark filled the space my silence had created.

'He doesn't need a painting Francis. I've given him three lithos.'

Perhaps he was protecting Francis, perhaps he was protecting his own interests — perhaps it was a bit of both.

The lithos John was referring to were limited edition, signed lithographic prints of Francis's work. They were produced as sweeteners and given to potential clients in the hope of tempting them into buying a proper picture. It was true, I did have three lithos that had been passed to me on a separate occasion by John. They were all signed by Francis, but John had added 'Thank you James, John.' What I should have said, right there and then to one of them, was, 'Well, actually I'd love to have a painting too.' As anybody would have done. To own a Francis Bacon is a remarkable thing. But of course, I didn't say that. And then the moment had gone. On his death, Francis would leave everything to John, and a more cynical observer than me might say John was simply protecting his inheritance when he stopped Francis giving me a painting. I don't think that was it. I grew very close to John; we were fond of each other and he would have gone out of his way to help me. But he guarded Francis and his work from all comers, friend or foe, like a dog guards its master. It never came up in conversation again.

We went on to Fred's followed by the Apollo. John was often in the mood to go to gay bars and clubs after dinner. Francis invariably insisted that I came along too. He liked to watch John cruising and enjoying himself, but he did not want to be left on his own at the bar without anyone to talk to.

'Champagne all the way' I wrote in my journal, adding: 'Francis is worried again about the Moscow show, though he won't tell me why.'

I was still doing the practical work on the show as its instigator and was continually corresponding with the Union of Artists in Moscow as best I could. However, in London, the only hard information I was getting was from Francis, who was speaking to the Marlborough who, in turn, were in touch with the British Council. My thoughts returned to Klokov's letter warning me about the Marlborough being 'difficult, sharks'. Having got this far with Francis I felt an immense personal obligation to do all I could to make everything run smoothly.

Had I badly miscalculated? Given too much information away? Telling anyone who asked pretty much everything I knew about Moscow, the people who were important, where influence lay?

At some level, Francis continued to work with me as if I were solely in charge of the show, so I got on with it as best I could. It had finally been decided that the exhibition was going to be held in the Union of

Artists' Gallery, next door to Tretyakov Gallery, in the Central House of Artists, opposite Gorky Park.

I had never seen it, as during my first visit to Moscow it was under refurbishment. I had been told that they couldn't provide a floorplan so it had been decided with Francis that Paul Conran and I were to go back to Moscow to measure up the rooms and complete the floorplans ourselves. Francis told us that he wanted his pictures to be hung with the frames five or six inches above the ground at eye level so that visitors would focus in the centre of the pictures, and he was concerned that the rooms would not be big enough. I knew it would be a time-consuming job for us to measure up the galleries, but at the same time I felt a sense of excitement. I took a long architectural tape measure with me, paper and pens and the much sought after Lea & Perrins, and I looked out for some magazines for Elena.

On Friday, 3 June 1988, we gathered at Heathrow duty free once again to fill our luggage with whisky and cigarettes. To get us into the country, Klokov had arranged for us to join an official Intourist group. Johnny Stuart and a team from Sotheby's were also at the gate and I saw as we approached the familiar figure of Bob Chenciner. When I asked why he was joining us, he said, 'Looks like the Russians have got more textiles for me to see.' I strapped myself into my seat and felt the familiar nervousness. In some respects, flying to Moscow was like going to prison and not knowing if you would ever get out. Also, I felt the additional anxiety about completing successfully the vital task that Francis had asked of us.

VII

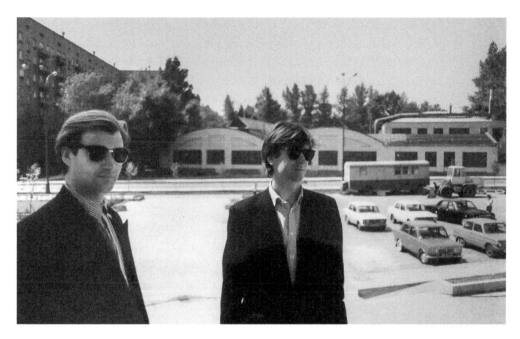

JAMES BIRCH AND PAUL CONRAN
PHOTOGRAPH BOB CHENCINER

Klokov was waiting at Sheremetyevo airport in his green Pierre Cardin
suit, holding one of the soft leather men's hand bags that he favoured
and which, he told me, with pride, had cost $1,000. I shook his hand,
adjusting to the rules of Klokov time and Klokov space as I did so. I had
prepared Paul as best I could for the arrival in Moscow which, if it was your
first time, was like landing on another planet.

For one, we would be watched, Paul should presume that everything
we said or did would be overheard and reported and that all our
conversations would have another, hidden, audience. Since my first visit
I had become an avid consumer of news from Russia and, as well as
ploughing through Elena's reading list, I had continued my crash course in
Sovietology in a desire to understand my rather complicated notion
of the Russia I had discovered. I loved the deep and hidden sensuousness

of the writing and the complexity of characterisation in Russian literature as it fanned the flames of my growing passion for all things Russian. My reading also connected me in some way to Elena ; it felt important though I didn't know why.

In the meantime, the West had become fascinated with events beyond the Iron Curtain. For over forty years we had viewed the Soviet Union as our significant other, the totalitarian state that would never go away. And now it was changing.

How far that change would go we couldn't know. Some thought that *perestroika*, like Khrushchev's brief thaw in the early 1960s, was doomed and argued against naively trusting in Gorbachev. Those like the defector Oleg Gordievsky, who had escaped the Soviet Union's clutches, argued it would always be a tyranny. Amongst his many revelations Gordievsky had confirmed the obvious, that notable visitors from the West were assigned officers to report on them. Klokov, I knew, was monitoring us under licence and probably reporting on our every move.

Looking back on my first visit to Moscow, in July 1986, I realised that I had only gone to the places that Klokov wanted me to go. If a stranger came up and spoke to me to ask for a Marlboro cigarette, in the Union of Artists café-cum-restaurant, somebody else in my group which usually consisted of Klokov, Misha and sometimes one of the Union's technicians — and not always someone I had previously realised was in our party — would push them away. The first time this happened I thought it was an over-zealous attempt to protect me from unwanted attention, but it kept happening and I came to the gradual realisation that, just as John protected Francis in Soho, I was being prevented from speaking to anyone other than those people that Klokov or Misha wanted me to speak to. Occasionally someone would get through the invisible cordon to ask me for a smoke. Essentially, they were begging me for cigarettes and to make the encounter less embarrassing they would offer to show me photographs of their children who as a general rule they revered. I was pleased to be able to share the moment and in return, I would take out my wallet and show them a picture of my daughter Zoe. I had found these encounters strangely moving but I now realised they only happened when Klokov allowed it.

Despite this I experienced the same guilty thrill I had on my first trip when Klokov waved his KGB badge at the waiting officials and marched us through customs again. But this time Paul and I were officially part of an Intourist tour and there was no exception to the rules. A government ministry had sent along a guide to ensure all travellers went straight to their hotel without photographing military installations, keeping assignations with Soviet double-agents along the way, or more generally undermining international communism wherever we might find it. The tour guide was a middle-aged woman and absolutely determined that we should get into her waiting bus with the rest of her group. She was

implacable, we had to travel with her. Klokov put his hands up in mock surrender. There were some things even a KGB badge couldn't fix.

An hour and a half later we arrived at our hotel, The Belgrade II, opposite the Ministry of Foreign Affairs, a looming and ominous Stalinist building. I never discovered a Belgrade I. Our tour guide took away our passports and our return tickets, which were only to be given back on the day of departure from Moscow. This was standard practice, but invariably I felt the familiar sinking feeling that I would find myself trapped in Russia and never able to return home. Throughout the period of my visits to the USSR I never got used to it. To my admiration, Paul seemed much more accepting of our situation. He handed his documents over happily and I admired his carefree attitude but then, I reflected, it was his first time behind the Iron Curtain.

I found the time difference exhausting, and the anticipation of arrival and its associated problems stress inducing. I lay on the bed and closed my eyes briefly before showering and shaving, delighted to find there was a bathroom plug this time. I had agreed to take Paul on a city walk so he could get a feel of the place, and we then joined the others in the bar. Klokov came to take us for dinner at his house. As we got into his car I asked Klokov if he had enjoyed his lunch with Francis at Wiltons.

'It was very good. Lord Gowrie! Bread and butter pudding! I will tell you all about it later.'

Things were changing. The posters in the streets of Moscow were no longer about fighting imperialism but about fighting alcoholism, according to Klokov who translated as we drove. One particularly plaintive example that Klokov translated for me showed a miserable-looking family and the slogan, 'The wife and children are asking tearfully, stop before it is too late!' *Perestroika* and *glasnost* were picking up pace. Gorbachev had begun the liberalisation of the economy, allowing small businesses to open as long as they were run as co-operatives. It was the first private enterprise activity since Lenin's New Economic Policy in 1923, Klokov told me, a policy which saved the young Soviet economy from collapse. In 1987 Gorbachev had announced the policy of democratisation. There would be elections in 1989, to a new congress of people's deputies, and the process of the congress would be broadcast live and uncensored. This, Klokov explained, was unparalleled.

To me it seemed the course of events was leaving the old regime behind.

'Democracy must mean the end of communism,' I said, and was rewarded with Klokov's deep and resonant laughter.

'No James, democracy will save communism.'

And such was Klokov's confidence, I almost believed him.

Klokov lived centrally in Moscow near the Cuban embassy. It was only the second private home in the Soviet Union that I had visited.

It was spacious and open and the walls of the large white rooms were virtually bare. Instead of the art I had expected the living room was dominated by a huge TV set, which was showing a news report; villagers in traditional dress were folk dancing somewhere in the Ukraine.

Although it was loud and distracting, the television was there as a backdrop to the main event, Klokov himself. He was no longer wearing the green suit but had changed into trousers and a fitted shirt which were also, he said, by Cardin. I was intrigued by Klokov's apparently inexhaustible supply of outfits by this one expensive designer.

Klokov's female coterie was also in attendance. Communists didn't have domestic staff so Klokov had girlfriends instead. He had told me that he seldom cooked, that was left to Marina, who was now busy putting out snacks and offering vodka. And there, in the centre of the room, was Elena. I had not seen her since that last day we had spent together at the dacha with Klokov's parents.

She was wearing a combination of fashionable Soviet and Western clothes rather than one of her constructivist outfits, but was no less striking for it. In the past few months I had been living at a frantic pace and had put Elena in a corner of my mind. But I had not forgotten her. I realised that I was very happy to see her and I felt intense desire flooding through me.

'I have something for you Elena.'

I opened my case and brought out *The Face*.

'James!'

I handed the magazine to her. It had finally published a piece about her. It was only small, and rather than my photographs they had used three of Elena's dress designs that she had given to me on slides on my first visit to Moscow. Initially Elena was delighted to be handed the magazine but her face fell when she saw the photograph on the cover, a picture of The Beastie Boys.

'What's wrong?' I asked.

'Who are these people?' she demanded. 'What is this James? They not serious.'

Elena's dark brows creased with displeasure.

I realised that she had expected to be on the cover herself.

'No one gets on the cover the first time they are in the magazine Elena.'

'I think Madonna would James.'

'Well, perhaps.' Her confidence made me laugh. I stopped myself before I could say, 'But you are not Madonna.' What was obvious to me was probably not obvious to Elena.

She searched through the main features section.

'Here, let me show you.' I took the magazine back and flicked through the front section where new bands, clubs and designers were given brief profiles until I found the three designs and one column of text below them based on a conversation I'd had with Louisa in London.

'Is that it James?'

'Yes, Elena, it is!' It seemed she had also expected a five-page feature.

'But look, your designs are fantastic.'

Elena's frown slipped away and I was happy to see her totally engrossed. 'These vibrant but somewhat naive designs use geometric shapes taken from townscapes and technology in a truly dissident tradition.' Elena paused, unsure if this was entirely good or not. 'Khudiakova's work shows the current loosening of state attitudes is making clothing as artistic expression as well as utilitarian product gradually acceptable.' She stopped again. 'But James, they not said I designed Pierre Cardin exhibition in Moscow.'

'I didn't know you had,' I said. As usual, in Moscow, I was not entirely sure if I was being told the truth.

Klokov nodded. 'It's true. Elena helped organise an exhibition of his designs. She made the sets. It was a big success. That is why she was part of the Soviet delegation in Paris.'

In my mind there was a faint memory of the first time I had met them both. Hadn't Klokov said she was allowed to travel because she had a boyfriend who was a party official?

'So, you see James,' Elena said. 'I know prestigious people in the fashion world. So does Sergei, he is friends with Cardin.'

If I had learned anything about Klokov it was that there was always more to learn; even so discovering that he was acquainted with the most famous fashion designer in the world at the time was unexpected.

'How did you meet Pierre Cardin Sergei?'

'I had a friend who worked at *Architectural Digest*.' Klokov's usual boastful tone had softened. He seemed sad, a state alien to my conception of him.

'Richard Napier,' said Elena. 'He handsome man, gifted. He died of AIDS.'

I really wanted to ask Klokov more about his lunch with Francis but he declared it was time to eat. Marina busied herself directing us to the table which was laid out with the ubiquitous Russian salads and pickles. Klokov declared he was getting more vodka. As he disappeared into the kitchen, he gestured for Elena to join him.

I sat next to Bob who had overheard our conversation.

'They were very close,' he said quietly, helping himself to salad. 'Klokov was shattered when Richard died.'

'It seems an unlikely relationship,' I whispered, aware that Klokov could come back at any moment. 'Klokov and a gay Western designer.'

'Not at all,' said Bob. 'He's very well connected in that world. Klokov has important friends in the Paris fashion scene too. He knows Hubert de Givenchy and Philippe Venet.'

I knew that Klokov had several gay friends and could veer towards

the camp on occasion but he clearly had plenty of girlfriends too. Klokov's appearance was unusual, even in Moscow, and if he was attractive it came from his power not his sexuality. He certainly surrounded himself with beautiful women and as an onlooker it appeared that they were prepared to go to bed with him because they wanted the favours that only he could grant.

Looking out of the window, at the drab Moscow evening beyond our dinner party, I could understand that a night with Klokov might be a price worth paying for some luxuries, but it seemed a desperate state of affairs. And what did he get, other than the obvious? For Klokov, sex was currency as much as passion. This was true of many people in Moscow. Elena told me that women used sex to bribe the police or jump to the front of a housing queue. Swapping sex for favours was standard practice in a city where there was nothing else to swap. Even Lea & Perrins could be used as sexual currency. Klokov's strange request made sense now. Elena also told me that there were so few condoms available that abortion had effectively become the main form of contraception. In such a macho, patriarchal society I am sure it was advantageous for Klokov to be seen as the sort of man who had sex with beautiful women. Klokov had the manner of someone who had placed himself above his desires and appetites and called upon them only when it suited him to do so.

Was Klokov a bad man? Was he immoral or amoral? I came to understand that he saw all the things he encountered, particularly other people's desires and foibles (including my own), as opportunities to serve his ambition, as a route to getting what he wanted. And what did he want? Simply to be recognised and acclaimed, to be, in his own way, a star. The system he served would never allow that kind of success but he served it anyway. Communism and Klokov were joined together; if the state fell, so would Klokov.

He came back into the room with the vodka and Elena. '*Poyekhali*!' he declared — let's go! — the words uttered by Yuri Gagarin before blasting off in 1961. '*Poyekhali*!' we echoed.

In these circumstances, I had to see Klokov as a friend, and as I got to know him better I came to admire his apparent genius for pushing things just about as far as they could be pushed without incurring the wrath of the Communist Party. Klokov had the knack of judging what could qualify as acceptable under the Soviet system. He also took me seriously, which I responded to, and he was happy to consider the largest and most unlikely projects. This struck a chord with me. We were both, in our different ways, ambitious and I wanted to give the Russians the opportunity to see a different version of the world through art. It might sound foolishly idealistic now, but I believed it with complete conviction and I saw Klokov as the man who would help me make it happen.

As we sat at the table that evening, Paul talking to Johnny Stuart and Elena next to me, I mentioned to Klokov an idea I had had: might it be possible for the artists Christo and Jeanne-Claude to wrap the Kremlin? In September 1985 they had covered the Pont Neuf in Paris in bronze-coloured man-made silk, a project that attracted three million visitors. Imagine what the world would say if they wrapped the Kremlin in Russian Red? I wasn't being entirely serious but Klokov considered the suggestion as if I were in deadly earnest. He waved a finger around, grunted, pulled a face and then declared, 'Yes, why not wrap the Kremlin? It would announce *perestroika* to the world. Anything is possible!' We cheered and applauded, as indeed anything did seem possible in that moment.

Even Johnny Stuart, usually urbane and contained, was caught in the mood of excitement. 'It's happening already,' he said. 'Sotheby's are going to have an auction of early Soviet art and they're letting the contemporary guys take part. There'll be avant-garde pictures in the auction too.'

I had read the Sotheby's auction announcement. It was to be the first official art sale to take place in Moscow since the Revolution. Klokov knew about this already of course.

'It will bring influential people to Moscow,' Klokov said. 'The world will be looking at us and they will still be looking in September when we have the Bacon exhibition.'

The Bacon show was a radical departure from the norm but still recognisably within the parameters of the Soviet worldview, part of the state's remit to bring culture to the masses. In theory, anyone could queue up and buy tickets for Bacon in Moscow. However, the Sotheby's auction was an expression of pure capitalism and in stark contrast to official Soviet ideology.

'Will it be low key?' I asked.

'I doubt it,' laughed Johnny. 'The whole circus will come to town. There'll be Western dealers, international journalists, agents for wealthy bidders. I've heard Elton John and David Bowie are interested. And I guess there'll be some big nobs from the Politburo.'

'What about the Russian artists?' asked Paul. 'Won't they be there?'

'They're letting them in,' said Johnny. 'I think they are going to stand at the back and watch from behind a rope, but there won't be any mingling. The dissident artists will only be allowed a glimpse of capitalism.'

I knew enough to recognise the implications of the auction. It commodified an aspect of human existence that Marx and Engels had argued, in those long meetings above the Red Lion, would prosper through communism — man's innate artistic creativity. Sotheby's were the out-riders of a coming counter-revolution.

Did Klokov realise this? What calculations was he making? Which bets was he laying off in the months before the Bacon show? As we talked and laughed that evening, I found myself freshly intrigued by him.

His great knowledge, his occasional naivety and, of course, the ominous pressure he was subject to. Occasionally there would be a hint of a darker, more terrifying Russia just behind the city of empty shops and threadbare hotels we were encountering: the Soviet hinterland where Klokov also lived, with the long shadows of interrogations, prison camps and executions.

Marina cleared away the dinner things. It was, as usual, hard to engage her in conversation because Klokov always intervened. Any offer of help on my part was rejected out of hand. Paul asked about the number of beggars, many without arms and legs, he had seen in the underpasses beneath the city's streets.

'Afghanistan,' Bob interjected. 'They've been fighting there for nine years.'

'How come?' asked Paul.

Bob looked to Klokov, as if requesting permission to continue.

'Please,' said Klokov. 'Go ahead Bob. Give the Western imperialist version of our act of good neighbourliness in aid of our socialist brothers.'

'Well,' Bob continued. 'The act of good neighbourliness began with an invasion in 1979 that was intended to prop up Afghanistan's teetering communist regime. It has developed into a pretty terrible and costly conflict against the mujahideen, the fundamentalist Sunni Muslim guerillas, and it continues. The mujahideen fight with unabashed cruelty, as do the Soviets now.' Bob's tone had become a little less jaunty. 'The Soviets have helicopter gunships and tanks, the mujahideen have shoulder-launched rockets sent by the West and Saudi Arabia. Thousands of young conscripted Soviet troops have been killed or maimed, it's their Vietnam War. The truth of it is, Afghanistan is hidden from public view here; however, the state can't hide the young men without arms and legs you have seen begging in the streets. It is a national disaster.'

We looked to Klokov, waiting for him to challenge Bob's account of the war. But he simply said, 'I served for a year and a half with the army in Afghanistan.' Now the television was blaring out political commentary but the mood in the room had stilled.

'What did you do?' I asked, regretting it as an inexcusably direct question as soon as I had said it, but Klokov replied, 'I operated a flamethrower.' He appeared unmoved.

What had I expected him to say? A job at headquarters, right-hand man to a general, perhaps with a fancy uniform to match, or a post in the quartermaster office redirecting the supply of armoured cars for his own purposes? I struggled to imagine Klokov, who was a creature of the city, a strategist in move and countermove, an expert in subterfuge, operating such a terrible weapon.

'My God, Sergei,' I said. 'A flamethrower?'

'Yes,' he said. 'We would arrive in a village, surround someone's

house and then I would burn it down. I remember the smell of burning flesh and the sand that stayed in your mouth. It could be hard to breathe.'

I was horrified. Two years ago in Paris, I had signed up for an unlikely art adventure with a roguish diplomat on a cultural mission. But this new Klokov wasn't roguish. I wondered how many people had watched him approach how many villages with his flamethrower; he must have been a vision from hell.

Although the conversation continued to flow, I was struck by how unmoved the Russians were by this story; the air between us all had grown heavy. It felt like an ethical lobotomy. Briefly the room, the huge flickering television, the plates of bread and pickle, the half empty glasses of vodka, were visited by the shades of other places. If I had felt warmed, up until now, by a sense of comradeship and conviviality, Klokov's narrative also brought into focus the profound differences between us. He was not like me after all. I looked into his black eyes. Perhaps I was hoping for a spark of mischief, a laugh, a declaration that it was just a joke, albeit of the darkest kind. Alternatively, if it was the truth, a sign of recognition, an admission of horror about what he had been part of. But I saw nothing.

Although I knew that Klokov was not immune to fear himself, I was often surprised by what did scare him. After the Afghanistan story I felt the need to lighten the mood and stood up and went over to my bag and pulled out Dan Farson's article in the *Daily Mail*. I had thought that he would be delighted with the publicity and with his mention. Farson had quoted Klokov's observation to me that the Bacon show would bring in more people than Lenin's tomb. But Klokov cursed my naivety, I had put him in danger. I didn't understand.

'These kinds of remarks can have serious repercussions in USSR,' he said. Didn't I realise that a gag at the expense of the revered Lenin could still get someone put on the first train to Siberia?

The party broke up shortly afterwards. In the taxi on the way home, Paul asked Bob why Klokov had not avoided front line service, as children of the elite usually did around the world, regardless of the political system.

'It's simple. Because he was KGB,' Bob said. 'They wanted you to do time in Afghanistan because it is part of your training, getting used to killing people.'

Paul shook his head. 'It's all so fucked up.'

'Relax Paul,' said Bob. 'It's just a typical night out in Moscow.'

Paul later admitted to me that he had looked in his bathroom mirror before he went to bed and said to himself aloud, 'God, am I really here?'

In contrast, despite the horror of Klokov's story, I found myself much more at home on my second visit. Perhaps I was getting used to the huge contradictions and complexities of Moscow life and perhaps, I realised with pleasure, I was falling a little in love with Elena.

Paul and I both slept late the next morning and missed breakfast. We were hungry and a bit fuzzy when we set off to the Central House of Artists complex, opposite Gorky Park. If he was to choose the right number and size of pictures, Francis needed to know the exact dimensions of the gallery rooms.

Measuring up is an unglamorous and fiddly business, especially if you are hung over and the tape keeps springing out of your hands and shooting across the room. But it is also the point of no return where you pass from planning a show to actually thinking deeply about the hang. This was the moment I had visualised for months; Bacon in Moscow had left my imagination and become real.

We climbed to the second floor and a technician opened the gallery doors for us. The space was huge. The six inter-connected rooms immediately reminded me of a shabbier version of London's Hayward Gallery. I was struck by the height of the walls, probably sixteen feet tall. Artificial light flooded through ceilings made of glass panels. Despite the support of the Soviet State it was to prove impossible to ensure that all the light bulbs worked at one time throughout the exhibition. The light parquet flooring gave the room some warmth. Images of Francis's work flashed through my brain like a slide show. At this point we didn't know what the final selection would be but it was incredible to think of the Screaming Pope hung alongside a portrait of John Edwards, or the triptych of George Dyer shaving hung opposite the self-portrait of Francis leaning on a basin, or *Figure Study II* hung next to *Study for Portrait of Van Gogh III*. I felt that Francis would be happy that the rooms were tall enough, light enough, big enough. Conversely, despite the darkness that people perceived in Francis's art, the rooms' bright expansiveness would set off his work and illuminate his world very well.

As we worked, members of the Union of Artists' staff stopped to watch the two strange Westerners who were calling out numbers to each other and sketching a floor plan in an A4 pad. Almost all activities in Moscow used far more people than were required for the job. The city creaked under a system of bureaucracy and over-staffing that slowed everything down but guaranteed mass employment. This led to a certain turpitude; on the whole people did not whizz round exuberantly with measuring tapes.

We were grubby and tired but also exhilarated when we met Bob, Elena and Klokov for lunch at the National. It was a remarkably good meal, everybody was relaxed; we had achieved what we had set out to do and Elena, I think genuinely interested, asked me why Bacon was so important and I tried to tell her, as best I could.

'He rescued figurative painting. After the war everything went abstract, all drips and splodges. No one cared about the human form anymore. Francis went against that and he created something much more profound than the abstract painters, he caught something about the mood of the age.'

'What age do you mean James?' Elena said intensely.

'You know, the age of death. World war, holocaust, nuclear Armageddon. Fear, existential dread, why are we here? What are we doing? That age Elena.'

However, Elena had made it clear that she was less interested in an explanation of his pictures than she was in a sense of his reputation and, through that, the influence Francis could exert.

'I don't think Francis is really interested in influence Elena,' I said, slightly bemused by her notion of how an artist might seek to influence others — uniformly not the case, in my experience.

'Everyone is interested in influence and in power James,' interjected Klokov.

Elena made a particularly Russian exclamation, a sort of 'pfft!' then said, 'What will Bacon do in Moscow? He will want to meet prestigious people.'

'I don't think Francis will want to do that at all.' I laughed.

'Then what will he do?' Elena demanded.

'He wants to look at the Rembrandts in the Hermitage with his friend John.'

'His boyfriend?'

'Yes, I suppose so. Is that a problem? I know it's illegal here.'

Elena made another 'pfft!' and flicked the problem aside with a swatting gesture. 'It's not issue,' she declared. 'It's much easier for these men. Being gay is fashionable in Moscow. There is a big men's room at railway station where they all go for sex.'

'A cottage?'

'A cottage James?' Elena looked quizzical. 'Like a dacha?'

So, as we finished lunch, I explained to Elena just what the difference between a cottage and a dacha was.

That evening we were once again going to eat at Klokov's apartment and Marina was going to cook for us. I was aware that she never joined us for lunches or suppers at restaurants but I was informed this was because her job at the State Historical Museum by Red Square was very important and time consuming. Bob said it would be good form for us to provide supper. So, Paul, he and I went in search of ingredients in the afternoon. It was a dispiriting task. Moscow's shops were a dirty testament to the system's inefficiencies. The only fish we could find was off and the smell drove us out of the store. A meat counter offered cuts of pork that were nearly all fat, hacked apart with what looked like an executioner's hand-axe. We did find a shop stuffed with breads and pastries. This was the famous Filippov bakery built in the Art Nouveau style, and there was a long queue to get in.

A man behind the counter hit each loaf with a small hammer: if it didn't bounce off then the bread was fresh. Finally, armed with bread, pastries, the few edible cuts of meat we could find, some vegetables and whisky we arrived at Klokov's at 7 p.m. ready for a feast.

We were a happy party. Johnny Stuart joined us once more and we had brought the rest of the magazines for Elena, *i.D.* and *Arena* this time. She was delighted with them and quizzed Paul and me endlessly about every designer, group and street style that they featured. She particularly loved The Grey Organisation, a group of grey-suited, shaven-headed art activists who staged interventions in galleries. This appealed to Elena's appetite for artistic notoriety without the need, necessarily, for a time-consuming body of work to be completed first. Klokov was also happy. Any of his fears about the *Daily Mail* piece had, apparently, quickly evaporated. I could only guess what might have eased his concerns. Had he performed a service for an influential party official that week? Had someone let it be known that he was still in favour? Perhaps a politburo member, maybe even Gorbachev, had been given the cutting in his weekly report and laughed at Klokov's allusion to Lenin, and word had got back to Klokov? Whatever it was, his brief anger with me had been forgotten.

'I have been showing the article to my friends,' he told me.

Klokov then proposed the first toast of the day. In yet another weird contradictory Moscow moment, Paul found himself drinking to the health of the *Daily Mail*, an odd thing to do behind the Iron Curtain.

As we celebrated the completion of the measuring up and Klokov's new-found media recognition I marvelled at his ability, when inclined, to lift the mood of the people around him. Even Elena, although she was standing apart, was smiling. I took her a drink.

'Here Elena, let's make a toast.'

'To what James, the exhibition?'

'Yes, to the exhibition. Do you think your family will come?'

'My family is not so good.'

'Why?'

'I have never loved my mother. We are unalike, James, that if you to see us together, you won't believe we were mother and daughter.'

Elena was dark and tall; her mother, she said, was 'small and blonde'. Eventually I did meet her mother and found she was not small and blonde at all, but just like Elena. But by then, I had learned that Elena was unable to tell the truth. Perhaps I was being given a glimpse of darker things to come. If so, I failed to realise; I felt as if I were among friends and increasingly comfortable in Elena's presence. Later when Misha, a little worse for wear, leant over to me and said, 'Watch out for Elena, James. She has a broken brain,' I brushed it aside.

Our third day in Moscow, 5 June 1988. We were going to see the studio of Grisha Bruskin, the potential star of the contemporary section of the Sotheby's auction. Misha and Elena were due to pick us up from the hotel. Elena arrived but Misha didn't appear. This wasn't unusual in Moscow, people often failed to show up. Unexpected absence was an everyday event, largely because travel was so difficult unless you were one of the Politburo members in the ZiL limousines that swished down the reserved lanes in the centre of Moscow's highways. Untroubled, Elena strode out into the street and flagged down a passing car which took us, in exchange for five of my cigarettes, to Bruskin's studio near Gorky Boulevard.

The studio block smelt terrible in the distinctive way that most Moscow blocks did. Rather than vodka, there were empty whisky bottles on the stairs which, I suppose, denoted a degree of privilege within the ambience of desperation. We climbed to the top of the block and entered Bruskin's studio. One of Johnny's colleagues, a valuer from Sotheby's, was already there and so was Bruskin's wife, who told us Bruskin was too ill to see us. His work was ranged all around the studio. I liked it immediately and admired how he gathered groups of small figures together and arranged them in such a way that they may, or may not, have been mocking the proletarian heroes of officially sanctioned Soviet social realism. If my mind had not been on Francis and the show, I would have tried to buy something there and then.

After failing to meet Bruskin himself we hailed a taxi to go and see Leonard Berlin. His paintings were in the traditional Soviet realist style but his drawings, even though cartoonish, were witty and anti-state. It was another inkling of a more openly subversive mood abroad in Moscow. A world away from the work I had seen on my first visit. Afterwards we went to the Mezh, which in a few weeks' time would fill with a flamboyant cast from the international art market in town for the Sotheby's auction.

After lunch I decided to make a serious attempt to buy a picture from Bruskin. On my behalf, Bob called from one of the Mezh's phone boxes, but Bruskin's wife said he was still too ill to discuss it. Cynical of us, perhaps, but we didn't believe this, reckoning instead that Bruskin was waiting to hear what the Sotheby's estimate would be. Our cynicism was justified, it turned out he was smart. One of his pictures was to sell for £400,000 at the auction a few weeks later. After that it would be too late to get a bargain. Bruskin was the star of the bidding, and a glittering life in the West awaited. But how could anyone who had just climbed the stinking steps to his studio have foreseen that?

We walked across Red Square, past Lenin's tomb, to meet Klokov and Marina at the bar in the National. Elena was a little ahead of me. As she crossed the road a car slowed and the driver said something to her through his window. She answered with some venom.

'What was that?' I asked on the pavement outside the National.

'I called him a pig. Да пошёл ты, скотина!' she said, still angry. 'He asked how much I was.'

Misha was already in the bar when we arrived, released from whatever task had kept him away that morning. He ribbed me for my summer suit, a Comme des Garçons number with fantastically wide shoulders, in fact the only summer suit I owned. He claimed that the rather conservative Russian bureaucrats at the Union of Artists were outraged by it. There were other Westerners in the bar, and I watched Elena as her eyes fell upon them. She drank in their difference and she wrapped herself in it. I felt a wave of pity for her. She had such a strong desire to make a mark on the world and more than enough talent as a designer to do it. Klokov had told me that her designs could never achieve success in Moscow, people simply were not interested in re-imaginings of old constructivist imagery — they were looking to the future not the past. The irony, I knew, was that in the West people really had an appetite for this style. It was such a paradox. New Order and other bands were playing with this kind of imagery across record covers and fashion and merchandise. Here people mistook her for a prostitute in the street. In the West, who knew what she could achieve?

Years later I would meet Elena's friend Larissa Kouznetsova, who had studied at MARCHI, the Moscow Architecture Institute, where Elena had also studied some years ahead of her. Getting in to the school, Larissa said, was a major achievement. 'MARCHI is very, very prestigious. It's so difficult to get in there, you either have to be very talented or you have very good connections. In order to get in you had to provide a portfolio and you had to pass very rigorous, very strict entrance exams. The teaching was exacting too. Elena had to learn to draw for seven years before she could apply oil on canvas. She was very talented.'

So here was Elena in Moscow waiting, and hoping, that Gorbachev would open the door to the rest of her future. Perhaps I could offer her an escape route. I knew that an arranged marriage was an accepted way out of Russia for many people. I felt giddy with the idea that I could rescue Elena and change her life. So out it came, almost unbidden.

'Elena,' I said. 'Why don't we get married?'

Elena scowled at me. 'You're joking James!'

Perhaps I was only half-joking but now I had asked, it sounded like a reasonable idea. It was a practical solution but at the same time felt like a romantic thing to do.

'I'm serious Elena. Marry me and come to the West.'

Elena turned to Klokov, 'Sergei, James wants me to marry him. Should I do it?' Klokov barely paused to consider this question. There was none of the usual pantomime of finger wagging and humming. Paul's jaw dropped. He was speechless.

'Marry James? Of course! You must! A toast!'

So we all drank to the marriage of Elena and James before Klokov and Small Marina excused themselves and left.

It was only after their departure that I realised Klokov had appeared unsurprised by my proposal, he almost seemed to have anticipated it. And that technically, it had been Klokov and not Elena who had said yes. Strangely, I had no physical impulse to touch Elena and I made no effort to kiss or hug her. Even as I said it I felt uncertain of our future together. Perhaps Misha sensed my unease for he was now determined to make the most of the moment.

Filled with slightly suspect bonhomie he declared, 'Now back to my apartment friends. We will have a party. But first James and Bob, we will need whisky.' So, we picked up whisky from the Belgrade and then went back to his wife Olga's flat. Olga was a biochemist by profession and the daughter of a general, which made her one of the elite, and she had her own flat separate to Misha's. We drank whisky-laced coffee and ate cake. As Bob addressed the company in his bad Russian, Elena took me aside and asked if I was serious about marrying her.

'James, when you came to Moscow first time, you touched my soul.' I could hardly think of a more Russian scene. I pushed my fears away. Elena was happy. That, in itself, was enough to make me happy too.

That evening would also mark the beginning of a real friendship with Mikhail Mikheyev. Misha was a remarkable man and, as we drank, he told me much of his life story. He had been born in Moscow in 1945, the son of a Communist Party official.

'As a teenager I drifted from job to job, then spent three years in Siberia in the Red Army,' he said. 'When we were young conscripts in Siberia we were not allowed to drink. So, we would dip bandages in a bucket of vodka and then wrap them around our feet.'

'To stop frost bite?' I asked naively.

'No James, to get drunk. The alcohol would be absorbed through our skin and into the bloodstream. We'd be standing up on parade, swaying, and the sergeant would come right up to our faces and yell, "Breathe out!" But he couldn't smell any alcohol on our breath.'

'And that worked every time?'

'Well,' Misha said ruefully. 'Nearly every time.'

Coming back to Moscow he worked in a design studio, had played the trumpet in a jazz band. After a period of suppression of jazz in the early days of the Cold War, Soviet authorities had softened their attitude, Misha claimed, because statisticians predicted a fall in the working population and it was thought jazz concerts would lead to more pregnancies.

All Misha's stories seemed to combine brutality with humour. Knowing him was as close as I got to understanding the real Russia; the Russia that suffered the attentions of Napoleon, Hitler and Stalin and came out with a joke on the other side.

When he was still a young soldier in Siberia, he had realised that the only way to have any personal freedom in Russia was to move up the power structure.

'I had to find my way up,' he said. 'I started at the Theatre Institute where I stitched together backdrops for the plays, then I managed to get a job in the State Copyright Agency. Each time you get a new job you move up a little, that's how you do it.'

Arriving at the State Copyright Agency, Misha said he looked around and saw his path to a kind of freedom. 'There were about 500 well-dressed persons with good ties pretending to protect the copyrights of Soviet writers, painters and composers.' He was finally inside the Soviet bureaucracy, where all advancement took place.

In the same period Misha became the lover of the poet and writer Olga Ivinskaya, not to be confused with his wife, also called Olga. She had been Boris Pasternak's mistress and the inspiration for the tragic heroine Lara in *Dr Zhivago* and was a lot older than Misha. In 1950 Olga had been sent to the Gulag for three years, an attempt by the authorities to stop what they saw as Pasternak's anti-Soviet work. She was pregnant with Pasternak's child when she was arrested and had miscarried. Pasternak won the Nobel prize for literature in 1958 after the world-wide success of *Dr Zhivago*, published uncensored in Italy to the rage of the Soviet authorities. He died in 1960. Olga was arrested again in 1961 and charged with assisting in the smuggling of the *Dr Zhivago* manuscript to Italian Communist publisher Feltrinelli. In fact, it was given to Feltrinelli's agent, Sergio D'Angelo, in person by Pasternak. Olga spent four years of an eight-year sentence in the Gulag. This was the Russian state's way of persecuting Pasternak, who was dead but unforgiven.

Ivinskaya was a risky lover for Misha. She was not officially rehabilitated by the Party until the 1980s when Gorbachev came to power. I felt, as we talked, that Misha was not completely in thrall to the system. He had an inner life and he was willing to take risks of a slightly different order to Klokov. They were born out of passion not personal gain. At the same time, he was an old-style Communist Party ideologue; he both believed in and worked the system. It had certainly worked for him. In 1986 Misha was promoted to become the Minister of Propaganda and Art Promotion of the Russian Union of Artists for the USSR, putting him in charge of 10,000 people. He was vital to the success of the forthcoming show but as I was beginning to glean, he hadn't quite had the power to initiate it. That decision lay with the shadowy Tahir Salahov.

Though he sometimes drove around in limousines and travelled the world, Misha was not motivated by self-interest but rather by survival. He was a good man, on the whole.

As he talked I found myself longing for a mixer with my drink, anything but another straight vodka or whisky.

'James!' Misha cried in triumph. 'We have a bottle of Pepsi-Cola left over from the Olympics.' I followed him into the kitchen where he searched through the shelves of tinned food until he pulled out a dusty bottle of Pepsi.

It was eight years old. I poured anyway, and it glugged out flatly into my drink. Misha beamed. Now that we were alone in the kitchen, he became remarkably open about the failings of the Soviet state.

'James, everybody has got blood on their hands,' he said. 'Whoever you are in the Soviet Union, you have blood on your hands. If you have a good apartment and you want a better apartment you can tell the authorities, so-and-so's not up to much, and they will be removed and then you move in. It happens all the time.'

'But not you Misha,' I said. 'You are a good communist.'

'Of course, not me. I am the people's Minister for Propaganda for Art Promotion. But let me tell you a story about an official visit for the purposes of culture in the Soviet Union.'

'Where to?' I asked.

'Let's say it was Alma Atar in Kazakhstan, for an exhibition of some old Kazakhstan painter. Let's also say that the artist would be there with his wife and his pretty and very young daughter, and then an official would look at the daughter and say, "Well Yelena, do you paint? Oh, you paint, would you like some canvas?" and the father would say, "No, she doesn't need any canvas, I give her canvas." "Oh well, maybe you'd like some paint brushes?" "No, no, she doesn't need paint brushes." So, the official would say, "Maybe you need to come to Moscow for some extra culture?" And the father said, "No, no. She doesn't need to go to Moscow," and then the official would say, "Right, OK. Five years hard labour to the father for not being cultured." So the father would go to the gulag and the daughter would go to Moscow anyway and it would be worse because the official would gain control over her in the end.'

I came to believe that Misha would not have used his power in that way, despite his fatal attraction to women. He did, though, have the unreconstructed attitude toward the opposite sex that many Russian men expressed. Some years later I stayed with Misha in Moscow. He had divorced Olga and was living with a new, younger woman, Sharafat. Misha, so drunk on one occasion that he thought I was his younger brother, said, 'Sharafat, strip for us.' She started to strip, and I begged her, 'No, no, no, just stop! Stop!' I was so shocked and embarrassed. She did stop but showed neither anger nor amazement at her husband's request.

Misha could amuse me too and often would in the years ahead. On 4 October 1993, a tank shot at the White House, then seat of the Russian parliament, during the attempted coup against Boris Yeltsin. This pretty much took place outside Misha's apartment. I asked Misha what it was like.

'James,' he said, 'It was a Sunday morning and suddenly all the car alarms went off, from the vibration.' And Russian car alarms are pretty primitive. He said all he could hear was 'beep, beep, beep, beep, beep, beep — it went on all day!' This was when Misha realised that Russia as he knew it was on the verge of collapse and his circumstances were about to change.

Thanks to *perestroika* and *glasnost*, that change was already preordained in 1988. I could sense it around me, the feeling was palpable in the conversations I was having in the Union of Artists, at supper tables and in restaurants. In a comparatively short space of time, essentially between my two visits, the first in 1986 and now this one, a Sotheby's auction was on its way, we were allowed inside our friends' homes, and we were mounting the Francis Bacon exhibition. These events were a microcosm of much larger freedoms, the shifting tectonic plates of East-West relations. Change was coming.

For now, Misha was in a powerful position; he could help or destroy the careers of thousands of artists, but arts administrators and cultural ambassadors were not the sort of men who would thrive in the new Russia that was coming with the promise of the Sotheby's auction. While he couldn't be its instigator it was Misha who made the bureaucratic wheels turn and the Bacon show happen. He was extraordinary and he really believed in me and in the whole idea of showing Western art to thousands of people in the Soviet Union. He didn't really want anything from it for himself. As we went to leave the kitchen Misha stopped me.

'This exhibition, Bacon in Moscow, it is important. I am glad it is happening and it has my full support. I think it might be something that we will remember as significant for a long time. But you must understand something James.'

'Misha?'

'Sergei is a manipulator. He only really does things that benefit himself. Be careful.'

The next morning was our last. Paul and I were worried about getting our tickets and passports back from our tour guide but they appeared in her hand as if by magic. We sat around in the hotel lobby with the rest of the tour group, who regarded us with a degree of resentment. We had taken no part at all in the group itinerary apart from arrival and departure. I could only imagine the lengthy repetitive unspontaneous tours of the Kremlin and other city sites they had endured. Misha picked us up in his Lada and drove us to the Union of Artists, where we chain-smoked our way through a meeting and went over a draft of the Bacon catalogue before I took the proof back to London. I felt a sense of achievement; the date was set, we had the vital floorplan and the catalogue was underway.

As we waited to leave the hotel, Klokov assured me that he would be in touch about making the arrangements for Elena and me to marry.

Throughout this last hour Elena was becoming increasingly agitated, perhaps because my attention was focused elsewhere. Her mood darkened and she said she had to go. We said a rather abrupt, formal goodbye and that was it. I regretted that I couldn't say more but Elena had gone. Misha drove us to the airport. Throughout all this Paul Conran had been subdued. As we passed through customs, I asked him what he thought. After a pause, he said, 'I have never known anything like it in my life.' I knew exactly what he meant but at the same time I couldn't help but be both excited and trepidatious of what lay in the future.

VIII

With a large undertaking such as an international art exhibition, no matter how well the major obstacles are negotiated, it is the smaller unforeseen issues and the very human weaknesses of the participants which can cause the biggest problems. For all their shared ambitions, knights of the realm, Soviet spy chiefs and London gallerists can be undone by pride, hubris or greed. I was merely a cog in a very large wheel.

When I had last seen Francis he had told me how much he was looking forward to catching the overnight train from Moscow to Leningrad. In particular, he wanted to visit the Hermitage to see the thirteen Rembrandts from the collection of Catherine the Great and he was determined to overcome his worries about his health. His doctor Paul Brass had agreed that he would accompany Francis to Russia and bring an oxygen tank with him in case he had a bad asthma attack on the journey. Francis had even been learning Russian on a Walkman with a cassette.

Back in London, Soho was welcoming summer and even the pale-faced habitués of the Colony seemed healthier and happier for it. But as the opening of the exhibition, now finally scheduled for 22 September 1988, rapidly approached, my own mood was touched by the chill of fear. The art world can get collective shivers at the memory of great paintings that had gone AWOL at the last minute, grand openings that had failed to open and shows that had been cancelled when they seemed certain to happen.

And the question was who, or what, would create the problem?

My nervousness intensified when I met up with Francis and John to hand over the required floorplan. I was delighted to see them but my delight faded when Francis told me over dinner that the Marlborough was planning to deduct £300,000 from his account to cover the Moscow exhibition costs.

'Francis, it can't possibly be that much,' I said. 'Valerie Beston indicated to me that the Marlborough were ready to contribute. Have they looked elsewhere for funding?'

Francis waved this away.

'What about Sotheby's?' I continued. 'Why not ask Grey Gowrie to help? Or go back to the British Council? This is their chance to get back into Moscow around the show, surely if you asked personally, they would find a way to support the exhibition?'

None of my appeals appeared to register with Francis; he would not be persuaded that there were options. I knew it wasn't his style to ask for help but this felt like he was distancing himself from the endeavour. A dark fatalism had settled upon him.

As dinner progressed, Francis's mood turned to anger, but it was directed at John rather than me. Francis's strong antagonism towards John's boyfriend Philip Mordue boiled up. He had complained about Philip to me too, many times, but not with so much venom. He now demanded that John end the relationship.

'Just get rid of him,' Francis barked over the remains of our meal. 'Pay him to go away.'

John, having I suspected been through this many times before, did not immediately agree to dump Philip, which further provoked Francis.

'All right,' said Francis, even more irritated. 'If you won't, I know someone who can get rid of him.'

I felt he was only half-joking; Francis wouldn't really have Philip killed, but John and he both knew people that could make that sort of thing happen. From that point on it was a cheerless meal and afterwards we went our separate ways.

The next day I rang Francis with a degree of nervousness. I found him much happier.

'It's marvellous James. Miss Beston telephoned me to say that the Marlborough are paying for the show after all.' Relief flooded through me. It seemed the obvious choice for the Marlborough to make. It was one of the richest privately owned institutions in the art world, with galleries in London and New York. The kudos that would come from a successful Bacon show in Moscow would be huge, and the ground was already being prepared by the forthcoming Sotheby's auction. All eyes were focused on Russia and I, along with many others, had seen the recent fourteen-hour documentary, *Portrait of the Soviet Union*. I had watched avidly week upon week.

The press was buzzing. It was reported that Sotheby's had laid on an elaborate formal dinner at the Mezh for the international art set on the night before the sale. The news of the auction was now all over the art world and Paul had most of the details. The event took place in the Sovincenter, the conference centre attached to the Mezh. Bidding was in US dollars, the currency of international capitalism. As Johnny Stuart had

predicted, locals were allowed to watch but from the back of the room. This group, which included some of the artists in the sale, looked on intrigued and amazed by the spectacle unfolding. The auction was divided into two parts and the auctioneer, Simon de Pury, opened bidding at 7 p.m. The first part was given over to eighteen works of avant-garde art from the 1920s and the optimistic estimates of $1.3m to $1.8m soon proved to be way short of the mark. Sotheby's had turned the event into a circus and the audience, the international art crowd and its hangers-on, were all done up to the nines and there to enjoy themselves. They intended to spend. *Line* (1920) by Alexander Rodchenko, estimated at $165k, went for $561k.

In all, the avant-garde part of the sale brought in $3.5m, which caused wonderment at the back of the room. When de Pury moved on to the contemporary work, the wonder turned to disbelief. Sotheby's had arranged the contemporary art section in alphabetical order, using the Latin alphabet. This meant that Grisha Bruskin was the first under the hammer. One of his works, *Fundamental Lexicon* (1986), had been estimated at $32,000 ; it went for $416,000. Bruskin, like everyone else, was evidently astonished. He dropped his glasses and broke them. His wife re-assured him, ' Don't worry Grisha. You're a rich man now. I will get you new glasses. '

Artists such as Ivan Chuykov, whom the Moscow crowd behind the rope regarded as among the country's best, went for low figures or even failed to reach their estimate, while more experimental work by hitherto unrecognised artists went for tens of thousands. Few people from the West knew anything about the contemporary Russian artists, so they were buying on novelty value. When Elton John's manager, Robert Key, paid $75,000 for an essentially decorative landscape painting by Svetlana Kopystyanskaya the Russians at the back of the room, who clearly didn't think much of Kopystyanskaya, gasped. Key also bought two of Elena's dresses, which were on show in a glass case in another part of the Mezh.

Contemporary artists who had previously been denied access to studios or space by the Union of Artists, artists who I had been told on my first visit to Moscow didn't even exist, now had a route to a world-wide audience, public recognition, freedom and, they must have thought, undreamt-of riches. That of course assumed that the artists would actually get their money. Sotheby's paid the Ministry of Culture as soon as they received the funds from the purchasers, but after the auction, months went by and still the Ministry did not pay out.

Finally, Grey Gowrie managed to get the non-payment of the artists on to the official agenda ahead of Mikhail Gorbachev's arrival on a state visit to Britain on 5 April 1989. They were finally paid on 4 April. By then Grisha Bruskin was signed up by the Marlborough Gallery and living in New York.

On 18 July 1988, without consulting me, the British Council sent out a press release announcing the Bacon exhibition and crediting Marlborough International Fine Art with 'generously sponsoring' the show.

They kindly sent me a copy:

The first Francis Bacon exhibition to be held in the Soviet Union is being organised by the British Council in collaboration with the Union of Artists of the USSR and will open at the Central House of the Union of Artists in Moscow on 22 September. The press conference will take place there at 4 p.m., immediately before the opening, which Francis Bacon himself hopes to attend.

The release sketched out the key encounters that had made the exhibition come about. At no point was I mentioned. Yet again Klokov's words rang true. 'If [the exhibition] is a success,' he had written in his letter to me, 'a lot of people will appear to take all advantages.'

Still, I was thrilled that an official announcement had been made at last, but I felt crushed and furious at my omission.

So, disappointed and weary, I flew to Tunisia for a two-week holiday. I had no contact with Francis for the fortnight I was away but those words in the press release, 'hopes to attend', stayed in my head. Sure enough, at the end of my first day back at work John Edwards appeared and we went upstairs to the Colony to meet Francis, who was talkative but seemed wary. I had a strong feeling that something was wrong. That night 1 August I wrote in my journal, 'I suddenly feel it's very weird,' and I put in brackets, 'The spell is broken.'

Since the 1950s, Francis had taken the journalist and critic David Sylvester into his trust. It was Sylvester who did most of the interviews with Francis and who appeared as a talking head to discuss his art on television shows. He liked to think of himself as the one great authority on Francis's work. He once told me that Sylvester knew nothing about art but, even so, he had been happy enough to let Sylvester style himself as his oracle. Perhaps it suited Francis. Sylvester was quite controlling and regarded Bacon as his property, but the television encounters between the two in the 1960s gave Francis a conduit to a public audience without putting him under too much pressure — Sylvester would invite Francis to explain his genius, rather than challenge him about his work.

Now it was Sylvester's turn to be the unforeseen harbinger of disaster for Bacon in Moscow.

At my suggestion, Francis had written a short introduction for the exhibition catalogue that acknowledged the influence of the great Soviet film director Eisenstein.

It is a great honour to be invited to have an exhibition of paintings in Moscow. When I was young, I feel I was very much helped towards painting after I saw

Eisenstein's films 'Strike' and 'Battleship Potemkin', by their remarkable visual imagery.

In one of Van Gogh's letters he makes this statement: 'How to achieve such anomalies, such alterations and re-fashionings of reality that what comes out of it are lies, if you like, but lies that are more true than literal truth.'

Francis Bacon. London 4/6/88

The catalogue was also to contain two essays, one by the writer Mikhail Sokolov giving the Soviet view, the other was to be written by an appropriately qualified Western academic or critic, who would put Bacon and the show in its full historical perspective. The catalogue would mark that moment for posterity.

David Sylvester was, in his own estimation, the natural choice — the only possible choice — to write the second essay. It would also be a crowning moment in Sylvester's career, which was largely based on his relationship with Francis, a very public proof of both his unique access to, and understanding of, Bacon.

I knew his ambition was unlikely to be fulfilled. Among the many things that Klokov's letter about lunch at Wiltons had revealed was Francis's unwillingness to have Sylvester involved with the catalogue. 'He did not spoke [sic] in favour of David Sylvester,' Klokov had written, 'saying that he [Sylvester] starts to rewrite and republish one and the same thing about Bacon to earn easy money.' According to Klokov it had been suggested at the same lunch that Grey Gowrie should write the essay. Now Francis confirmed to me that it was he who had asked Gowrie. I knew that Francis had complete editorial control over the catalogue and I could see the appeal. In Moscow, Gowrie was now closely associated with the success of the Sotheby's auction, and while he was also an unashamed fan of Francis's work, he might bring a much-needed fresh perspective.

Gowrie did write a very good essay. Elegantly and eloquently it set out the development of Bacon's particular genius in the context of the twentieth century's dark history. Gowrie also made a bold claim: 'He [Bacon] is the greatest living painter and the most important Britain has produced since Turner.'

We were now in August 1988, a month away from the exhibition and trouble was brewing. According to John, Sylvester was furious that he hadn't been invited to write an essay for the catalogue, and as it turned out his anger proved to have a decisive influence on Francis. Sylvester clearly decided that if he wasn't going to be part of this hugely significant moment, then he would lessen the blow to his own pride by making the moment less significant for everybody else. How important would the Bacon in Moscow exhibition really be without Bacon himself? Dan Farson

and others have confirmed this to me, that Sylvester began, as one of Francis's East End boyfriends might have said, to put the frighteners on him.

'You're very wealthy now,' he must have whispered in Francis's ear. 'You might get kidnapped.' And what was unsaid but implied; 'fear might bring on an asthma attack.'

According to my diary, John rang me with the news I most dreaded on the morning of 19 August. Francis no longer wanted to go to the USSR. I was devastated. The work of two years, all that effort and the hopes and the dreams, were starting to unravel.

I went to see John at the Groucho that same afternoon, and though he said he thought Farson was right — that David Sylvester had scared Francis off — he reassured me on one account: 'I'd still love to come James, but you'll have to show me around.'

Sylvester would never tell the full story in his lifetime, but the level of his influence is inadvertently revealed in an interview the *Independent* published on 24 September 1988. He said: 'The main reason he's not going there is because he's had terrible asthma recently. Terrible. I can assure you of that. I know what goes on. His doctor's a friend of mine. Who also happens to be my doctor.'

Officially, said John, Francis's excuse was his worsening asthma but the truth was that, alongside Sylvester's prophecy of doom, he had also been seething about the amount of official engagements that the British Council were asking him to undertake in Moscow. This was their moment and Francis was their man — they wanted to make the most of the occasion and schedule public appearances such as photo ops with Soviet officials, tea at the embassy and interviews with the world press. It was a chance for the British Council to re-enter the exciting political space that Russia had become, but their charmless demands and lack of insight into Francis's character — his wants and his needs — were to have dire consequences.

All Francis really wanted to do, according to John, was go to his own opening and then catch the night train to Leningrad. Now it appeared that David Sylvester was telling him that there was a good chance that he could be kidnapped on the train. In addition, Francis loathed protocol and flummery. I had long ago told Klokov and Elena as much.

In his book on Bacon, *The Gilded Gutter Life of Francis Bacon*, Dan Farson blamed the British Council for Francis's decision not to attend his own show and, at the same time, defended me and my role. It turned out that Farson had run into Francis and John at the Groucho Club that same September.
After which he wrote:

Francis was testy. Something or someone had annoyed him, but I was taken by surprise when he told me that he doubted if he would be going to Moscow

7 Reece Mews
23/8/88. London SW7.

Dear James

I am terribly
sorry I will not be
able to go to Moscow
as I have had some
bad goes of asthma it
is a real bore as I would
have liked to have gone.
I am so glad you and
John are going and I
enclose this cheque toward
some of your expense
all but mine
Francis

LETTER FROM FRANCIS BACON SAYING HE IS NOT GOING TO MOSCOW

after all [...] He had lunched with a director and his assistant from the British
Council and found their complacency so irritating that he insisted on paying
the bill in order not to be beholden to them. [...] Then he added, 'I think
James is trying to con me.'

'Oh no,' I protested gently. 'I think he can be absolved of that. He'll do
anything you ask.' It was plain that the two rotten apples from the British
Council were spoiling the whole barrel.

'James never warned me of all the protocol involved,' said Francis.
Seldom had I seen him look so angry [...] I reassured him that James had
behaved impeccably throughout and had suffered (as I had by now discovered)
from the Council's machinations himself, but stressed, 'You must do exactly
as you want to do Francis ...'

If I had known at the time that Francis even partly blamed me for the many
demands, social or otherwise, that the British Council were making on
him I would have been very upset, but I wouldn't have been able to change
his mind. Now, given everything that I do know, I don't think he meant
to blame me. When we first cooked up the plan, it was meant to be a fun trip
and instead it had turned into a bureaucratic nightmare. But there was
no doubt he was in a temper, as cross with himself as anyone else.

The next time I saw Francis was at pop artist Allen Jones's birthday party
at the Groucho. It was a starry gathering of British artists ; Peter Blake,
Joe Tilson and Bridget Riley were there. John and Francis arrived and, to
my relief, it was as if nothing had gone awry. After Francis had talked
to friends and acquaintances alike, employing his airy charm as he did so,
he and John whisked me out to dinner. Whatever Francis had been telling
other people about me I apparently wasn't so out of favour. John handed
me an envelope from Francis and inside was a cheque for £3,000, money
for me to look after John, who would be officially representing Francis
in Moscow.

So far, I had been spending my own money trying to get the Moscow
show to happen. From the beginning I had paid my own expenses, I had
signed no contracts with any of the parties involved, I had chased no fees.
It was an honour and I was beginning to hope that I might be able to bring
Gilbert and George to Russia in due course. On hearing of the forthcoming
exhibition, they had invited me to tea, showed me their work and professed
a huge enthusiasm for the USSR.

I knew it wouldn't make me rich but my role in instigating the exhibition
was at least recognised in some areas of the art press. The September 1988
issue of *Art Line International* wrote :

... throughout the fulsome press releases by the British Council, there is no
mention of James Birch, co-director with Paul Conran, of Birch & Conran

Fine Art. This is surprising as it was at a private dinner party that Birch himself threw a light-hearted proposal at Bacon about the possibility of a Russian exhibition, only to get a serious and positive response from the artist in return.

Somewhere in the ensuing scramble for publicity and acclaim over the project (most certainly a major coup for those involved and with more than a nod in the direction of an emerging new, and previously untapped, commercial market place), Birch was pushed into the background.

As the date of the exhibition approached, Francis was already looking beyond it and talking to me about the things he still wanted to do or had wanted to do, and the sense of failure he felt about paintings that he had abandoned or ambitions that had not been fulfilled. Unusually for him, he talked about art and other artists: particularly about Henry Moore, L.S. Lowry and Carel Weight. He gave a 'Nero's thumbs down' to their work.

The weather was still warm, and there were still wonderful nights out. One evening when a group of us dined at Bibendum, Francis was on such amazing form, lucid, fun, clever, shocking, that I remember thinking, 'I must never forget this,' but of course I did, or most of it, anyway. Although I do recollect, as he entertained us on that particular night he barely drank, and revealed surprisingly that he wanted to be a sculptor and to make films. He was a great admirer of Andy Warhol's *Flesh*, and thought Warhol's films were better than his paintings.

'There are still so many things I want to do, James.'

Conversely, in losing my professional claim on him I seemed to have got closer to him. Perhaps this was my compensation for his non-attendance in Moscow.

By then, it was time to go to Russia.

IX

On 18 September, Francis was interviewed in the *Sunday Times*. 'It is a great disappointment,' he said. 'If it wasn't for this bloody asthma, I would be over there. I had been looking forward to it. Everything was closed up after 1917. It would have been fascinating to see the country now.'

On the following Wednesday, 21 September 1988, I was invited for breakfast, to collect John and to say goodbye to Francis. Francis cooked us eggs and bacon. On my way out I saw that his suitcases were still packed and waiting by the front door, as if he was expecting to overcome his own fear and come with us. I felt a wave of disappointment.

'I'm sure you'll have a marvellous time.'

As we took off at Heathrow, I imagined Gill Hedley of the British Council and her team putting the finishing touches to the hanging. There was no message for me from the British Council. I had to assume that the paintings had arrived safely in Moscow. I knew that a near-military operation had been undertaken to get the pictures to the USSR.

In 1988 the value of the thirty-odd works in the convoy would have been in excess of £20 million. The prospect of a raid while the art was on Soviet territory was too audacious to entertain but the authorities had to be prepared for that eventuality. The pictures were driven through Poland in lorries and then accompanied by an armoured military convoy from the USSR border, which drove all the way to the gallery space at the Central House of the Union of Artists. Gill accompanied them all 1,794 miles from London to Moscow.

Later that day, John, 'suited and booted' as he liked to describe it, and I, in a pinstripe suit, a far more sober affair than my Comme des Garçons number, stepped off the British Airways Heathrow—Moscow flight. Klokov and John eyed each other speculatively in arrivals and decided that they liked the cut of each other's jib. Klokov delivered John to the National Hotel on Red Square, and then he took me to the Hotel Ukraine, a twenty-eight-storey Stalinist wedding-cake Baroque edifice. It was one of the few places

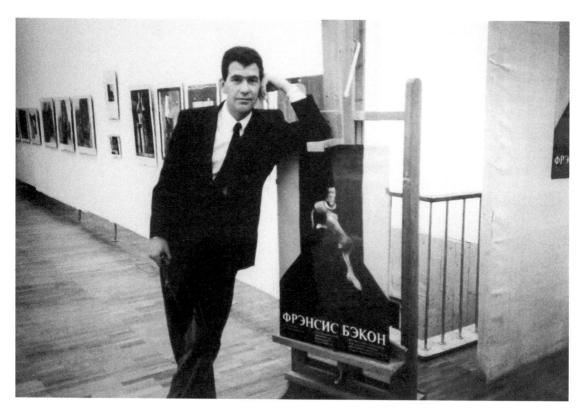

JOHN EDWARDS BY POSTER OF HIS PORTRAIT

where Gorbachev's anti-alcohol push had been adopted wholeheartedly and the bar had been closed down. I wondered, now that Klokov needed me less, if my currency had fallen or if it simply suited Klokov to keep John and I apart. Quite possibly it was all three.

On my last visit I had found Moscow changed; thanks to Gorbachev those changes were being consolidated. International travel was newly available and it was much easier to apply for a visa. Huge, dynamic transformation was underway; Soviet citizens were now free to travel the world. Free, that is, if they had connections abroad. But other things had worsened. In Moscow food was beginning to run out and basics like butter or coffee were almost impossible to obtain. When the show opened, one embittered Moscow wit would write in the visitors' book, 'We want bacon, not Francis Bacon.'

When I woke up the next morning, I was to discover maddeningly that I couldn't talk to John and make the necessary arrangements to meet up because the phones were not working between our hotels.

In 1988 we didn't have mobile phones, so for the duration of the trip if I wanted to find John I had to go and hunt for him. I assumed that both our rooms were bugged. I don't doubt that Klokov kept a close eye on John and knew where to find him all the time. He always knew where you were

and who you were there with, as I was well aware. I had explained to John that everyone we interacted with was probably reporting back everything we did.

That evening John and I met in the bar at the National Hotel. John was delighted with the appearance of his portrait on the catalogue cover.

'Oi, James,' he called when I walked in. 'There are posters of me all over the shop!'

We had drinks with Bruce Bernard, William Packer from the *Financial Times* and art critic Charles Darwent, friends from my Soho life. Their presence in Moscow impressed the reality of the exhibition on me. We were invited to dinner in Klokov's apartment, in the centre of Moscow. At some point, I joined him in the kitchen, where all private chats seemed to take place. There was nowhere else to go. I wanted to know what plans I would need to make to hold true to my promise to Elena.

'It's different now James. All you need to do is agree to sponsor her and be responsible for her and she will get a visa.'

I felt relieved. 'Great, that's a simpler and better option Sergei.'

The kettle began to boil. I turned and asked, 'Shall I turn it off?' And he said 'No!' Instead he just whistled, as you might whistle for a dog, and Marina came running in. It was yet another example of how Klokov wielded power in his private life as well as his public one and I found it disturbing. But there were other, more pressing matters.

Back at the table, I could see that John was deeply impressed with Klokov's enthusiasm for, and apparent knowledge of, Francis's work. A knowledge I noted to myself that Klokov had only recently acquired. John didn't take a critical view of Bacon's work but he understood his importance and was incredibly protective of his critical reputation. I could see a very instant affinity had grown between them. It was evident that Klokov's apparent worldliness and charm, even though by now I was beginning to think it was verging on the sociopathic, had engaged John. I suspected too that he was finding his first experience of Moscow both dizzying and profoundly strange.

John asked with true innocence, 'Why doesn't the Pushkin Museum have a Bacon painting on display?'

'They don't own one,' Klokov replied airily. 'But if I were given one, I would leave it to the Pushkin Museum.'

I nearly laughed out loud at Klokov's blatant self-interest but John, I think, was beguiled by Klokov and probably, as I knew from my first visit to Moscow, experiencing some kind of out-of-body moment with the strangeness of it all.

'That's a great idea,' said John. I was incredulous. John, who had talked Francis out of giving me a picture and who fended off chancers again and again in London, had just offered one to Klokov on the fanciful

understanding that, without guarantee, the picture would eventually be donated to a national museum. But the moment passed, we drank more vodka, and I turned to talk to Elena. If the next morning I remembered John's promise, in the cold light of day it seemed so implausible and outlandish that I forgot about it.

I had promised Francis that I would look after John and I was true to my word. In particular, he loved GUM, the Harrods of Moscow, which had literally nothing in it. It was an in-joke between us but we spent hours trawling the aisles. My parents and some of their friends came to Moscow for the show. I was immensely touched by their support but also by their understanding that I would have to look after John rather than spend time with them. Mum, of course, was an old hand in the Soviet Union and my father was well travelled and enjoyed the general air of excitement and sociability.

John, conversely, needed guiding in everything. I started by showing him how to get around the city by holding out a packet of Marlboro cigarettes until a car gave you a lift (it wasn't always a car, on one occasion I was picked up by the military and sat in the back with soldiers — that lift cost me a lot of cigarettes).

We saw little of Klokov, who was caught up in the to and fro around the exhibition, so we made our own way around. In Moscow the roads are wide so you can't cross them; you have to go under them. Going through one underpass we were stopped by a crop-haired guy with a sallow, hungry face, presumably an 'Afghanets'. He rubbed his fingers with his thumb in the circular motion which meant did I want to exchange Western money into roubles. Neither of us had any money to change.

Then John said, 'I'd love to get some caviar,' and I said 'Caviar?', an international word of sorts. The guy said 'Da'. John didn't have any dollars but he did have condoms, a perennially scarce resource in Moscow, and was delighted to swap two packets for a large jar of caviar. The feeling that we were under constant observation had dropped away.

On Thursday 22 September, the opening day, I woke early and excited. The portents were good. In my bathroom the water was hot, my shower worked and, for the second time in Moscow, my eggs arrived soft-boiled at breakfast.

My luck continued outside the hotel; within seconds of putting my hand out a car pulled up and I was on my way to collect John, once more beautifully suited and booted. When we arrived at the Central House of Artists there was a long queue outside.

John saw it and whistled, 'Fucking hell James, I think Francis is going to be a sell-out.'

Inside we were told the queue had been forming since daybreak and the crowd's excitement had built through the morning. It was thrilling

QUEUE OUTSIDE THE CENTRAL HOUSE OF ARTISTS, MOSCOW

to observe. We climbed the stairs and I was surprised to see the work of
German op and installation artist Günther Ucker on show on the first floor.
Amusingly, because of a national nail shortage, quite a few nails from
his sculptures had gone missing. I wasn't bothered. There would be no
competition. Francis's work would completely overshadow Günther's.

The first sign of unrest came later in the afternoon, but not from the
queue. John and I, along with every other Western visitor to the exhibition,
had been invited to the press launch. Because of Gorbachev's anti-drunkenness
drive, it had been announced that no alcoholic drinks were to be served
at official functions. On hearing this, a shiver had run through the
international press corps. The news of a 'dry' party sharpened their
outlook as well as their pens, so when the press conference began at 4 p.m.
they were looking for a target. Henry Meyric Hughes, Grey Gowrie and,
at last, the mythical Tahir Salahov, the man I had pursued for over two years,
were gathered in a reception room.

Gowrie first delivered Bacon's apologies for not attending, explaining
that he was prevented from travelling by a bad asthma attack. Bacon was,
he said, 'possibly the finest artist alive'. This was a landmark show, he
explained, thirty works from 1945 to 1988 had come to Moscow, including
five large triptychs and two recent works which had not been exhibited

before, drawn from public and private collections in Britain and Europe. But the British press was interested in a picture that wasn't there, the one Klokov had described so eloquently in his letter to me. Word had reached them that Tahir Salahov had rejected the Tate's offer of one of Francis's most important works, *Triptych*, from August 1972, on the grounds that it was too pornographic. The central panel of the triptych was supposed to show two men wrestling but they were clearly having sex. It was definitely what Klokov would call 'a cock-exalting canvas'.

Why was it not here? demanded the press. Why had the Soviets censored such an important work? Was there no *perestroika* or *glasnost* for homosexuals?

In the face of these enquiries Salahov looked uncomfortable. 'Our government has certain laws which are under review in the era of *glasnost*, especially concerning that category of people. I do not think this will be the last exhibition that Francis Bacon will have in Moscow. Perhaps someday, we will have another exhibition that will show other sides of his ... creativity.'

Andrew Graham-Dixon, one of the British press corps, shouted out: 'Why, if you are a homosexual, are you locked in the gulag for twenty-five years?'

'We are interested in Francis Bacon's art, not his private life,' came Tahir Salahov's reply.

Gowrie, fearful for the success of the show and a potential diplomatic incident, albeit a cultural one, smoothed the waters. No paintings had been censored, he said clearly and calmly. There was only one major painting by Bacon that could be seen as having a homosexual theme, he said.

'As far as I know it wasn't suggested at any stage. I suppose when human beings wrestle, if you put them on top of a bed, it is possible to interpret it sexually.'

The next day, Klokov would reveal the truth to a journalist, which was then printed in the *Independent*. 'We decided to leave out the triptych, and I telephoned Francis Bacon and told him that, unfortunately, this painting might be misunderstood by the general public in the USSR. I had to explain, in the end, that what I actually meant was that it might be understood.' He laughed. 'But it is not such a bad thing that this picture was left out. It was very important not to give the exhibition too much the appearance of a scandal; to include the triptych might have made conservative elements in this country dismiss the whole show, to make it an object of ridicule.'

Salahov gave a speech, the British Ambassador Sir Rodric Braithwaite gave a speech, and then more Russians gave speeches for what seemed like an agonisingly long time but was probably only a matter of minutes, after which, at last, everyone entered the big hall to see the show. I remembered that the gallery had six large rooms. I had warned Francis that the walls

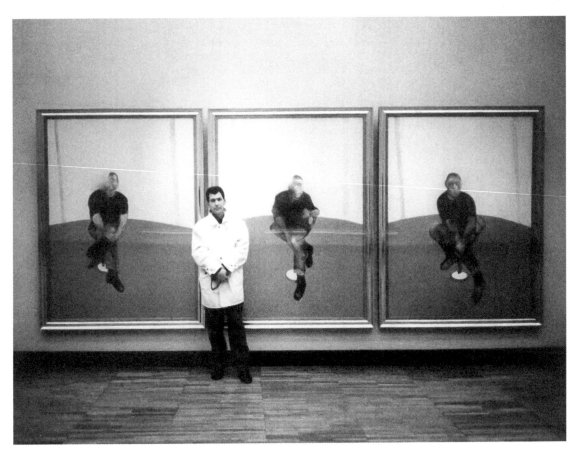

were slightly dirty looking. In fact, they enhanced the effect of Francis's
work, but even in my wildest dreams I hadn't expected the paintings
to look so spectacular in the slightly shabby surroundings. I was freshly
astounded by his genius.

They had been beautifully hung by Gill Hedley and the impact of the
exhibition was dramatic, much better than the Tate retrospective of 1985
which had too many pictures. Here they were properly spaced, mixing early
and later works. I was freshly reminded of Francis' choice to have *Study
for Portrait of John Edwards* on the front of the catalogue and the exhibition
posters which we kept seeing in hotels and key public places. I knew
it was Francis's tribute to John. But the overwhelming feeling was one
of disbelief. The pictures were here behind the Iron Curtain. The exhibition
was happening. The impossible had happened. I felt joy surge through me.

John and I had been invited to the official after-party at the Union of Artists
House on Gogolevsky Boulevard. Elena, John and I jumped into a taxi as
the queuing Muscovites poured in to see the show, which was open until
9 p.m. The entrance fee was only a few kopeks, which I thought was

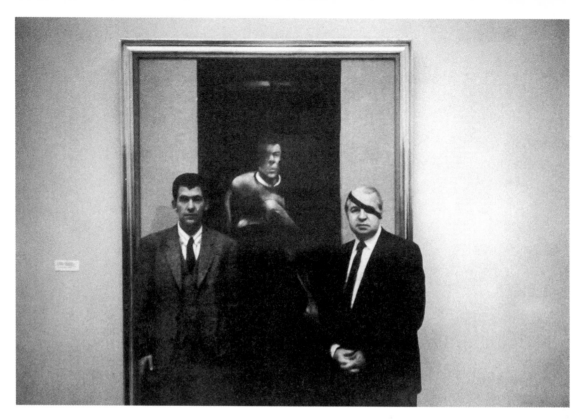

JOHN EDWARDS AND VLADIMIR ZAMKOV IN FRONT OF
"STUDY FOR A PORTRAIT OF JOHN EDWARDS", 1988

a reasonable price, but even that was a much-discussed novelty in a city where exhibitions were always free.

There was not a formal dinner at the Union of Artists House. The protocol involved in deciding the seating precedence would have been beyond the Union officials. Instead there was a stand-up buffet, a line of tables laden with Soviet bounty. Outside the room people were going hungry, inside there were platters of 'Olivye' salad, 'Stolichnaya' salad, cucumber salad, celery leaves, the ubiquitous caviar, both red and black, black bread, smoked sturgeon, all kinds of cold meats. The fare was considerably better than you were likely to find in a restaurant and The Union of Artists had cleverly contrived to avoid government diktats about alcohol at official functions. Vodka and champagne flowed.

I remember feeling numb and disembodied. Looking across the room I could see British grandees, members of the Politburo, KGB agents and then John Edwards laughing with Henry Meyric Hughes. Klokov, who as ever was wearing Pierre Cardin, flitted from group to group. It was almost amusing to see him assiduously building his contacts and, no doubt, accepting the credit for the exhibition. It was, after all, his great achievement and perhaps only possible for a man with his family credentials.

JOHN EDWARDS AND SOLDIER

I passed him as he spoke with a journalist: 'This exhibition is only possible, administratively, morally, ideologically, at this particular moment in Soviet history,' Klokov said. 'Bacon paints the evil in humanity, without mercy. That is new in Russia. The exhibition is a symbol of our whole concept of *perestroika* — now, thanks to Gorbachev, we are not afraid to show the dark side of life, the dark side of society — of our society.' He reached out to me, 'Ah James, I was right all along. The queues are longer than those for Lenin's mausoleum.'

And then there was Elena, beautiful in one of her constructivist dresses, clearly interested in and smiling at the opulence and excitement around her and chatting to Kate Braithwaite, the Ambassador's daughter and a newfound friend, but as ever keeping her cool.

On the following day, there was a round of official engagements and meals. Sir Noel Marshall, Deputy Ambassador, gave a lunch and a few members of the UK contingent were invited.

Afterwards John and I walked back to the National. I wanted to show him Red Square and Lenin's mausoleum but the square was closed off to the public and we were stopped by a soldier. John happened to have Sir Rodric's card, printed in English and Russian, in his hand and, chancing my arm, I said to John, 'Show it to the guard.' These were new times after all. What would the soldier do? Doubt played across his forehead. In the end he relented and let us past the barrier. John and I strode to the centre of Red Square which was, for this brief moment in time, ours and ours alone.

John looked around and took it all in, the Kremlin, the onion domes of St Basil's cathedral, the glowering block of Lenin's mausoleum.

'Not bad, eh James?' He said. 'Wait till I tell Francis about this. He'll love it.'

On the second evening, I met up with Elena. John was elsewhere in hot pursuit of somebody with whom to wrestle on a bed. Elena and I went to Stalin's favourite restaurant, a typical old-fashioned Georgian place near Smolensky Prospekt. The food was delicious. We had soup followed by some salad, 'khachapuri' — cheese-stuffed bread — yoghurt with dill and some very good Georgian wine. There were many bottles of vodka on display behind the bar, and not for the first time, I wondered just how effective the war on drink could ever be in a country so steeped in alcohol.

A passing waiter, seeing a beautiful woman apparently with her foreign lover, drew the curtains to our booth. We were alone. Elena fixed me with one of her more intense Slavic gazes and leaned across the table. I leaned towards her and our hands touched. I remained beguiled by her beauty, but I was too shy to ask her to stay the night with me. She seemed unconcerned that we no longer had to make plans to marry. The night felt enchanted. I reassured her that I would sponsor her trip

and that she would come and live with me in London, and that I would love and support her.

'I only have to sign a piece of paper Elena. Sergei says he can fix it.'

I realise now that I fell in love with the idea of a person who I had unconsciously conflated with my love affair with a country. Unbeknownst to me, relationships like these were known as 'The Russian Bug' in Russia. But on that particular evening, the only disconnect I could perceive was one of language, which I found charming. Any absence of shared experience, such as her revelation that during the Cuban Missile Crisis her schooling took place in a bunker, seemed a minor problem that could be overcome with time.

Elena's face brightened.

'Yes,' she said. 'Sergei can fix everything.'

Misha had given me an article in Russian by the well-known critic Morgova. I showed it to Elena who translated, 'the revolutionary nature of this exhibition will open doors to more Western Art coming into the Soviet Union, and Soviet Art going to the West. It was, he said, the best and most important exhibition he had ever seen in the USSR.' It was a triumphant moment — all the more because I had someone to share it with.

Elena lived quite far out of central Moscow, near the Kosmos Buildings. We went outside to get her a car. I held up my cigarettes to stop a driver and there in the Moscow fug of cheap petrol fumes we finally kissed. It was tentative rather than passionate and had barely begun before a battered Lada clanked up at the kerb beside us.

'Here take these.' I gave Elena my last two packets of Marlboro. 'See you tomorrow.'

And with that the Lada rattled off into the night.

Klokov rang me the next morning.

'James! Elena wasn't at home when I called her last night. Did she sleep with you?'

'No,' I replied truthfully.

I thought it was an odd question, but it was only years later that I realised that he had expected her to report back on the evening's activities, and perhaps had been expecting more than that.

Before John returned to London, Elena, he and I spent an afternoon at the gallery, soaking up the show so we could tell Francis every last detail. We were allowed an hour in the gallery on our own — it felt incredible to have the chance to see the pictures again. It only reinforced my sense of accomplishment. The queues were even longer than the day before, and then the doors opened. It was packed within a matter of minutes. In front of each picture, a large group of Russians was looking intently at the canvas. Not glancing and moving or talking to each other like a London crowd but taking in everything that they could. There was

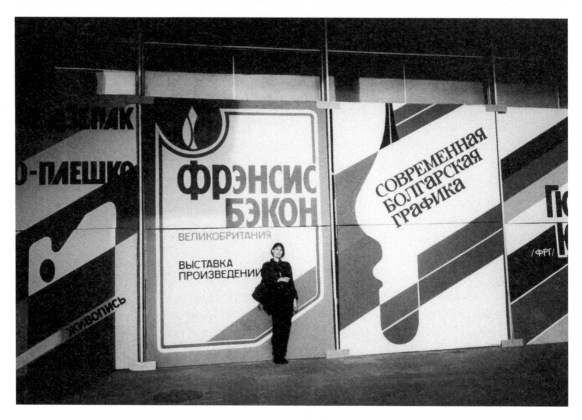

ELENA KHUDIAKOVA OUTSIDE THE EXHIBITION HALL

complete silence. This time, with Elena's help, I asked a number of people what they thought of the exhibition.

One man in his forties, who looked very down at heel, appeared to be transfixed by *Study for Portrait of Van Gogh III*, 1957.

All the clichés that were trotted out in the West, about Bacon as the painter who had uniquely responded to the horrors of war, Holocaust and coming nuclear conflagration made sense in this context, they weren't clichés in a city where the Nazis had reached the suburbs and untold millions had died. When the Russians looked at Francis's work they understood and they connected. My dream was made real.

A middle-aged lady said she 'couldn't understand it at all'; another woman said she 'didn't find it close to her art' but was interested in Bacon's direction. She praised 'his energy and style'. A young soldier liked the exhibition and praised Bacon for great imagination but was a bit confused. Another man we spoke to had seen a reproduction of the Screaming Pope in a magazine and was overjoyed to see it in the flesh. A female artist believed 'it was a very important event in the history of the Soviet Union'.

Perhaps I had not anticipated how overwhelmed I would feel hearing people's powerful responses to Francis's work. It made the highs and lows

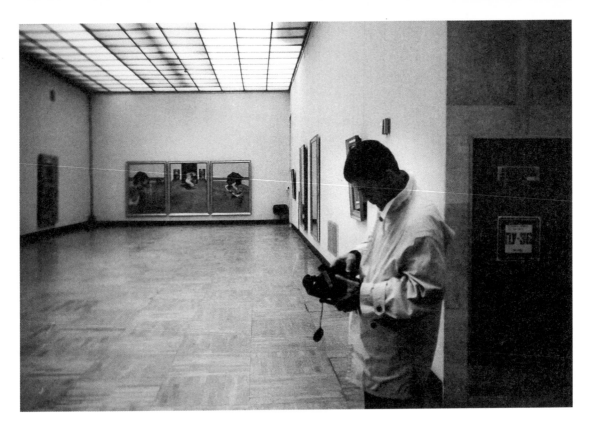

JOHN EDWARDS IN A GALLERY EMPTY OF PEOPLE

and the dreadful anxiety feel worthwhile. People didn't connect the portrait of John with John in the flesh. But I could tell that even he, despite his apparent cockney insouciance, was excited by people's reactions and was genuinely delighted on Francis's behalf.

And I was grateful, more than I could admit to myself, for Elena's companionship and help on this trip. It seemed to bode well.

Much later, perhaps four hours later, I went to leave the exhibition. On my way I passed the man in ragged clothes, still looking at *Study for Portrait of Van Gogh III, 1957*. He hadn't moved.

EPILOGUE

I finally met Tahir Salahov on Monday 26 September 1988 in his office. I had always imagined Salahov to be a Brezhnev-like figure; a dour and brooding Party official with huge black bushy eyebrows. So it was to my great surprise when I laid eyes on him at a press conference that he looked like a minor Mafioso. Salahov had olive skin, and today was wearing a shiny lightweight suit — legend had it that all his suits came from Savile Row — and a black moustache. Mineral water was served. He was beaming from ear to ear, and we got straight down to business.

'James, the show is a triumph,' he greeted me. 'Do you have any other artists for us?'

'Well, I would like to propose Gilbert & George, and here are their catalogues.'

'Are they good?'

'Yes, the best,' I replied.

'*Horosho*, let's do it.'

And we did. In partnership with Anthony D'Offay we opened Gilbert & George's One World exhibition in Moscow on 28 April 1990.

Everyone had left Moscow by Sunday night. Elena continued to be helpful and extremely attentive. I was still on a massive high. She met me at the hotel every day and took me to the Moscow sights, including the Pavilion of Economic Achievement, of which she was very proud. One of its prize exhibits was a giant pig. The whole scene reminded me of a gilded Soviet Disneyland. She also took me out for meals and gave me presents including, to my surprise, a pair of Soviet military underpants. She accompanied me to the airport on the day of my departure. I quote from my diary, dated Thursday, 29 September: 'I always feel very sad at goodbyes.'

Meanwhile the exhibition continued until 6 November. Some 400,000 visitors poured through the doors.

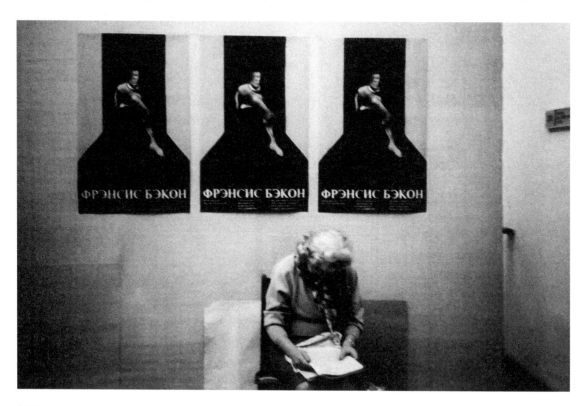

CUSTODIAN BY EXHIBITION POSTER

Klokov came to London towards the end of 1988 on a private visit. He must have told Francis of his fanciful plan to leave a painting in his will to the Pushkin Museum, as Francis gave him a small portrait of John Edwards. The next day Klokov dropped by to show me his prize. To my horror Valerie Beston rang me later that same day to tell me Klokov had sold the picture at Sotheby's. Apparently, it made over £250,000, although this amount is disputed.

'I thought he was leaving it to the Pushkin.'

'No, he's sold it,' she said, scandalised.

On Friday, 3 March 1989, I was invited by the British Council to a lunch given for Francis in a private room at the Groucho Club. A visiting delegation from the Union of Artists would be present. The night before the lunch Klokov rang to ask me if Tahir Salahov would be among the party.

'I think so Sergei.'

'Please, James, don't tell him that Francis gave me a picture.'

It was the only time in our association that I heard genuine fear in Klokov's voice. By selling a painting for private profit that he had pledged to leave to the state gallery he had, in effect, defrauded the Soviet Union. He could have been sent to Siberia, or worse, and he knew it.

'But what about Francis?' I said. 'He might tell him.'

'Try and intervene.'

At lunch the next day I had mixed feelings. Francis was late and on his arrival the conversation took an unusual turn.

'Mr Bacon,' said Salahov. 'We would be honoured if you give one of your paintings to the Union of Artists.'

'That's not possible,' came the terse reply. 'The only painting I could give you has already been censored by the Union.'

Francis was taking quiet revenge for the Union of Artists' rejection of one of his greatest works, for what Klokov called 'cock-exalting'. Klokov, meanwhile, had got away with his deception — Francis did not mention the portrait of John he had given to Klokov in London to me ever again.

Following the fall of communism, Klokov used the money from the portrait of John to buy a snake farm in Uzbekistan, where he had plans to produce cobra venom commercially as a health tonic. He also took on the lease of a basement flat in Cadogan Square in Knightsbridge, where he would stay on his visits to London until his new girlfriend Tall Marina accidently set fire to the apartment. The cobra venom business failed.

Elena came to live with me in March 1989. She became a great favourite of Francis's who found her exquisitely beautiful and enchanting. In October, Paul and I gave her a show of her fashion pieces, which re-interpreted Soviet imagery and design from the 1920s, at Birch & Conran Fine Art. In the same year, she designed the costumes for the Bastille Day Parade in Paris, organised by the fashionable French art director Jean-Paul Goude. She went on to show her own work at The Anthony Reynolds Gallery, curated by Jane Rankin-Reid. She was painting in the style of Soviet Pop Consumerism, immortalising everyday objects such as televisions and motorcycles in a boldly coloured pop-art style. Charles Saatchi, on seeing one picture, wanted to see more and bought the series.

Between 1994 and 2010 she worked for the fashion designer Vivienne Westwood. She had exhibitions at the Russian Embassy (2008), Pushkin House (2008) and the Rossotrudnichestvo, the Russian Culture Centre on High St Kensington, the last two which I curated. She married and divorced but I never met her husband.

Elena's hopes and expectations of a life in the West were idealistic and perhaps I hadn't understood the depth of my responsibilities towards her in this respect.

She rang Moscow constantly, unable to break the connection. My telephone bills were astronomically high.

We once more discussed marriage but my mother, anxious about my future, rang me to say, 'Darling, you can't marry her, she's KGB!' I understood her, but I couldn't believe her.

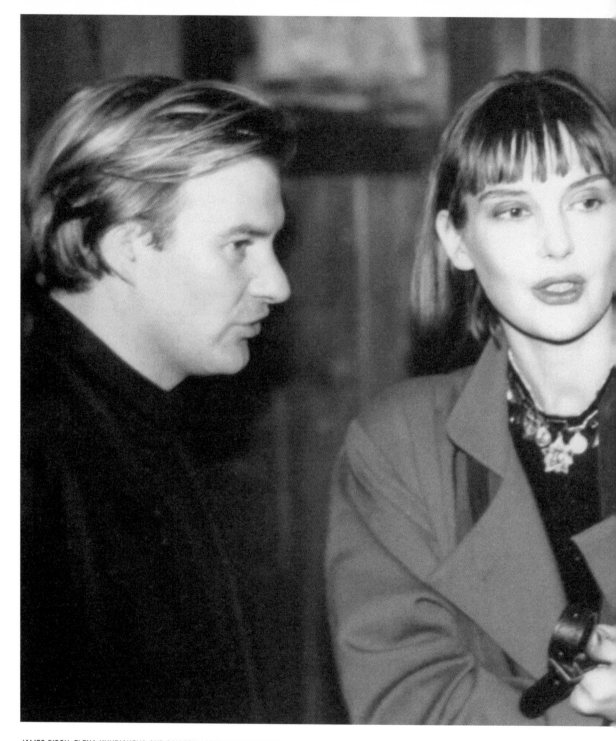

JAMES BIRCH, ELENA KHUDIAKOVA AND GALLERY ASSISTANT ALICE WILSON
PHOTOGRAPH BY TYREL BROADBENT

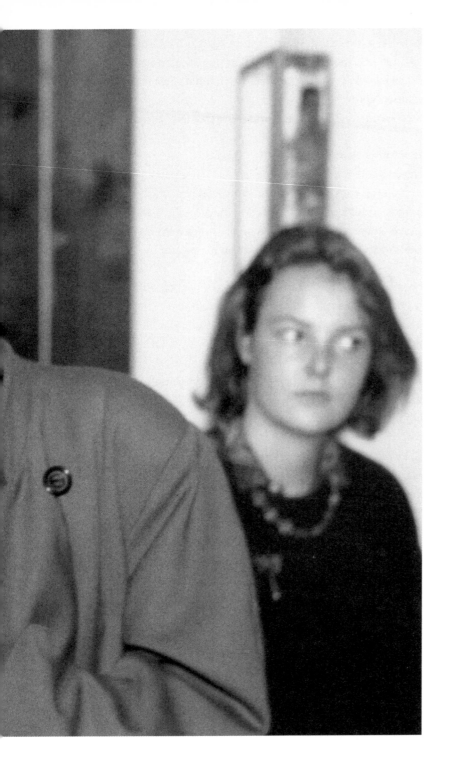

Elena couldn't live within the Soviet system but she couldn't live without it. Nor could she escape the transactional nature of relationships that was intrinsic to survival in the USSR but which had no meaning or resonance for those living in the West.

My father once asked her, 'What's the best thing that ever happened to you?'

Elena replied without hesitation. 'Meeting Klokov.'

In a conversation about children, she told me she would remain in the West but send her children back to be brought up by Klokov.

We parted in 1992, at which point she went to lodge with a Labour councillor in Camden where she was expected to join in with the singing of the Internationale every night before sitting down for supper.

Arise, ye workers from your slumber,
Arise, ye prisoners of want.

She was horrified.

The first block of the Berlin Wall came down in 1989 and with it the Communist German Democratic Republic (GDR) began its collapse. The Soviet Union followed in 1991.

Francis died on Friday, 24 April 1992. I was in Moscow, meeting Misha and his new wife Sharafat for lunch. They had heard the news on the BBC World Service. I was devastated and the worst of it was not knowing how it had happened as it was virtually impossible to ring out of Moscow.

My friend Leila, from Kazakhstan, who I had recently met and who helped introduce me to the underground avant-garde in Moscow, happened to be in the bar of the restaurant. She could see I was desperate and suggested that we drive to the flat in the suburbs she shared with her Finnish boyfriend where, somehow, they had an international line.

Foreigners still needed a permit to travel outside of central Moscow and I didn't have one. Leila explained she had a wonky headlight so if we were stopped by the traffic police, I would have to pretend to be deaf and dumb.

We were stopped. I faked sign language but they turned out to be more interested in Leila than me and took her to the police car. Most traffic fines could be avoided with a bribe of roubles but watching from my seat I saw Leila's head bobbing up and down and realised, to my horror, that the bribe on this occasion was oral sex. There was so much civic unrest, violence, rape and police brutality in every city as the Soviet Union broke up that perhaps it was not a surprise that this dreadful exploitation took place. Leila and I never spoke about the incident.

I finally got through to Dan Farson, who told me what he knew of the struggle and loneliness of Francis's last days. Francis died in Madrid while on a trip to see his lover, Jose Capelo. John had remained in London. It was common knowledge that Francis didn't want a funeral or memorial service. I felt unbearably sad. A great artist had died. A lifelong friendship had come to an end. An era was over.

David Robilliard died of AIDs aged 36 in late autumn of 1988.
Misha Mikhev died of liver failure aged 53 in 1998.
John Edwards died of lung cancer aged 53 in a Bangkok hospital in 2003.
Johnny Stuart died aged 63 in 2003 after a long illness.
Elena Khudiakova died of an aneurism aged 58 in 2015 while visiting friends in Moscow.
Sergei Klokov died aged 57 in a hospice in Moscow in 2017.
Tahir Salahov died aged 92 in Berlin in 2021.
Alexander Hore-Ruthven, known as Grey, the second Earl Gowrie, died aged 82 of complications after long COVID on 24th September 2021.

I continued to explore the idea of mounting exhibitions in communist countries. I took Gilbert & George to Beijing and Shanghai with their China Exhibition in 1993 and travelled to DPKK (North Korea) three times in an effort to exhibit artists such as Keith Coventry, but due to sanctions imposed by the West it proved impossible.

GAZETTEER TO THE EXHIBITION WHICH IS NOT
IN HANGING ORDER. FRANCIS BACON HAD
THE FINAL CHOICE IN THE PICTURES MADE
AVAILABLE FOR THIS SHOW.

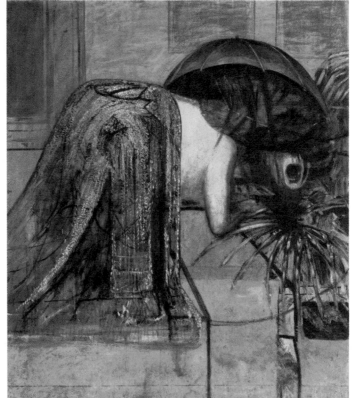

FRANCIS BACON,
FIGURE IN A LANDSCAPE,
1945

FRANCIS BACON,
FIGURE STUDY II,
1945 — 1946

FRANCIS BACON,
HEAD VI,
1949

FRANCIS BACON,
HEAD II,
1949

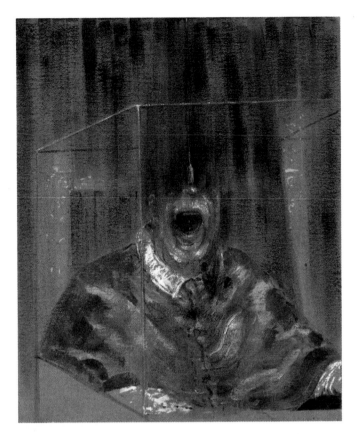

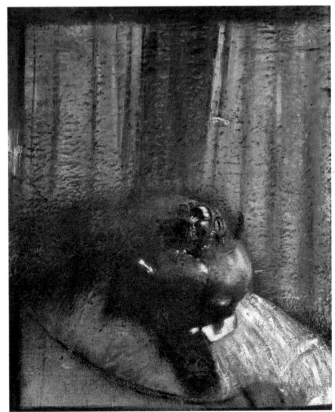

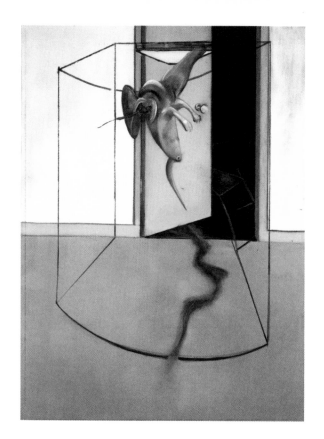

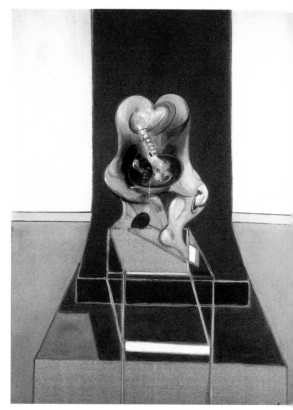

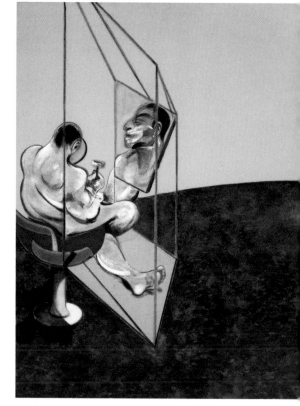

FRANCIS BACON,
TRIPTYCH INSPIRED BY
THE ORESTEIA OF AESCHYLUS,
1981

FRANCIS BACON,
THREE STUDIES
OF THE MALE BACK,
1970

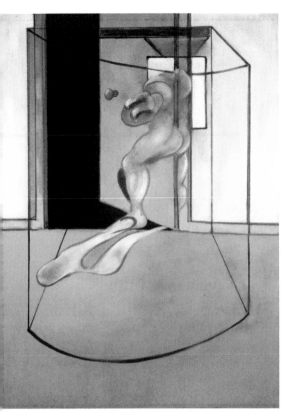

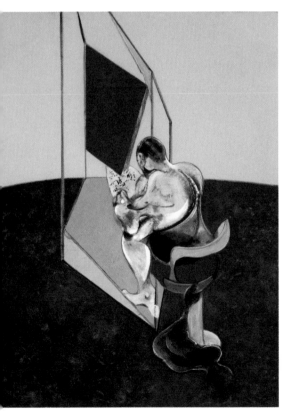

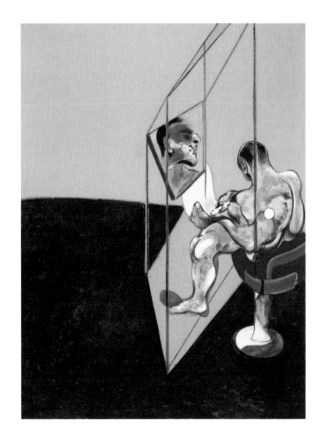

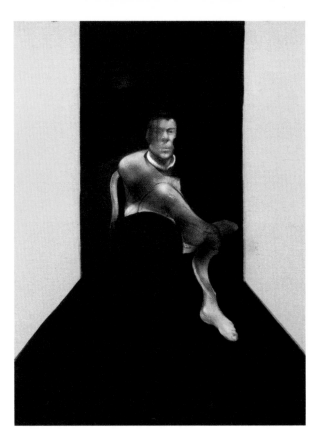

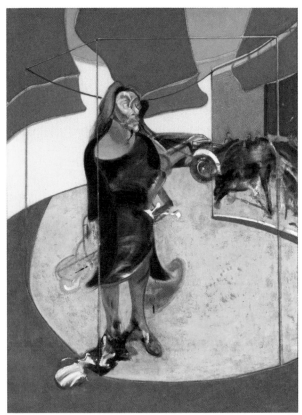

FRANCIS BACON,
STUDY FOR A PORTRAIT
OF JOHN EDWARDS,
1988

FRANCIS BACON,
PORTRAIT OF ISABEL RAWSTHORNE
STANDING IN A STREET IN SOHO,
1967

FRANCIS BACON,
SEATED FIGURE,
1974

FRANCIS BACON,
AFTER MUYBRIDGE — WOMAN
EMPTYING A BOWL OF WATER AND
PARALYTIC CHILD ON ALL FOURS,
1965

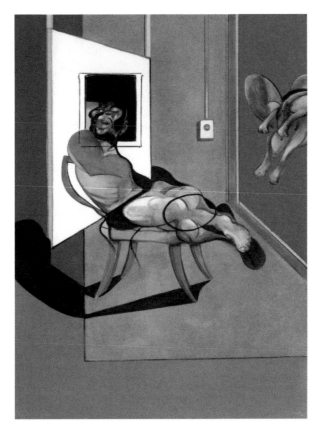

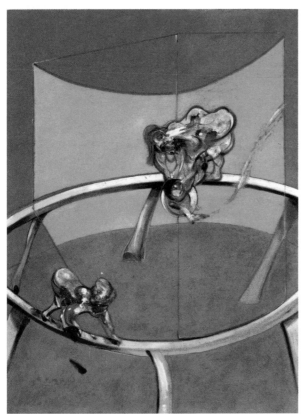

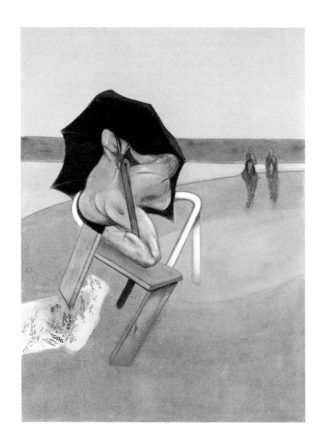

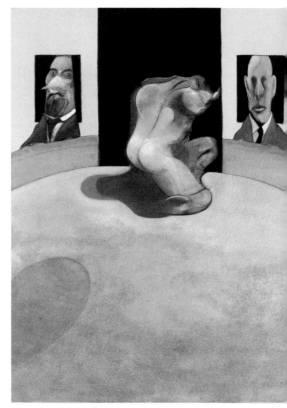

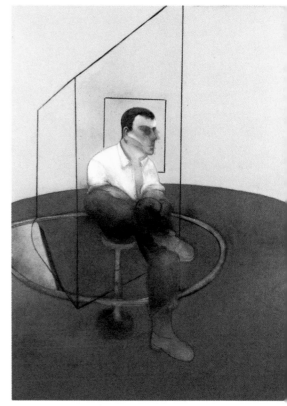

FRANCIS BACON,
TRIPTYCH 1974 — 1977,
1974 — 1977

FRANCIS BACON,
THREE STUDIES FOR A PORTRAIT
OF JOHN EDWARDS,
1984

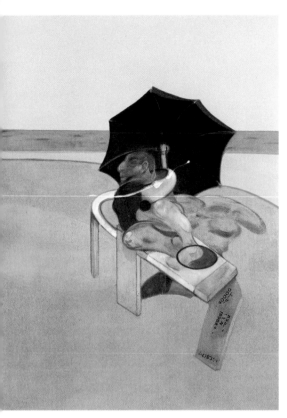

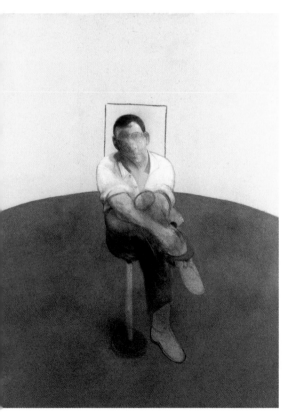

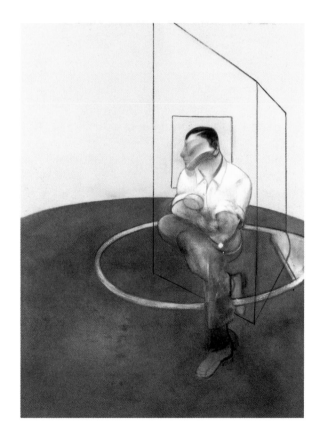

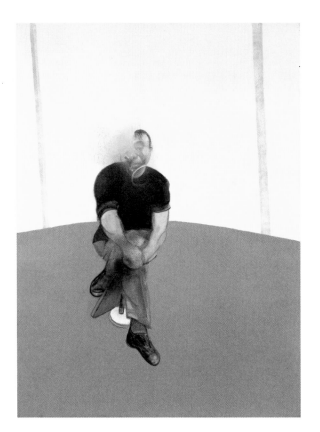

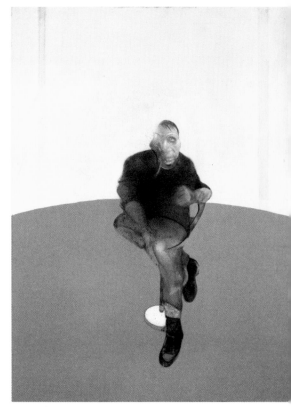

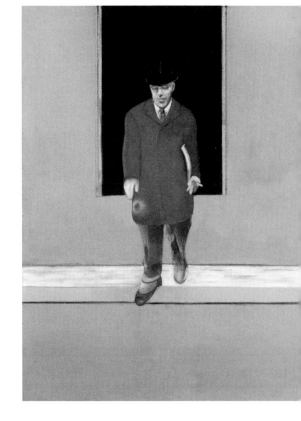

FRANCIS BACON,
STUDY FOR A SELF-PORTRAIT —
TRIPTYCH,
1985 — 1986

FRANCIS BACON,
TRIPTYCH 1986 — 7,
1986 — 1987

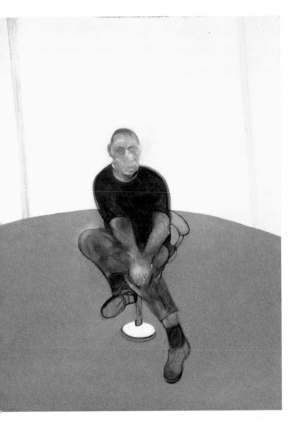

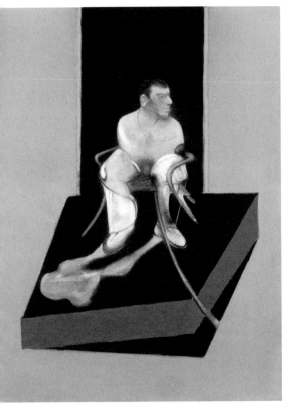

FRANCIS BACON,
JET OF WATER,
1988

FRANCIS BACON,
LYING FIGURE,
1969

FRANCIS BACON,
FIGURE IN MOVEMENT, 1985

FRANCIS BACON,
SELF-PORTRAIT,
1973

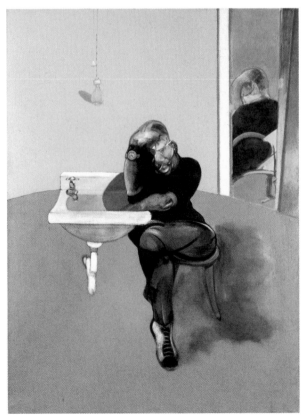

FRANCIS BACON,
STUDY FOR PORTRAIT
OF VAN GOGH III,
1957

FRANCIS BACON,
LANDSCAPE NEAR MALABATA,
TANGIER,
1963

FRANCIS BACON,
BLOOD ON THE FLOOR —
PAINTING,
1986

FRANCIS BACON,
FIGURE IN MOVEMENT,
1976

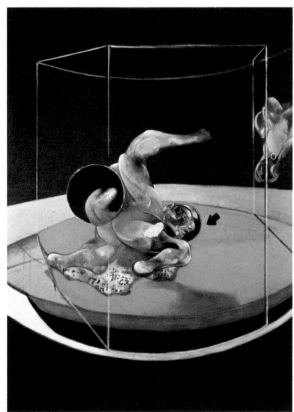

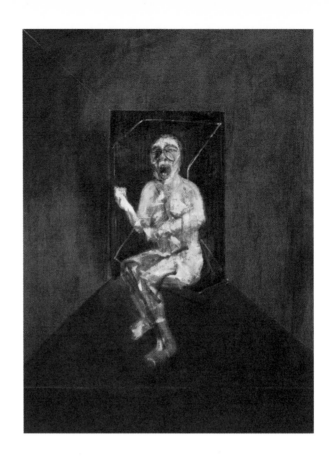

FRANCIS BACON,
STUDY FOR NURSE
IN BATTLESHIP POTEMKIN,
1957

POSTSCRIPT

At some point in 1992/1993, Misha told me that the KGB held, somewhere in the bowels of Lubyinka Square, 2,000 pages or so about my activities in Paris, Moscow and London from 1985 onwards. They were Elena's reports.

The files were opened to the public. Misha told me that the my files would be available to me at a cost of $500. At the time it seemed like a lot of money to read that I had eaten an expertly boiled egg.

I regret, now, that I didn't take advantage of this brief period of openness to gain access to these records of the activities of my younger self.

After our separation Elena and I remained friends. When I questioned her about her involvement in reporting on me to the KGB, her simple reply was 'So?' I was genuinely shocked and upset by her betrayal, but I have come to understand that she must have been put under huge pressure, possibly in fear for her life, if she did not meet Klokov and the KGB's demands.

And I knew from the story of Olga Ivinskya, the Russian State would relentlessly persecute those that betrayed the mother country. They would never be forgiven.

FROM THE VISITORS' BOOK TO THE EXHIBITION

' INDEED HE IS THE GREATEST ARTIST SINCE
REMBRANDT. I DIDN'T EXPECT TO SEE
HIS PAINTINGS IN THIS COUNTRY. THANK YOU. '

— Makarov Vladislav, artist, aged 38

'BACON IS BEAUTIFUL IN HIS MONSTROSITY.
IF HE IS MAD, HE IS NEITHER MORE NOR LESS
SO THAN THE MODERN WORLD.'
— A.V., engineer, aged 35

'I WOULD LIKE TO ASK ARTISTS:
"HAVEN'T WE GOT ANYTHING BETTER TO SHOW
THAN THIS DAUB?" WE REGRET THE WASTE
OF TIME SPENT AT THIS EXHIBITION.'
— [two illegible signatures]

' GREAT ARTIST, GREAT IMPRESSION!
MY GREETINGS TO YOU, FRANCIS'

— Mikhailov V., artist, Leningrad

'AT LAST THIS EXHIBITION HAS FORCED SOVIET YOUTH TO THINK ABOUT THE MEANING OF LIFE AND DEATH, TO HAVE THEIR OPINION. MANY PEOPLE HAVE FORGOTTEN ALL ABOUT THIS! WE NEED MORE UNDERSTANDING OF THE REAL PRICE OF LIFE, TRAGEDY AND BEAUTY. THANK YOU.'

— students and professors from Moscow Cinematographical Institute

'I LIKE FRANK ZAPPA. I LIKE FRANCIS BACON. THANK YOU.'

— [illegible signature]

'THIS IS THE ART OF THE INFERNO — SHOULD
WE DISPLAY IT? YES, WE MUST! WE NEED DANTE!
IT IS A PITY THAT IN CHRISTIAN GREAT BRITAIN,
THERE IS NO PRIEST WHO CAN HELP THE VIEWER
TO ORIENTATE HIS ARTISTIC PERCEPTION
AS THE PERCEPTION OF THE INFERNO.'
— Marclento V.

'GRATITUDE TO THE ARTIST,
THESE PAINTINGS ARE RELATED TO THE REAL WORLD.'

— [illegible signature], academician of physics and biophysics

'THIS ART CAN AROUSE NOTHING BUT DISGUST
AND NAUSEA. I FELT LIKE THAT AFTER THE EXHIBITION.
THE MAIN FEATURES CHARACTERISING BACON'S
PAINTINGS ARE FRANK CYNICISM, SPITTING INTO
THE HUMAN SOUL, AND MISANTHROPY. THIS IS MY VISION.
I HAVEN'T SEEN ANYTHING MORE NIGHTMARISH.'

— [illegible signature]

' BACON'S VISION! WHY IS IT SO HORRIBLE?
WHAT DOES HE SEE? IS LOATHSOMENESS
A CONSTANT PART OF OUR LIFE? I LEFT THE
EXHIBITION WITH THE FEELING THAT I AM
NOW WORSE THAN BEFORE SEEING IT.
IT IS TERRIBLE. LIFE IN RUSSIA WAS ALWAYS
SPIRITUAL AND MORAL. INTRODUCING
SUBSERVIENCE IS IMMORAL. WITHOUT RESPECT,
A MEMBER OF THE CULTURAL FUND.'
— Bilwitina, Moscow

' I SAW MYSELF IN FRANCIS BACON'S PAINTINGS.
FEELINGS VERY COMPLICATED ... THANK YOU ...'
— Yanke Laura, aged 18

'IT'S HARD TO BELIEVE THAT FRANCIS BACON AND WILLIAM SHAKESPEARE ARE OF THE SAME NATIONALITY. THE EXHIBITION REMINDS US THAT MADNESS IS A REAL PHENOMENON.'
— [illegible signature], Moscow

'BACON HAS MANAGED TO RENDER HORROR, PESSIMISM AND HOPELESSNESS WELL ENOUGH. HE IS VERY GOOD IN SHOWING ALL THE HORROR IN THE USSR DURING THE REPRESSIONS.'
— Ivanov

' AT THE BEGINNING, EVERYTHING WAS INCOMPREHENSIBLE BUT SOME PAINTINGS TOUCHED MY HEART. I THINK IT IS WONDERFUL. '

— [illegible signature], Moscow

' OUR SOCIETY WAS ALWAYS AFRAID OF SURREALISTS. BECAUSE OF THEIR GREAT ABILITY TO PENETRATE INTO THE DEPTHS OF EVERYTHING. NOW WE HAVE STOPPED BEING AFRAID. '

— [illegible signature]

'EXCELLENT! THANK YOU FOR YOUR INTERESTING, UNUSUAL PAINTINGS. I HAVEN'T SEEN ANYTHING LIKE THIS BEFORE IN MY LIFE. DO COME AGAIN. '
— Chernova, Moscow

'IT IS GOOD THAT THE EXHIBITION IS SMALL.
IT COULD DRIVE ONE MAD. SET OUT INTO
THE FRESH AIR AS SOON AS POSSIBLE.'
— [illegible signature]

'SPEAKING FRANKLY, THIS EXHIBITION
DEPRESSED ME. IN THE PAINTINGS,
I SAW PESSIMISM AND ILL-NATURE. HOWEVER,
IT IS BETTER THAN SOCIALIST REALISM.'
— [illegible signature]

**' YOU FEEL GRIEF AND THE BRUNT OF LIFE.
THANK YOU, MR FRANCIS BACON,
FOR FORCING US TO THINK ABOUT MANY THINGS. '**

— Apolonovna Nadezhda Vasilyevna, retired, aged 60

' I LIKE YOU AS A MAN AND AS AN ARTIST. '

— Yanke Laura, aged 18

'EXCELLENT, AMAZING AND INCREDIBLE!
INDELIBLE IMPRESSION FROM
FRANCIS BACON'S EXHIBITION! HE IS A GENIUS!'
— Chernobrovkina Anna Vladimirovna, student, aged 15

' WE WANT BACON, NOT FRANCIS BACON'

— unknown

ACKNOWLEDGEMENTS

James Birch
A huge thank you to Harriet Vyner whose original idea it was that I write this book.

Thanks also to Jeremy Cassel, Brian Clarke, the trustees of the Estate of Francis Bacon, Riot Communications, Tom Davenport and his team, Peter Jones and the Profile team, Mike von Joel, Syndicut, Mark Hampshire and Keith Stephenson of mini-moderns.

Early readers: Maria Alvarez, Liza Andronova, Darren Biabowe Barnes, Charlotte Black, Robert Chenciner, Paul Conran, Rachel Goldblatt, Michael Hodges, Barry Miles, Freddie Pegram, Gillian Stern, Jacqueline Taber, Jon Lys Turner.

Further thanks: Judy Adam, the late EileenAgar, Sharofat Anarkulova, Maria Anastassiou, Atlantis Print, William Bangor, Kate Braithwaite,Louisa Buck, Bryan Cartledge, Emelia Colliver, Rohan Daft, Robin Dutt, the late John Edwards, Sarah Hall, Mark Inglefield, Deniz Johns, Larissa Kouznetsovia, Mail Boxes ETC Clerkenwell, Emile Mardacany, the late Mikhail Mikheyev, Harland Miller, Grayson Perry, Jane Rankin-Reid, Varvara Shavrova, Polly Stenham, Mark Stevens, Annalynn Swan, Zinovy Zinick. And to the British Council for the quotes from the visitors' book.

And lastly, a big thank you to the brilliant Clare Conville for her inspiration and invaluable editorial suggestions. Without Clare this book would not have been possible.

Michael Hodges
My immense thanks to Anna Crane.

Picture credits:
Thanks to the Estate of Francis Bacon for kind permission to reproduce the Bacon paintings from the exhibition.

Further thanks to Francis Bacon, Jeremy Blank, Tyrel Broadbent, Robert Chenciner, Jane England, Stuart Keegan, the Estate of Claudia Lennon — Eleanor Kanter and Thomas Lennon — Phillip Mordue, Grayson Perry and Alastair Thain for photographs featured in the book.

Unless otherwise credited, all other photographs are by James Birch.